ANIME & MANGA
Digital COLORING Guide

Choose the Colors That Bring Your Drawings to Life!

Teruko Sakurai

TUTTLE Publishing

Tokyo | Rutland, Vermont | Singapore

CONTENTS

CHAPTER **1**

Color Basics

FOR PEOPLE WHO DRAW

CHAPTER **2**

Eye and Hair Colors That Create a Character's Image

COLOR PSYCHOLOGY FOR COLORING CHARACTERS (PART ONE)

CHAPTER 3

The New Science of Color

FOR PEOPLE WHO DRAW

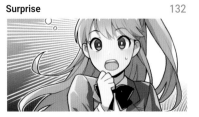
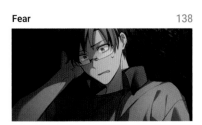
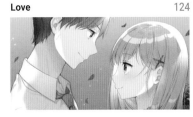
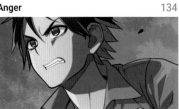

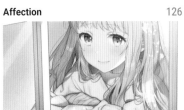
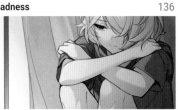

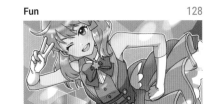
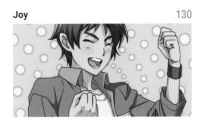

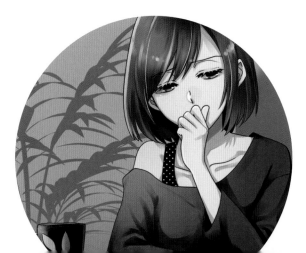

World Views Created Through Color

PRACTICE CATALOG

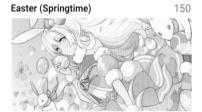

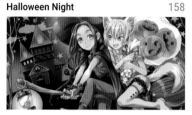
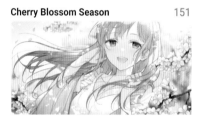
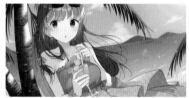

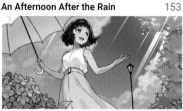

Fantasy and Futuristic Palettes 163

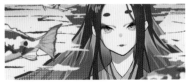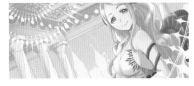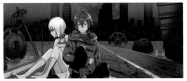
ASK THE EXPERTS 5

● The PCCS (Practical Color Coordinate System) images used in this book are based on the data provided by the Japan Color Research Institute, but they are not accurate according to standard values.

● To refer to the standard colors of the PCCS, please refer to the "New Color Cards 199" or the "PCCS Harmonic Color Chart 201-L", issued by the Japan Color Research Institute. (Website of the Japan Color Research Institute: http:/www.sikiken.co.jp).

Why I Wrote This Book

"Although my line art looks good, once I add color, that's when the illustration starts to falter." "My color sense is disastrous, and I want to do something about it." "I always use the same colors, it's monotonous." Does this sound like you? No worries, these issues can all be solved, not with coloring technique, but with a knowledge of color schemes! This book offers a revolutionary way to acquire and apply an understanding of color schemes for manga and anime characters.

This book has been designed so that you can leaf through it as if you're flipping through a color tone sample book. Or use it as an encyclopedic guide, studying the effects and influence of tone, palette, hue and saturation.

The comments quoted in the introductory paragraph all came from you: artists expressing their difficulties, struggles and frustrations on social media. This is why I wanted to create a book that would teach you about color theory in a fun and easy-to-understand way.

I started by interviewing the veteran instructors in the manga and animation departments of specialized schools. The instructors are also professionals who work in the field, so the stories they shared with me are the essence of this book.

A knowledge of color is useless if it is just knowledge. I believe that by using that knowledge in your evolving illustrations, you see the applications at work in your own choices and process. As long as you have a firm grasp of the basics, you'll be able to freely create a world of your own. If you have this book on hand and use it as a guide when you're coloring your characters, my production and team and I couldn't be happier.

—**Teruko Sakurai**

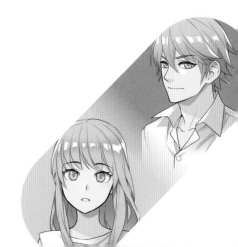

How to Use This Book

It's time to color your creative world, putting color theory into practice and applying color to your characters. With so many examples and color swatches included, even those new to coloration and painting techniques will be able to apply attractive tones to their characters right away.

1 You can bring out the attractiveness of characters through the power of color based on color theory!

You'll learn the relationships between the colors that determine the impressions the characters make, such as hair and eye color, and their relationship with background colors. You'll be able to create the characters and world view that you envision.

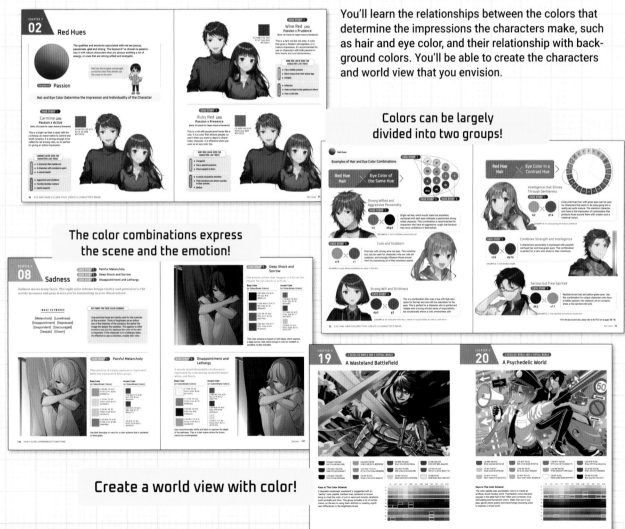

Colors can be largely divided into two groups!

The color combinations express the scene and the emotion!

Create a world view with color!

2

Learn the basics of color science that anyone who draws or illustrates should know!

I'll explain the basics of color theory such as hue and tone in an easy-to-grasp way. The more you know about color, without a doubt the more fun it will become to color your characters.

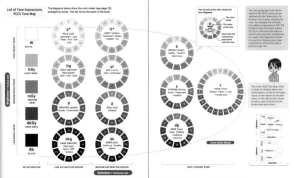

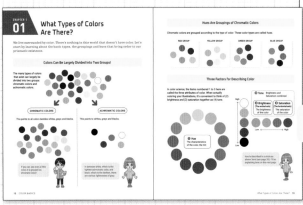

Explained in an easy-to-understand way with diagrams and example illustrations !

3

You can copy them right away! Lots of full-color examples are included!

I've included examples of effective color combinations with illustrations. Since these allow you to understand the effects of color instinctively, you can choose the color combinations that you like.

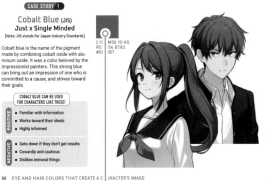

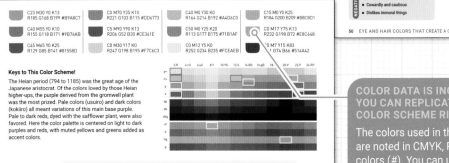

C23 M30 Y0 K13
R185 G168 B199 #B9A8C7

C40 M55 Y0 K10
R155 G118 B171 #9B76AB

C45 M65 Y0 K25
R129 G85 B141 #81558D

C0 M70 Y35 K10
R221 G103 B115 #DD6773

C5 M90 Y90 K13
R206 G52 B30 #CE341E

C0 M30 Y17 K0
R247 G198 B195 #F7C6C3

C40 M0 Y30 K0
R164 G214 B192 #A4D6C0

C50 M0 Y25 K20
R113 G177 B175 #71B1AF

C0 M12 Y5 K0
R252 G234 B235 #FCEAEB

C15 M0 Y0 K25
R184 G200 B209 #B8C8D1

C0 M17 Y75 K13
R232 G198 B72 #E8C648

C0 M7 Y15 K83
R61 G74 B66 #514A42

Keys to This Color Scheme!
The Heian period (794 to 1185) was the great age of the Japanese aristocrat. Of the colors loved by those Heian higher-ups, the purple derived from the gromwell plant was the most prized. Pale colors (usuiro) and dark colors (kokiiro) all meant variations of this main base purple. Pale to dark reds, dyed with the safflower plant, were also favored. Here the color palette is centered on light to dark purples and reds, with muted yellows and greens added as accent colors.

You can test out the color combination that catches your eye right away!

COLOR DATA IS INCLUDED SO THAT YOU CAN REPLICATE THE SAME COLOR SCHEME RIGHT AWAY!

The colors used in the example illustrations are noted in CMYK, RGB and web safe colors (#). You can use them immediately in digital coloring.

Color Basics

FOR PEOPLE WHO DRAW

It's useful to have a knowledge of color science and color
classification when bringing your illustrations to life.
In this chapter, I'll walk you through the basics of applying
color, harnessing the power of the color wheel and
its many hues.

01

What Types of Colors Are There?

We live surrounded by color. There's nothing in this world that doesn't have color. Let's start by learning about the basic types, the groupings and hues that bring order to our prismatic existence.

Colors Can Be Largely Divided Into Two Groups!

The many types of colors that exist can largely be divided into two groups: chromatic colors and achromatic colors.

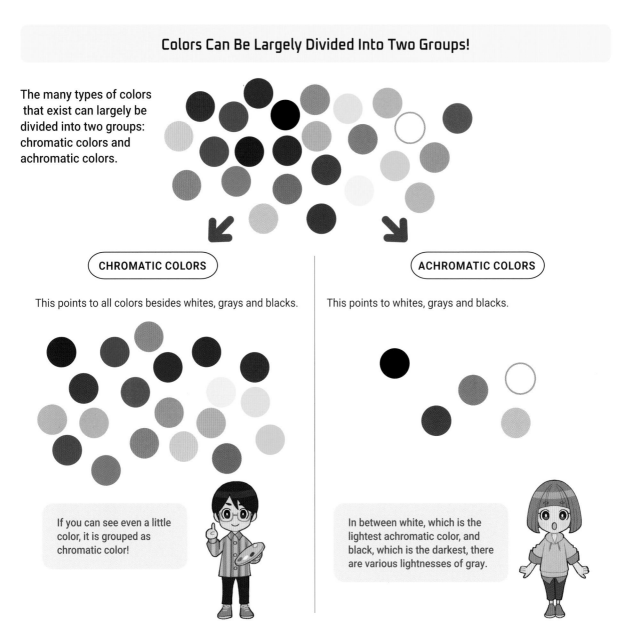

CHROMATIC COLORS

This points to all colors besides whites, grays and blacks.

ACHROMATIC COLORS

This points to whites, grays and blacks.

If you can see even a little color, it is grouped as chromatic color!

In between white, which is the lightest achromatic color, and black, which is the darkest, there are various lightnesses of gray.

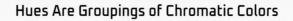

Hues Are Groupings of Chromatic Colors

Chromatic colors are grouped according to the type of color. These color types are called hues.

RED GROUP YELLOW GROUP GREEN GROUP BLUE GROUP

Three Factors for Describing Color

In color science, the items numbered 1 to 3 here are called the three attributes of color. When actually coloring your illustrations, it's convenient to think of (2) brightness and (3) saturation together as (4) tone.

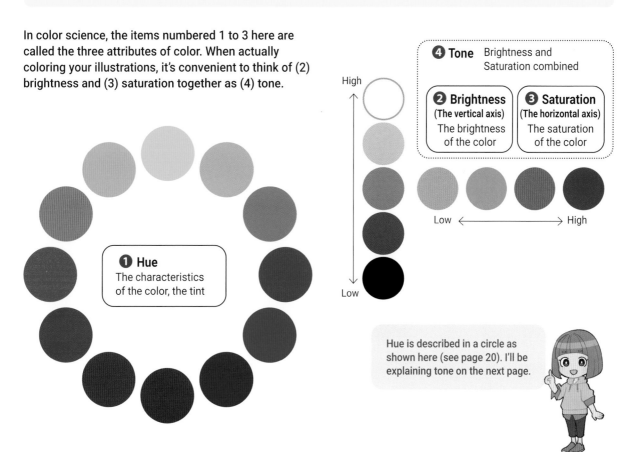

❹ **Tone** Brightness and Saturation combined

❷ **Brightness**
(The vertical axis)
The brightness of the color

❸ **Saturation**
(The horizontal axis)
The saturation of the color

High

Low ⟵ ⟶ High

Low

❶ **Hue**
The characteristics of the color, the tint

Hue is described in a circle as shown here (see page 20). I'll be explaining tone on the next page.

02 Image Is Determined by Tone

Even if the same red is used, the impression it gives can change a lot depending on how light it is and and how bright it is. If you think of color as a tone, it becomes easier to change the impression an image makes by changing the color.

Colors Can Change Depending on the Tone

Let's look at the changes of tone in one hue.

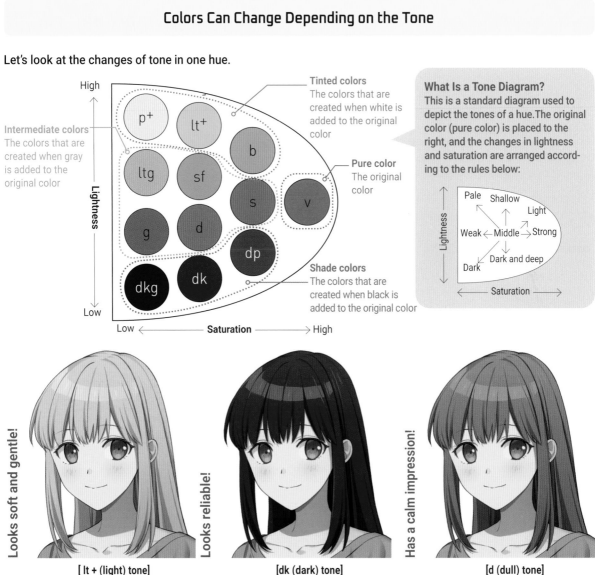

Intermediate colors
The colors that are created when gray is added to the original color

Tinted colors
The colors that are created when white is added to the original color

Pure color
The original color

Shade colors
The colors that are created when black is added to the original color

What Is a Tone Diagram?
This is a standard diagram used to depict the tones of a hue. The original color (pure color) is placed to the right, and the changes in lightness and saturation are arranged according to the rules below:

[lt + (light) tone] — Looks soft and gentle!

[dk (dark) tone] — Looks reliable!

[d (dull) tone] — Has a calm impression!

※The impressions that tones make are exlained in detail in the List of Tone Impressions on pages 16–17.

Highly Saturated Tones
These are the pure colors plus the tones that are created by adding a little bit of white, black or gray.

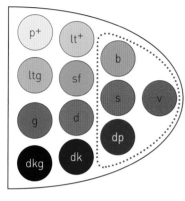

Unique and distinctive! Bright and gorgeous! Recommended for traditional Japanese characters too!

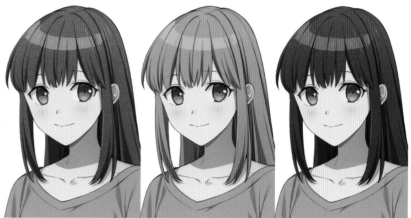

[v (vivid) tone] [b (bright) tone] [dp (deep) tone]

Low-Saturation Tones
These are the tones that are created by adding a lot of white, black or gray to the pure color.

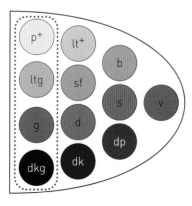

You can express a delicate allure! Stylish and fashionable! Strong and reliable!

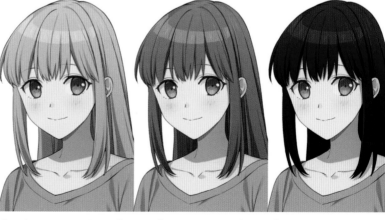

[ltg (light grayish) tone] [g (grayish) tone] [dkg (dark grayish) tone]

List of Tone Impressions
PCCS Tone Map

The diagrams below show the color wheel (see page 20), arranged by tones. This list forms the basis of the book.

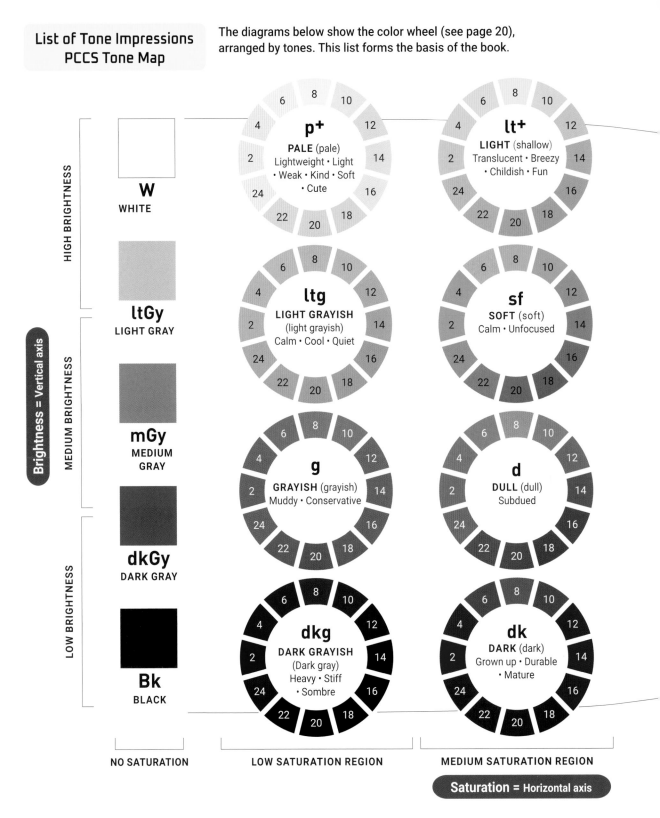

Brightness = Vertical axis

HIGH BRIGHTNESS

MEDIUM BRIGHTNESS

LOW BRIGHTNESS

W WHITE

ltGy LIGHT GRAY

mGy MEDIUM GRAY

dkGy DARK GRAY

Bk BLACK

p+ PALE (pale) Lightweight • Light • Weak • Kind • Soft • Cute

lt+ LIGHT (shallow) Translucent • Breezy • Childish • Fun

ltg LIGHT GRAYISH (light grayish) Calm • Cool • Quiet

sf SOFT (soft) Calm • Unfocused

g GRAYISH (grayish) Muddy • Conservative

d DULL (dull) Subdued

dkg DARK GRAYISH (Dark gray) Heavy • Stiff • Sombre

dk DARK (dark) Grown up • Durable • Mature

NO SATURATION

LOW SATURATION REGION

MEDIUM SATURATION REGION

Saturation = Horizontal axis

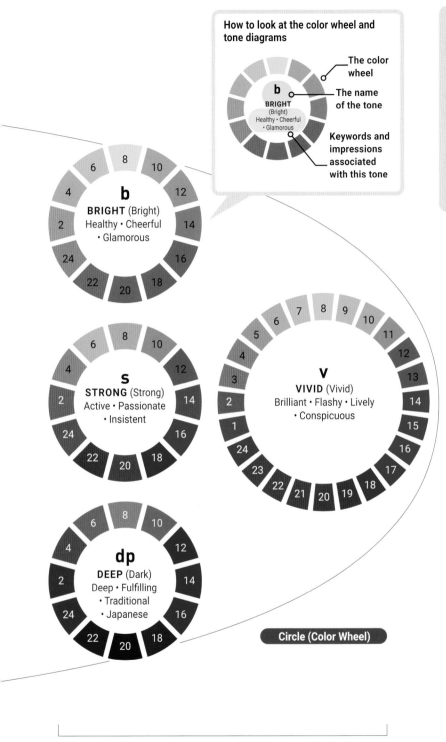

How to look at the color wheel and tone diagrams

- The color wheel
- The name of the tone
- Keywords and impressions associated with this tone

b
BRIGHT (Bright)
Healthy • Cheerful • Glamorous

s
STRONG (Strong)
Active • Passionate • Insistent

v
VIVID (Vivid)
Brilliant • Flashy • Lively • Conspicuous

dp
DEEP (Dark)
Deep • Fulfilling • Traditional • Japanese

Circle (Color Wheel)

HIGH CHROMA ZONE

The color groupings in this list are based on the PCCS colors, and are depicted with the "abbreviation for the tone + the number inditating the color." For example, the b (Bright) tone yellow is expressed as "b8." The Practical Color Coordinate System (PCCS) is a discrete color space indexed by hue and tone, developed by the Japan Color Research Institute. It is useful for thinking about color combinations. PCCS color data is listed on page 180.

This is the PCCS Tone Map, which is useful for thinking about color combinations. On top are the bright colors, on the bottom are the dark colors, on the right are the saturated colors, and on the left are the desaturated quiet colors.

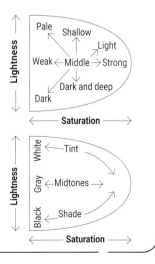

03 Create the Right Ambiance with Tone

When nailing down the ambiance and uniqueness of a character, refer to the List of Tone Impressions on pages 16–17. Consider if your aim to make the colors cohesive or to apply and highlight contrast.

Apply the Same or Similar Tones for a Cohesive Look

If you combine the same or similar tones, it is easy to create a cohesive look. The impressions given by the tones become the impression given by the character.

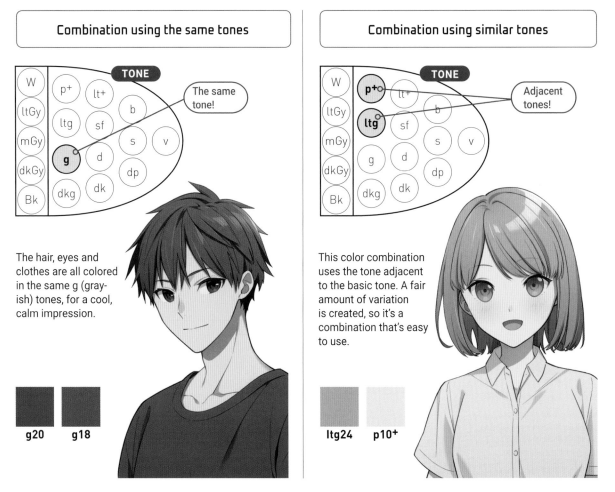

Combination using the same tones

The same tone!

The hair, eyes and clothes are all colored in the same g (grayish) tones, for a cool, calm impression.

g20 **g18**

Combination using similar tones

Adjacent tones!

This color combination uses the tone adjacent to the basic tone. A fair amount of variation is created, so it's a combination that's easy to use.

ltg24 **p10+**

※ The tone diagrams on this page are simplified versions of the Tone Impressions diagrams on pages 16–17.

Create Ambiance with Contrasting Tones

Contrasting tones are those that are far apart on the tone diagram. If they are separated vertically they have different brightness, and if they are separated horizontally they have different saturation. Diagonally, you can find tones that have contrast in both.

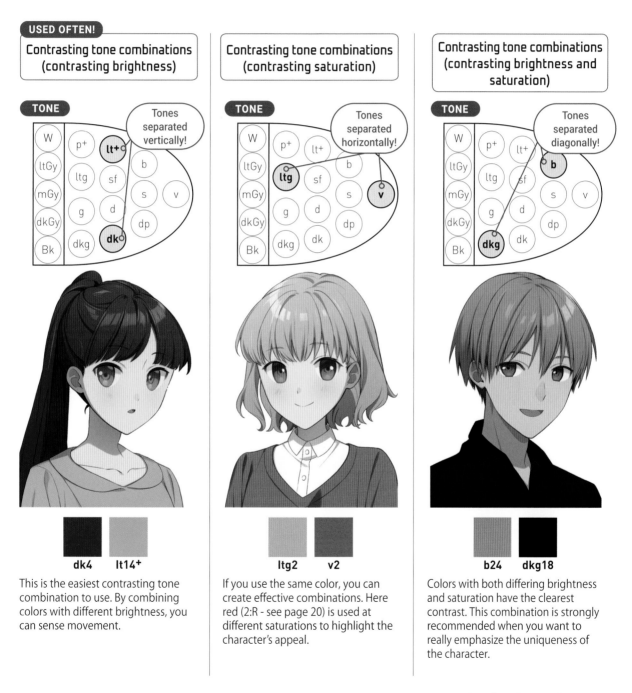

USED OFTEN!

Contrasting tone combinations (contrasting brightness)

TONE

Tones separated vertically!

This is the easiest contrasting tone combination to use. By combining colors with different brightness, you can sense movement.

dk4　lt14⁺

Contrasting tone combinations (contrasting saturation)

TONE

Tones separated horizontally!

If you use the same color, you can create effective combinations. Here red (2:R - see page 20) is used at different saturations to highlight the character's appeal.

ltg2　v2

Contrasting tone combinations (contrasting brightness and saturation)

TONE

Tones separated diagonally!

Colors with both differing brightness and saturation have the clearest contrast. This combination is strongly recommended when you want to really emphasize the uniqueness of the character.

b24　dkg18

Consider a Character's Palette with a Color Wheel

The color wheel is a depiction of colors in a circle. Colors that are placed close together on the wheel have complementary characteristics. Colors that are far apart on the wheel have contrasting characteristics.

Origins and Function of the Color Wheel

In this book we use the color wheel of the PCCS (the Practical Color Coordinate System developed by the Japan Color Research Institute). It's usual to depict the v (Vivid) tones of colors with 24 segments on the color wheel, but other tones are depicted with even numbers only in 12 segments. In the PCCS, even numbers like 2, 4, 6.... and so on are the stars.

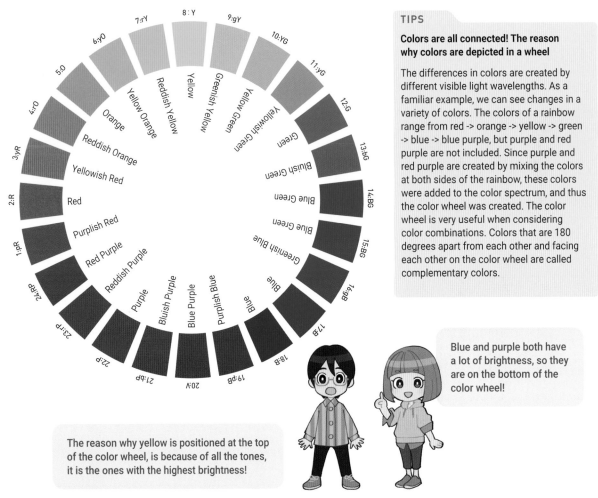

TIPS

Colors are all connected! The reason why colors are depicted in a wheel

The differences in colors are created by different visible light wavelengths. As a familiar example, we can see changes in a variety of colors. The colors of a rainbow range from red -> orange -> yellow -> green -> blue -> blue purple, but purple and red purple are not included. Since purple and red purple are created by mixing the colors at both sides of the rainbow, these colors were added to the color spectrum, and thus the color wheel was created. The color wheel is very useful when considering color combinations. Colors that are 180 degrees apart from each other and facing each other on the color wheel are called complementary colors.

Blue and purple both have a lot of brightness, so they are on the bottom of the color wheel!

The reason why yellow is positioned at the top of the color wheel, is because of all the tones, it is the ones with the highest brightness!

Color Combinations Based on Tones

Let's think about color combinations based on the color wheel. From this point on, the two colors used for the hair and the clothing will introduce the examples, with the hair color set to v (vivid) yellow.

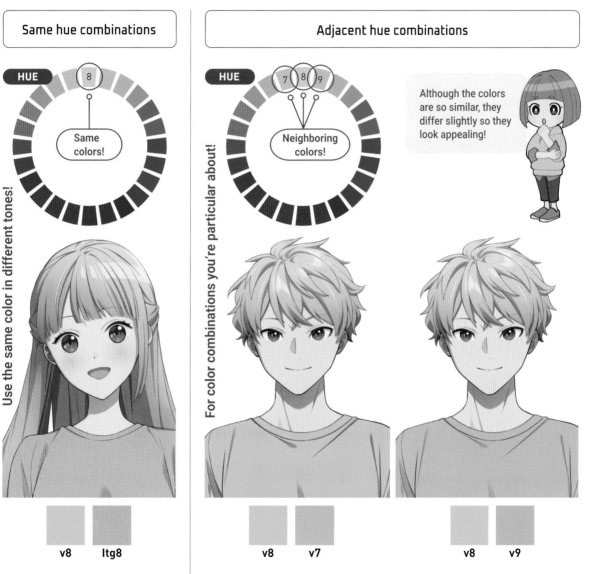

Same hue combinations

HUE 8

Same colors!

Use the same color in different tones!

v8 ltg8

This is a combination using the same color. The impression given by the color chosen is emphasized. Since the hue is the same, vary the tones to combine the colors.

Adjacent hue combinations

HUE 7 8 9

Neighboring colors!

Although the colors are so similar, they differ slightly so they look appealing!

For color combinations you're particular about!

v8 v7 v8 v9

These are combinations using neighboring or adjacent colors on the color wheel. The hue differences are very subtle so it's difficult to bring out the individuality of each; but the combination is very cohesive. Use this when you want to go for a particular impression with your color combinations.

Analogous hue combinations

Medium level (complex) hue combinations

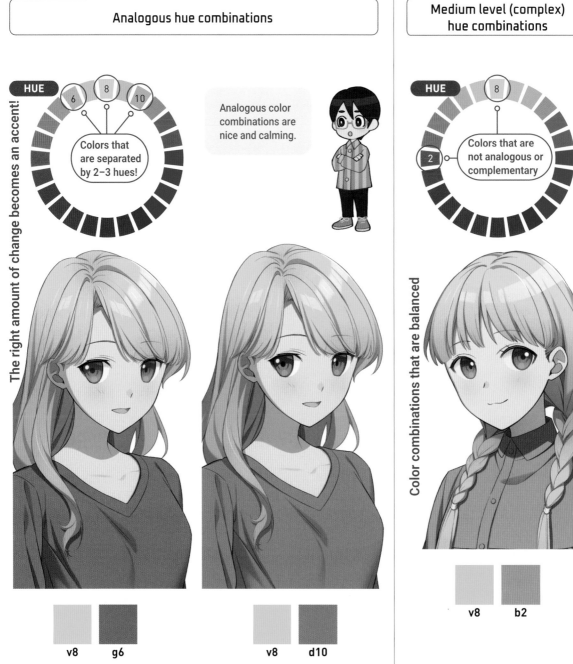

The right amount of change becomes an accent!

HUE

6 · 8 · 10

Colors that are separated by 2–3 hues!

Analogous color combinations are nice and calming.

HUE

8 · 2

Colors that are not analogous or complementary

Color combinations that are balanced

v8 · g6 v8 · d10

v8 · b2

These are color combinations where the contrasting hues are 2 to 3 places away from the base hue (8:Y Yellow in these examples). Since these combinations look cohesive with the right amount of contrast, they are easy to use.

Analogous hues and contrast hues are used often in combinations, but here is an example of a combination that is neither. The hues are somewhat different.

Contrasting hue combinations

Complementary hue combinations

HUE

Colors that are separated by 8 to 10 hues!

If you utilize this combination when using 2 colors for the hair, you can create a distinct character!

HUE

Colors that are opposite each other!

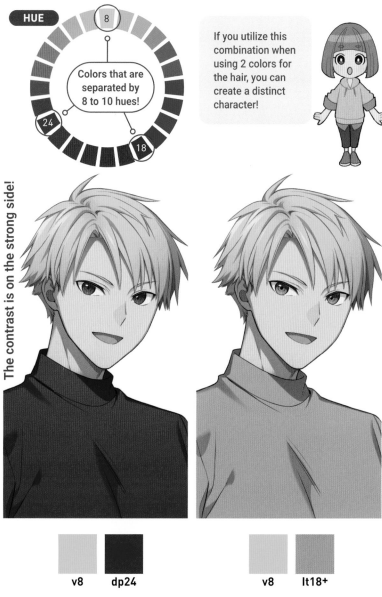

The contrast is on the strong side!

v8	dp24		v8	lt18+

This is a combination that uses hues that are 8, 9 or 10 positions away from the base color. Because the hue difference is large there is good contrast, but if you combine hues with high saturation the contrast can be too strong.

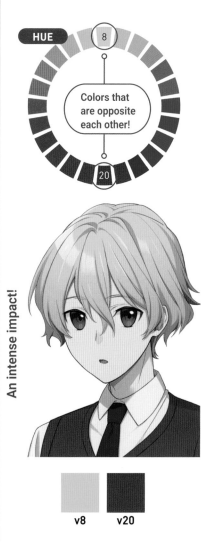

An intense impact!

v8	v20

This is a combination of hues that are on opposite sides of the color wheel. The basic hue difference is 12, but you can use the hues on either side of that number too. In particular, when creating a complementary hue combination with a v (vivid) tone, a strong impact will be created, so if you want to avoid that, use a hue with low saturation.

COLOR COMBINATION TECHNIQUES

Traditional Western Color Schemes You Can Use For Your Characters!

The effectiveness of color schemes has been studied since ancient times, and in the West several harmonic color theories have been proposed. The methods introduced here are classic ones, using colors that are at the points of a triangle or square when drawn inside the color wheel. You can use these color combinations when you want to use multiple colors in your character's hair, or when you want to make a strong impact.

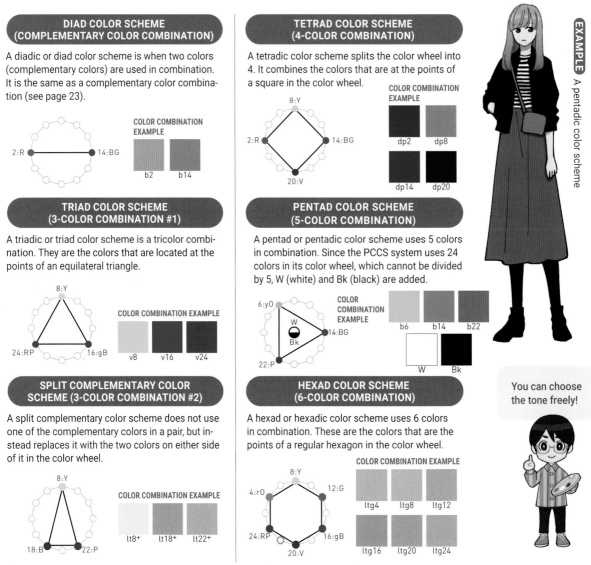

DIAD COLOR SCHEME (COMPLEMENTARY COLOR COMBINATION)

A diadic or diad color scheme is when two colors (complementary colors) are used in combination. It is the same as a complementary color combination (see page 23).

2:R — 14:BG

COLOR COMBINATION EXAMPLE
b2 b14

TRIAD COLOR SCHEME (3-COLOR COMBINATION #1)

A triadic or triad color scheme is a tricolor combination. They are the colors that are located at the points of an equilateral triangle.

8:Y
24:RP 16:gB

COLOR COMBINATION EXAMPLE
v8 v16 v24

SPLIT COMPLEMENTARY COLOR SCHEME (3-COLOR COMBINATION #2)

A split complementary color scheme does not use one of the complementary colors in a pair, but instead replaces it with the two colors on either side of it in the color wheel.

8:Y
18:B 22:P

COLOR COMBINATION EXAMPLE
lt8+ lt18+ lt22+

TETRAD COLOR SCHEME (4-COLOR COMBINATION)

A tetradic color scheme splits the color wheel into 4. It combines the colors that are at the points of a square in the color wheel.

8:Y
2:R 14:BG
20:V

COLOR COMBINATION EXAMPLE
dp2 dp8
dp14 dp20

PENTAD COLOR SCHEME (5-COLOR COMBINATION)

A pentad or pentadic color scheme uses 5 colors in combination. Since the PCCS system uses 24 colors in its color wheel, which cannot be divided by 5, W (white) and Bk (black) are added.

6:yO
W
Bk 14:BG
22:P

COLOR COMBINATION EXAMPLE
b6 b14 b22
W Bk

HEXAD COLOR SCHEME (6-COLOR COMBINATION)

A hexad or hexadic color scheme uses 6 colors in combination. These are the colors that are the points of a regular hexagon in the color wheel.

8:Y
4:rO 12:G
24:RP 16:gB
20:V

COLOR COMBINATION EXAMPLE
ltg4 ltg8 ltg12
ltg16 ltg20 ltg24

EXAMPLE A pentadic color scheme

You can choose the tone freely!

※ The color combination examples on this page use the same tone to make the hue relationships more understandable.

ASK THE EXPERTS 1

Q & A #1:
Problems with Applying Color

Q I always seem to use the same skin color.
How can I make it more varied and individualistic?

A Observe the actual scene carefully.
Skin color looks different depending on the time of day.

A lot of people tend to paint the skin yellow. However, skin color changes depending on the time of day and the environment. For example, in the evening the skin takes on a reddish tone, at night shadows deepen.

Another method is to differentiate the skin tones between male and female characters. Female characters can have a reddish skin tone, and male characters can have a yellowish skin tone; this way when they are side by side, you can create visual difference between them.

Skin tone in the evening

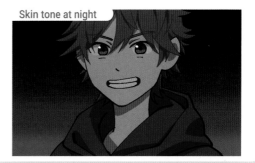
Skin tone at night

Q It's difficult to apply shadows.
They always turn out dark and have a flat effect....

A Get rid of the preconception that shadows = black.
Shadows have all kinds of colors.

When applying color to shadows, most people tend to choose black. However, in reality shadow color is more complex. For example, if you want to apply shadow to skin color to make it darker, instead of just mixing black into the base skin color, try adding a little red to make it a three-color combination. If you are having trouble with shadow colors, we recommend observing actual colors carefully to see what other colors besides black are in shadows.

We would like to thank Nippon Designer Gakuin and Nihon Kogakuin College for their cooperation with this section.

Q I always try to draw realistically, but my faces become too dark with shadows. What can I do?

A When you take a photo, you can use reflectors to lighten up the face, right? Drawing is the same thing.

Illustrations are created by distorting reality. For example, if you are drawing a character with a backlight, if you make the face totally dark, it may be too realistic. Just as you might use reflectors when taking photographs to cast light on the face, instead of aiming for realistic accuracy, do what you can to emphasize the point you want to make in the picture.

Q I'd like to know what I can do to apply color more skillfully.

A It's important to look at a lot of examples and to observe landscapes!

The keys to becoming more skilled at applying color are observation and consideration. If there is a picture you like, look at it carefully, and consider why you think that picture is good. You'll be able to see how you want to draw more clearly. In addition, you cannot draw something you don't know well. Sunrises and sunsets differ, right? Observe the everyday landscape around you, consider it, and repeat your drawings until you're happy with the result.

Q My colored drawings tend to come out looking rather indistinct. Why is that?

A Perhaps you don't have enough difference between lights and darks. And how much solid color did you apply to the drawing?

If a picture looks blurry and indistinct, it means that there aren't many tonal variances, and a lack of distinctions between lights and darks. In order to solve this problem, try applying a solid color to at least half of the drawing. A page with more solid color tends to give a clearer impression. In addition, if you are aiming to become a professional, it is important to always be aware of mixing the "CMY" colors that are used for printing.

We would like to thank Nippon Designer Gakuin and Nihon Kogakuin College for their cooperation with this section.

Eye and Hair Colors That Create a Character's Image

COLOR PSYCHOLOGY FOR COLORING CHARACTERS (PART ONE)

Hair and eye color perform an important role when designing and differentiating manga and anime characters. The right color scheme brings out the individuality of your characters, while also adding visual nuance and cohesion.

※The characteristics raised in this chapter are ones based on the impressions given by colors. They do not necessarily correspond with psychology or fortune telling theories.

Hair Color's Role in Conveying Personality and Image

The hair and eyes determine the impression given by the character. Although the clothes may change, the hair and the eyes never do, since they are unique to the character.

Sixty Percent of the First Impression Is Determined by Color!

We consistently receive essential information from our five senses, most of it coming from what we see. The first impression given by a character is largely influenced by the colors that jump into view.

Red hues give a passionate impression

Green hues give a gentle impression

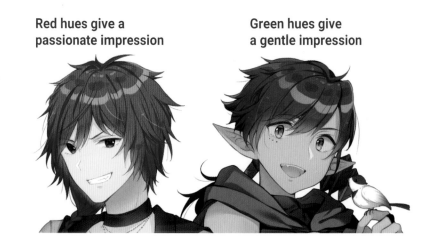

Hair and Eye Color Determine the Image and Individuality of the Character

When you want to give further individuality to a character, it's effective to paint the hair and eye colors in contrasting or complementary hues. In addition, you can start by setting a character's colors to ones that give an active impression, and as the story progresses you can aim for expressing more subtle shades, traits or qualities. There are general rules for colors, but none set in stone. That's the fun part of experimenting with them.

By using the same hues, that scheme suggests the character's personality!

Using contrasting hues makes it possible to strongly emphasize the character's individuality!

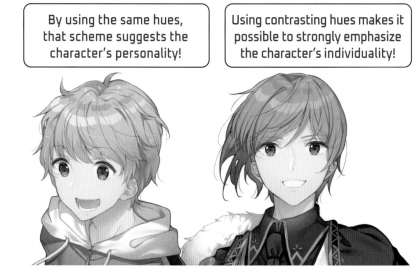

The Main Color Decides the Direction of the Image

Here focus on the inner circle first. We have crossed two axes (the arrows) to contrast large image categories. In addition, we've divided the 24 hues into 7 groups, and set the keywords for each hue category.

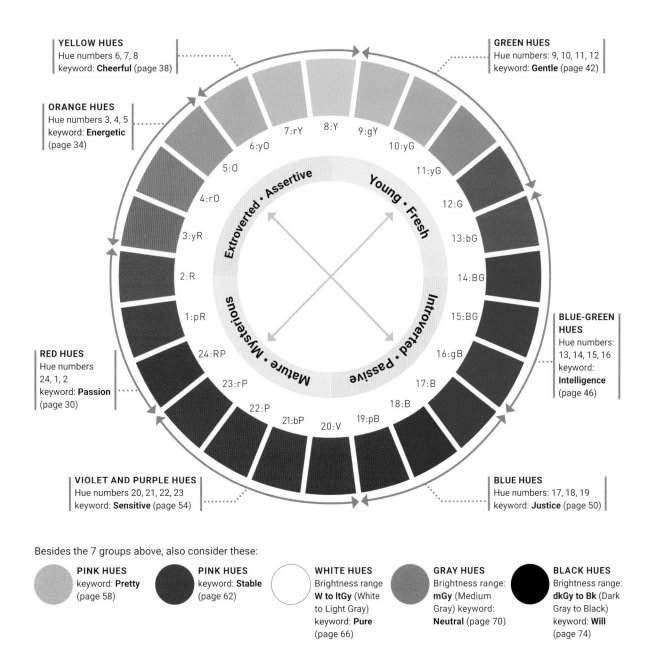

YELLOW HUES
Hue numbers 6, 7, 8
keyword: **Cheerful** (page 38)

GREEN HUES
Hue numbers: 9, 10, 11, 12
keyword: **Gentle** (page 42)

ORANGE HUES
Hue numbers 3, 4, 5
keyword: **Energetic** (page 34)

BLUE-GREEN HUES
Hue numbers: 13, 14, 15, 16
keyword: **Intelligence** (page 46)

RED HUES
Hue numbers 24, 1, 2
keyword: **Passion** (page 30)

VIOLET AND PURPLE HUES
Hue numbers 20, 21, 22, 23
keyword: **Sensitive** (page 54)

BLUE HUES
Hue numbers: 17, 18, 19
keyword: **Justice** (page 50)

Inner circle labels: Extroverted · Assertive / Young · Fresh / Introverted · Passive / Mature · Mysterious

Hue labels: 7:rY, 8:Y, 9:gY, 6:yO, 5:O, 4:rO, 3:yR, 2:R, 1:pR, 24:RP, 23:rP, 22:P, 21:bP, 20:V, 19:pB, 18:B, 17:B, 16:gB, 15:BG, 14:BG, 13:bG, 12:G, 11:yG, 10:yG

Besides the 7 groups above, also consider these:

PINK HUES
keyword: **Pretty** (page 58)

PINK HUES
keyword: **Stable** (page 62)

WHITE HUES
Brightness range **W to ltGy** (White to Light Gray)
keyword: **Pure** (page 66)

GRAY HUES
Brightness range: **mGy** (Medium Gray) keyword: **Neutral** (page 70)

BLACK HUES
Brightness range: **dkGy to Bk** (Dark Gray to Black) keyword: **Will** (page 74)

Red Hues

The qualities and emotions associated with red are joyous, passionate, glad and strong. The keyword I've chosen is passion. Use it with robust characters that are always emitting a lot of energy, or ones that are strong willed and energetic.

Red has the longest wavelength, so it's the color that stands out the most on its own!

keyword **Passion**

Hair and Eye Color Determine the Impression and Individuality of the Character

CASE STUDY 1

Carmine (JIS)
Passion x Active

[Note: JIS stands for Japan Industry Standards]

This is a bright red that is dyed with the cochineal, an insect native to Central and South America. It is strong enough to be called the red among reds, so it's perfect for giving an active impression.

C0 M100 Y65 K10
R215 G0 B58
#D7003A

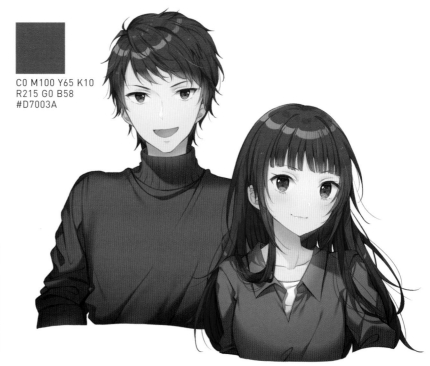

CARMINE CAN BE USED FOR CHARACTERS LIKE THESE!

POSITIVE
- A character that stands out
- A character with combative spirit
- A natural leader

NEGATIVE
- Aggressive and stubborn
- Forcibly decides matters
- Easily angered

Wine Red (JIS)
Passion x Prudence

[Note: JIS stands for Japan Industry Standards]

C0 M80 Y36 K50
R147 G46 B68
#932E44

This is a dark red like red wine. A color that gives a Western atmosphere, or a mature impression, it's recommended for use on characters with both passion in their hearts and cool decisiveness.

WINE RED CAN BE USED FOR CHARACTERS LIKE THESE!

POSITIVE
- Has a hidden passion
- More mature than their actual age
- Reliable

NEGATIVE
- Inflexible
- Does not listen to the opinions of others
- Has a cold side

Ruby Red (JIS)
Passion x Presence

[Note: JIS stands for Japan Industry Standards]

C0 M90 Y40 K15
R209 G46 B89
#D12E59

This is a red with purple jewel tones like a ruby. It is a color that attracts people, so use it when you want to depict a charismatic character. It is effective when just used as an eye color too.

RUBY RED CAN BE USED FOR CHARACTERS LIKE THESE!

POSITIVE
- Congenial
- Has a special presence
- Draws people to them

NEGATIVE
- Is easily swayed by emotion
- Their emotions are shown quickly in their actions
- Selfish

Red Hues

Examples of Hair and Eye Color Combinations

| Red Hue Hair | × | Eye Color of the Same Hue | > |

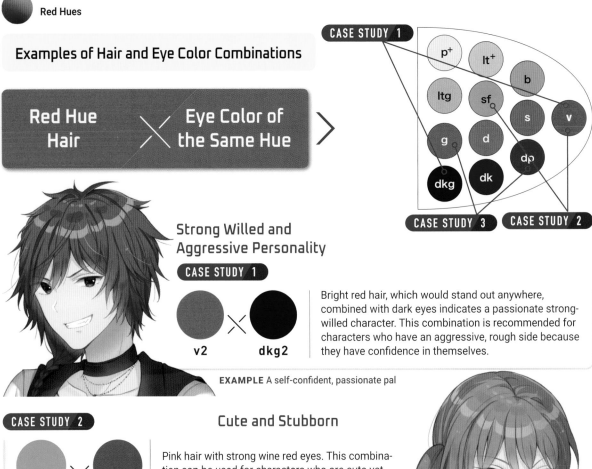

Strong Willed and Aggressive Personality

CASE STUDY 1

v2 × **dkg2**

Bright red hair, which would stand out anywhere, combined with dark eyes indicates a passionate strong-willed character. This combination is recommended for characters who have an aggressive, rough side because they have confidence in themselves.

EXAMPLE A self-confident, passionate pal

Cute and Stubborn

CASE STUDY 2

sf2 × **v1**

Pink hair with strong wine red eyes. This combination can be used for characters who are cute yet stubborn, and strongly influence those around them by expressing all of their emotions openly.

EXAMPLE A girl whose emotions are easy to discern

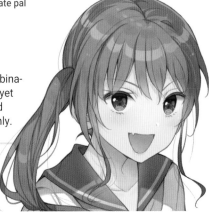

Strong Will and Strictness

CASE STUDY 3

dp2 × **g2**

This is a combination that uses a hue with high saturation for the hair and one with low saturation for the eyes. This is perfect for a character who is spirited and reliable with a strong will and sense of responsibility, but occasionally shows a cold, emotionless side.

EXAMPLE An instructor who has a sense of responsibility as well as cool nerve

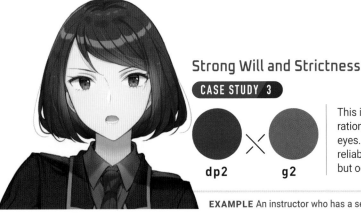

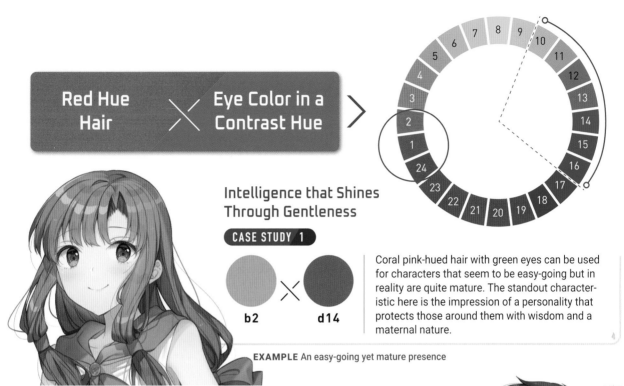

Red Hue Hair ✕ Eye Color in a Contrast Hue

Intelligence that Shines Through Gentleness

CASE STUDY 1

b2 ✕ d14

Coral pink-hued hair with green eyes can be used for characters that seem to be easy-going but in reality are quite mature. The standout characteristic here is the impression of a personality that protects those around them with wisdom and a maternal nature.

EXAMPLE An easy-going yet mature presence

CASE STUDY 2

v24 ✕ dp16

Combines Strength and Intelligence

A charismatic personality is expressed with purplish red-hued hair and blue-green eyes. This combination is perfect for a hero who sticks to their intentions.

EXAMPLE A charismatic knight

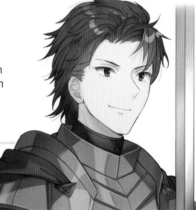

Serious but Free-Spirited

CASE STUDY 3

dk2 ✕ v11

Reddish brown hair and yellow-green eyes. Use this combination for unique characters who have a hidden passion into research, yet on occasion show a free-spirited wild side.

EXAMPLE A free-spirited yet serious researcher

※For the data on each color, please refer to the PCCS list on pages 180–184.

03

Orange Hues

At times orange is grouped with red, and at other times it's treated as a yellow. It's a color that brings to minds characteristics such as warmth, a sense of fulfilment and appetite. The keyword I've chosen for orange is energy. It's perfect for older characters who are good at taking care of others or characters who are tolerant.

In Japanese, orange is called daidai. Daidai is the name of the orange-like citrus fruit that is decorated on top of a stack of mochi rice cakes (kagamimochi) at New Year's.

keyword **Energy**

Let's Look at Orange Used as Hair and Eye Colors!

CASE STUDY 1

Vermilion (JIS)
Energetic x Courageous
[Note: JIS stands for Japan Industry Standards]

This is a color originally created with mineral cinnebar, and is a red with a strong yellow tint. You can use it to combine the energy of orange to give the additional impressions of courage and power.

C0 M75 Y75 K0
R235 G97 B59
#EB613B

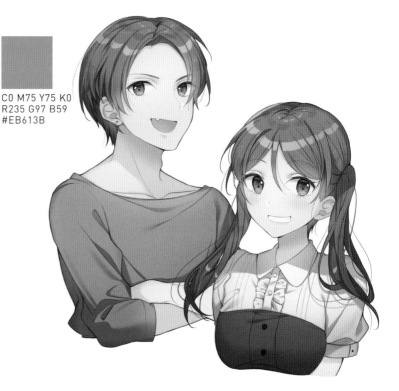

VERMILION CAN BE USED FOR CHARACTERS LIKE THESE!

POSITIVE
- Does what they've decided to do right away
- Powerful
- Values honor and humanity

NEGATIVE
- Shameless
- Careless; doesn't care about details
- Lacks sensitivity

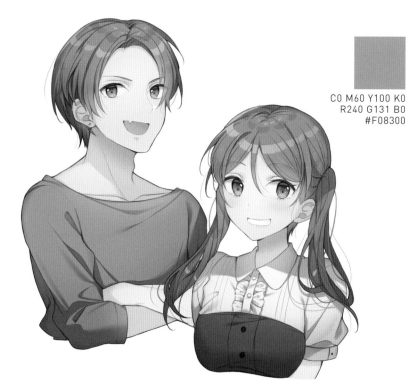

Orange (JIS)
Energetic x Cheerful

[Note: JIS stands for Japan Industry Standards]

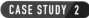

C0 M60 Y100 K0
R240 G131 B0
#F08300

A color like the peel of an orange. In Japanese as well as English, this color name originates from the fruit. This color expresses an aura that is always positive and full of energy.

ORANGE CAN BE USED FOR CHARACTERS LIKE THESE!

POSITIVE
- Fun-loving
- Caring
- Gets along with everyone

NEGATIVE
- Tries to please everyone
- Values friendship over love
- Isn't good at being patient

Carrot Orange (JIS)
Energetic x Quick Witted

[Note: JIS stands for Japan Industry Standards]

A color like a carrot. It is a bit darker and redder than orange. This color is effective for showing that a character is active yet is also logical and intelligent.

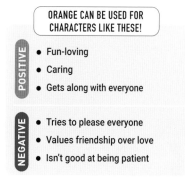

C0 M67 Y80 K10
R223 G108 B49
#DF6C31

CARROT ORANGE CAN BE USED FOR CHARACTERS LIKE THESE!

POSITIVE
- Proceeds logically
- Is resilient to changes in their environment or circumstances
- Likes new things

NEGATIVE
- Restless
- Dislikes inefficiency
- Lacks composure

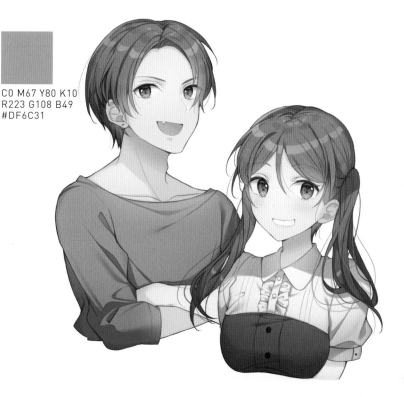

Orange Hues

Examples of Hair and Eye Color Combinations

| Orange Hue Hair | ✕ | Eye Color of the Same Hue |

CASE STUDY 3
CASE STUDY 2
CASE STUDY 1

Energetic and Healthy

CASE STUDY 1

v4 ✕ sf4

Vivid orange combined with eyes of the same hue gives an impression of both mental and physical health and power. Use for a character that eats everything without being picky, has a loud voice and gets along with everyone.

EXAMPLE An active girl who can get along with everyone

Optimistic and Positive

CASE STUDY 2

b4 ✕ d4

This example has light-colored hair and quiet-looking eyes, both in orange hues. The combination can be used for a character who is optimistic and positive, doesn't complain, and does the tasks assigned to them without complaining. They don't like to over-think things.

EXAMPLE A positive boy whose smiling face suits him

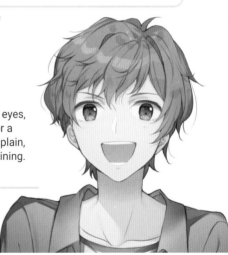

Free and Unaffected

CASE STUDY 3

lt4⁺ ✕ dp4

By making the hair color light and the eye color dark, this combination expresses a character with a free aura who is not bound by conventions. This character lives on their own terms, and likes fun things. The combination is recommended for unadorned wild child type characters.

EXAMPLE A wild child who lives in the forest

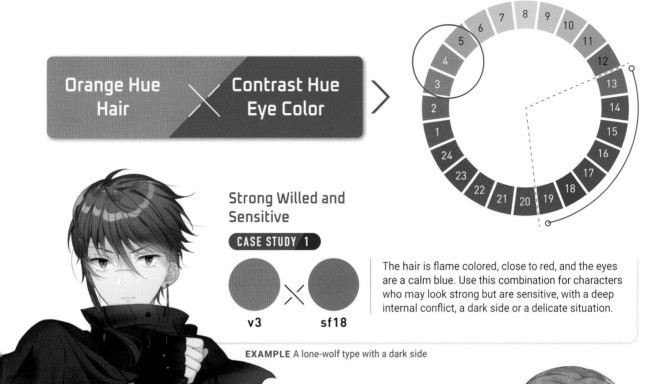

Orange Hue Hair × Contrast Hue Eye Color

Strong Willed and Sensitive

CASE STUDY 1

v3 × sf18

The hair is flame colored, close to red, and the eyes are a calm blue. Use this combination for characters who may look strong but are sensitive, with a deep internal conflict, a dark side or a delicate situation.

EXAMPLE A lone-wolf type with a dark side

Idealistic and Active

CASE STUDY 2

v5 × v19

The combination of vivid orange hair and very blue eyes can be used for a character that has high ideals and is also very active, with multiple talents. This character is not good at relying on others, and may try to hard on their own.

EXAMPLE A high school girl who tries too hard

Intelligent and Stylish

CASE STUDY 3

d4 × lt14$^+$

This Complex Harmony (page 95) combination with dark orange and light blue-green is recommended for an older sister character who is stylish and also good at her job.

EXAMPLE A girl who wears glasses who has a sense of style and is also hard working

※ For the data on each color, please refer to the PCCS list on pages 180–184.

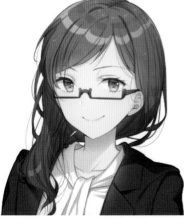

04

Yellow Hues (Including Gold)

Yellow is the color of the sun and its rays of light. The qualities and impressions associated with the color are happy, joy, bliss and immaturity. The keyword I'm using is cheerful. It's well-suited to a character that always has a bright disposition and is positive. When yellow is darkened, it takes on the impressions of gold.

In ancient China, yellow used to be the color of the emperor. In the Christian tradition, it was the color of the disciple Judas, who betrayed Jesus Christ.

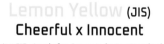 **keyword** **Cheerful**

Let's Look at Yellow Used as Hair and Eye Colors!

CASE STUDY 1

Lemon Yellow (JIS)
Cheerful x Innocent
[Note: JIS stands for Japan Industry Standards]

This is a color like that of a lemon peel. Since it brings to mind bright light shining down, it gives an impression of a character who is not defeated by anything, is innocent and playful.

C0 M0 Y80 K0
R255 G243 B63
#FFF33F

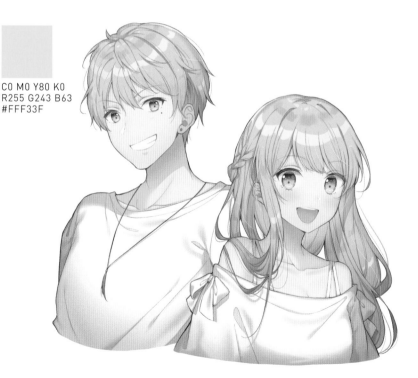

LEMON YELLOW CAN BE USED FOR CHARACTERS LIKE THESE!

POSITIVE
- Innocent
- Makes everyone around them cheerful
- Life of the party

NEGATIVE
- Careless or goofy
- Makes a lot of mistakes
- Thoughtless; acts without thinking

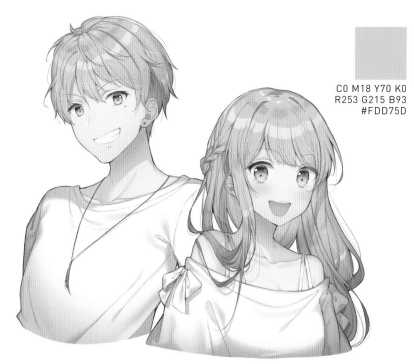

Neapolitan Yellow (JIS)
Cheerful x Curious

[Note: JIS stands for Japan Industry Standards]

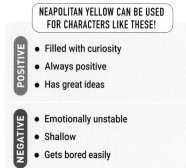

C0 M18 Y70 K0
R253 G215 B93
#FDD75D

The name of the color refers to the Italian city of Naples. This color, which gives an impression of brightness and warmth, can be used for very intelligent characters who are filled with curiosity.

NEAPOLITAN YELLOW CAN BE USED FOR CHARACTERS LIKE THESE!

POSITIVE
- Filled with curiosity
- Always positive
- Has great ideas

NEGATIVE
- Emotionally unstable
- Shallow
- Gets bored easily

Golden Yellow (JIS)
Cheerful x Exceptional

[Note: JIS stands for Japan Industry Standards]

A yellow that shines like gold. This is the color that is used to express gold digitally or in print. It's recommended for use with characters that you want to give the impression of having superhuman powers or abilities.

C0 M35 Y70 K0
R248 G184 B86
#F8B856

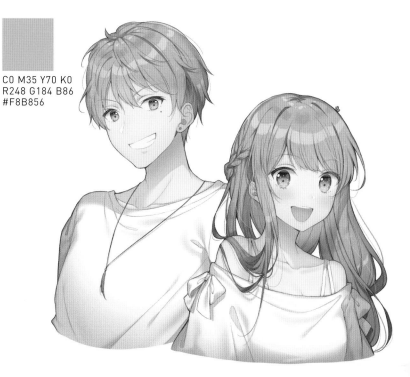

GOLDEN YELLOW CAN BE USED FOR CHARACTERS LIKE THESE!

POSITIVE
- Guides those around them
- Possesses superhuman powers
- Changes their circumstances

NEGATIVE
- Has unusual habits
- Says outrageous things
- Conceited/vain

Yellow Hues

Examples of Hair and Eye Color Combinations

| Yellow Hue Hair | ✕ | Eye Color of the Same Hue | ❯ |

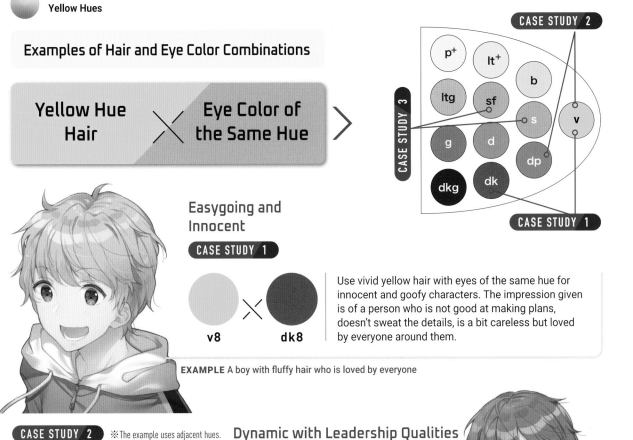

Easygoing and Innocent

CASE STUDY 1

v8 ✕ **dk8**

Use vivid yellow hair with eyes of the same hue for innocent and goofy characters. The impression given is of a person who is not good at making plans, doesn't sweat the details, is a bit careless but loved by everyone around them.

EXAMPLE A boy with fluffy hair who is loved by everyone

CASE STUDY 2 ※The example uses adjacent hues.

Dynamic with Leadership Qualities

dp8 ✕ **v7**

Shiny golden hair and eyes are expressed with yellow hues. This combination is recommended for a type of character that laughs out loud a lot, and acts as a leader. They're able to cheer and inspire those around them.

EXAMPLE A pirate ship captain who is proud of how charismatic he is

Goofy and Positive

CASE STUDY 3

s8 ✕ **sf8**

A combination of two bright yellow hues. This combination can be used for a character that is always optimistic and positive, and is never beaten by their circumstances. They are goofy and can have their head in the clouds, but that's part of their appeal.

EXAMPLE A girl who is never beaten by her circumstances

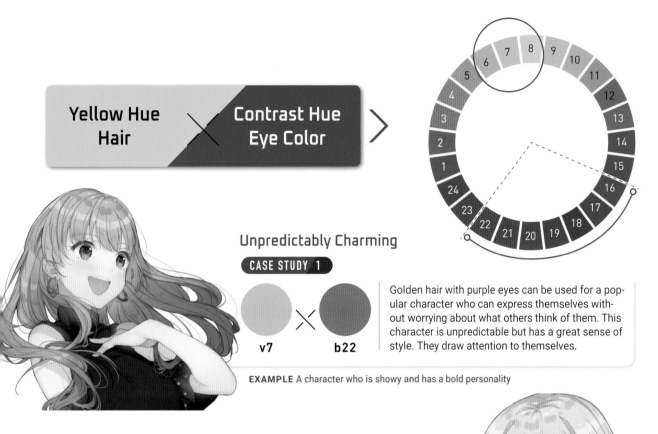

Yellow Hue Hair × Contrast Hue Eye Color

Unpredictably Charming

CASE STUDY 1

v7 × **b22**

Golden hair with purple eyes can be used for a popular character who can express themselves without worrying about what others think of them. This character is unpredictable but has a great sense of style. They draw attention to themselves.

EXAMPLE A character who is showy and has a bold personality

CASE STUDY 2

For a Melancholy Impression

lt8+ × **g18**

By combining yellow hair with grayish blue eyes, you can create a character who gives the impression of having a sad fate. It's also useful for scenarios where a character's smile is actually hiding a difficult past.

EXAMPLE A character who hides a sad past behind her smile

Resilient Dignity

CASE STUDY 3

sf6 × **v17**

Soft-colored hair and deep, beautiful blue eyes are well-suited to a character with a princely temperament. Use this combination to express intelligent nobility, a resilient spirit, or a humorous personality.

EXAMPLE A prince who gives the impression of being soft and kind

※For the data on each color, please refer to the PCCS list on pages 180–184.

05

Green Hues

keyword **Gentle**

The impressions associated with yellow green and green are natural, fresh, restful and safe. Use this hue for a character who can read the room and adjust their position accordingly, or one who is an indispensable member of the team that brings everyone together.

Green is the color of chlorophyll and is associated with health, abundance and growth.

Let's Look at Green Used as Hair and Eye Colors!

CASE STUDY 1

Chartreuse Green (JIS)
Gentle x Hopeful

[Note: JIS stands for Japan Industry Standards]

This is the color of a liqueur made at the Grand Chartreuse Monastery in France. This color brings to mind the growth of young leaves in the spring, and can express a bright, innocent artlessness.

C20 M0 Y70 K0
R217 G227 B103
#D9E367

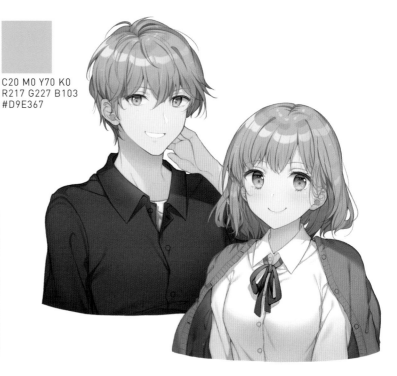

CHARTREUSE GREEN CAN BE USED FOR CHARACTERS LIKE THESE!

POSITIVE
- Nimble
- Always looking to grow
- Hopeful

NEGATIVE
- Sometimes their efforts are fruitless
- Has their head in the clouds / not practical
- Doesn't look at reality head on

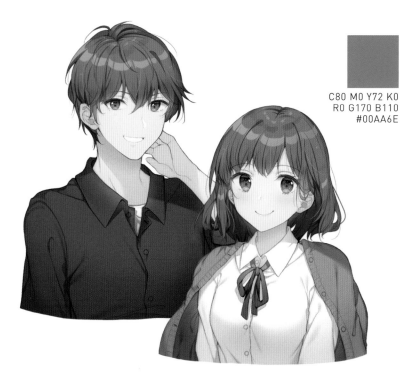

Emerald Green (JIS)
Gentle x Intelligent

[Note: JIS stands for Japan Industry Standards]

C80 M0 Y72 K0
R0 G170 B110
#00AA6E

A jewel color like an emerald. It brings to mind abundance and intelligence that comes from within. It gives an impression of a well-balanced character who is considerate of those around them.

EMERALD GREEN CAN BE USED FOR CHARACTERS LIKE THESE!

POSITIVE
- Easygoing
- A presence that puts people at ease
- Intelligent and brave

NEGATIVE
- Dislikes being controlled
- Can't spring into action quickly
- Neglects themself

CASE STUDY 3

Olive Green (JIS)
Gentle x Diligent

[Note: JIS stands for Japan Industry Standards]

C20 M0 Y75 K70
R95 G101 B30
#5F651E

A color suggested by the deep green color of olive leaves. It has a quiet yet cool appeal. Use this combination when you want to give the impression of a character who doesn't mind working diligently.

OLIVE GREEN CAN BE USED FOR CHARACTERS LIKE THESE!

POSITIVE
- Maintains their calm
- Unsung hero
- A presence that others rely on

NEGATIVE
- Does not change their opinions
- Doesn't do well in groups
- Tends to have a narrow point of view

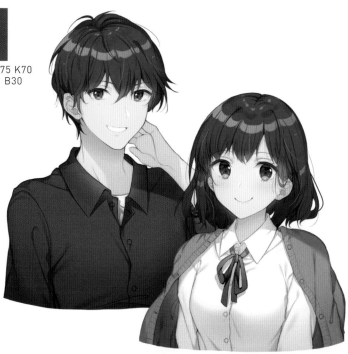

Green Hues

Examples of Hair and Eye Color Combinations

Green Hue Hair ✕ **Eye Color of the Same Hue** ⟩

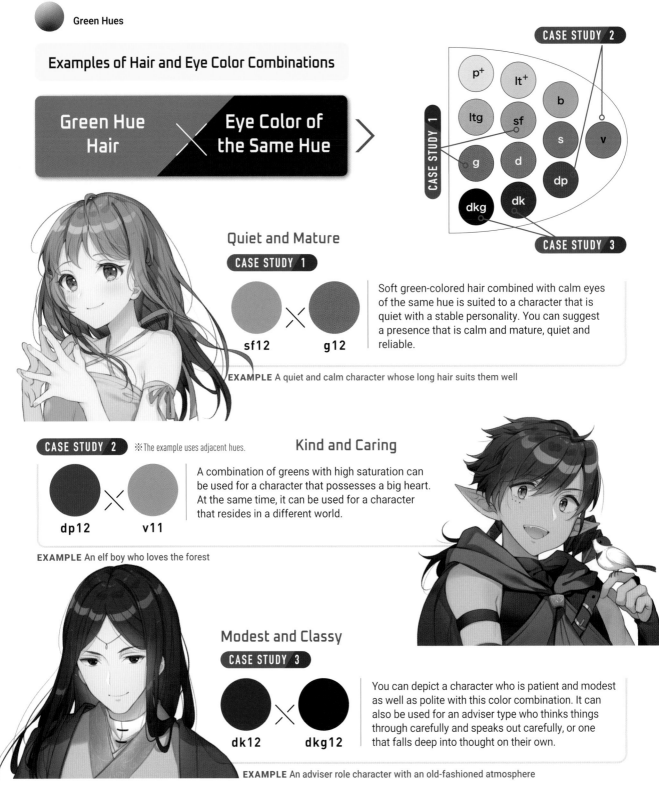

CASE STUDY 1
CASE STUDY 2
CASE STUDY 3

p⁺ lt⁺ b ltg sf s v g d dp dkg dk

Quiet and Mature

CASE STUDY 1

sf12 ✕ g12

Soft green-colored hair combined with calm eyes of the same hue is suited to a character that is quiet with a stable personality. You can suggest a presence that is calm and mature, quiet and reliable.

EXAMPLE A quiet and calm character whose long hair suits them well

Kind and Caring

CASE STUDY 2 ※The example uses adjacent hues.

dp12 ✕ v11

A combination of greens with high saturation can be used for a character that possesses a big heart. At the same time, it can be used for a character that resides in a different world.

EXAMPLE An elf boy who loves the forest

Modest and Classy

CASE STUDY 3

dk12 ✕ dkg12

You can depict a character who is patient and modest as well as polite with this color combination. It can also be used for an adviser type who thinks things through carefully and speaks out carefully, or one that falls deep into thought on their own.

EXAMPLE An adviser role character with an old-fashioned atmosphere

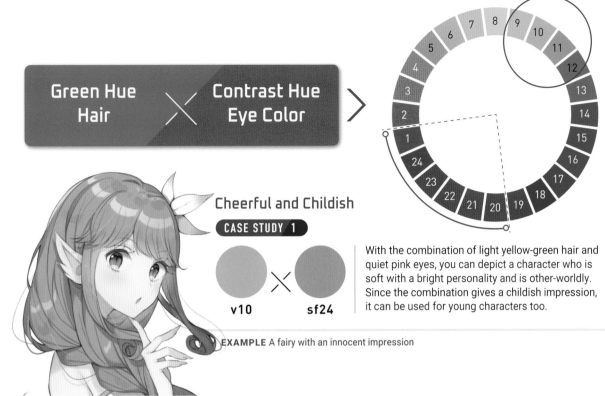

Green Hue Hair ✕ Contrast Hue Eye Color

Cheerful and Childish

CASE STUDY 1

v10 ✕ **sf24**

With the combination of light yellow-green hair and quiet pink eyes, you can depict a character who is soft with a bright personality and is other-worldly. Since the combination gives a childish impression, it can be used for young characters too.

EXAMPLE A fairy with an innocent impression

CASE STUDY 2

d12 ✕ **g20**

Tolerant Strength

This combination of neutral d (dull) and g (grayish) tones is recommended for mature characters who give an impression of calm. Express the character's tolerant impression with green and their strength with blue-purple.

EXAMPLE An older sister type of character that people aspire to be like

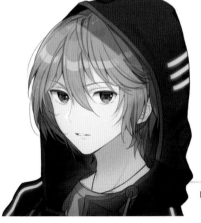

Fragile and Cool Atmosphere

CASE STUDY 3

ltg12 ✕ **g22**

Even when using contrasting hues, a combination of two colors with low saturation gives an impression of fragility and coolness. This is suited for a character who has a detached view of the world and is not swayed by anything.

EXAMPLE A boy who looks at the world with cold eyes

※For the data on each color, please refer to the PCCS list on pages 180–184.

06 Blue-Green Hues

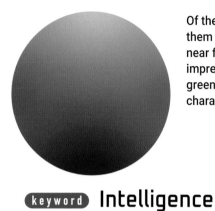

keyword **Intelligence**

Of the blue-green hues, the ones with a large amount of green in them give the impression of being, state of the art or depicting the near future. Blue-greens with a large amount of blue in them give the impression of freedom and openness. The keyword I chose for blue-green is intelligence. It is recommended when you want to give a character an unparalleled presence.

Red and blue-green are complementary colors (see page 23). Red enhances blue-green, and blue-green enhances red!

Let's Look at Blue-Green Used as Hair and Eye Colors!

CASE STUDY 1

Peacock Green (JIS)
Intelligent x Innovative

[Note: JIS stands for Japan Industry Standards]

This is a color like that of peacock feathers. Use blue-green, which is unusual in nature, when you want to give a character a special presence. It is also a color that symbolizes a high intellect and innovative thinking.

C90 M0 Y50 K0
R0 G164 B150
#00A496

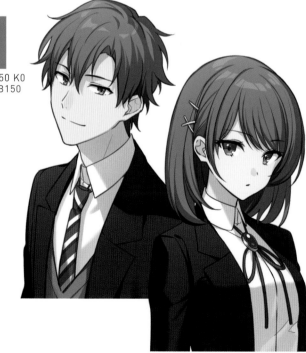

PEACOCK GREEN CAN BE USED FOR CHARACTERS LIKE THESE!

POSITIVE
- Quick thinking
- Dresses stylishly
- A hard worker with a lot of pride

NEGATIVE
- Worries about small things
- Is too involved in their hobbies
- Has strong likes and dislikes

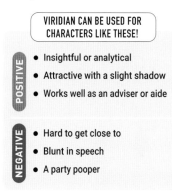

Viridian (JIS)
Intelligent x Insightful

[Note: JIS stands for Japan Industry Standards]

C80 M0 Y60 K30
R0 G137 B105
#008969

The name of a specific manufactured pigment. It is included in paint sets because you can't capture the "blueness" of this color by simply mixing yellow and blue. It gives the impression of insightful intelligence.

VIRIDIAN CAN BE USED FOR CHARACTERS LIKE THESE!

POSITIVE
- Insightful or analytical
- Attractive with a slight shadow
- Works well as an adviser or aide

NEGATIVE
- Hard to get close to
- Blunt in speech
- A party pooper

Turquoise Blue (JIS)
Intelligent x Free

[Note: JIS stands for Japan Industry Standards]

Turquoise is a mineral. This color can be used when you want to give the impression of a character that is not bound by rules and creates new things.

C80 M0 Y20 K0
R0 G175 B204
#00AFCC

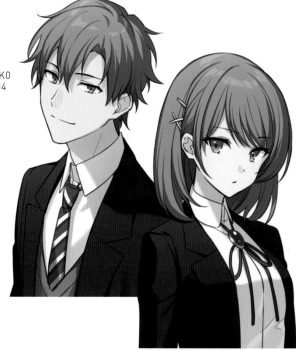

TURQUOISE BLUE CAN BE USED FOR CHARACTERS LIKE THESE!

POSITIVE
- Has high ideals
- Free-thinking and bold
- Possesses foresight

NEGATIVE
- Speaks without waiting for an answer
- Not good at repeating the same thing
- Dislikes restrictions

Blue-Green Hues

Examples of Hair and Eye Color Combinations

| Blue-Green Hue Hair | ✕ | Eye Color of the Same Hue | ❯ |

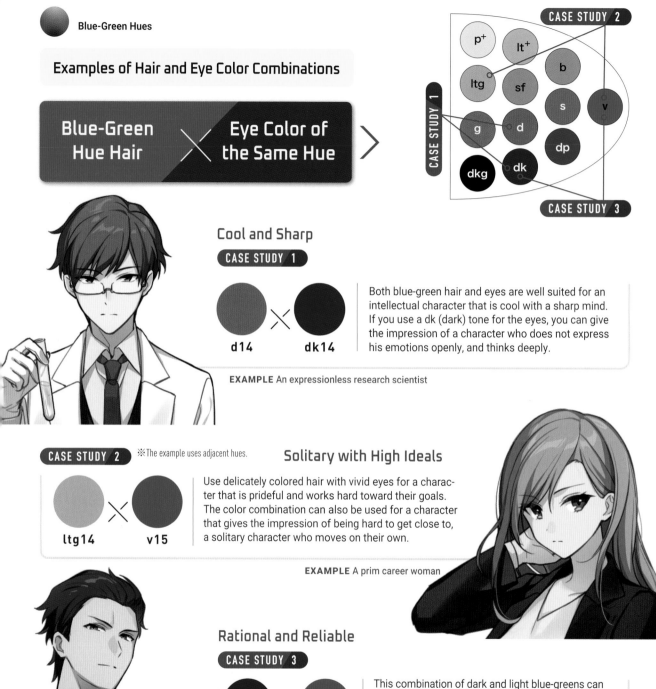

CASE STUDY 1
CASE STUDY 2
CASE STUDY 3

p⁺ lt⁺ ltg sf b s v g d dp dkg dk

Cool and Sharp

CASE STUDY 1

d14 ✕ dk14

Both blue-green hair and eyes are well suited for an intellectual character that is cool with a sharp mind. If you use a dk (dark) tone for the eyes, you can give the impression of a character who does not express his emotions openly, and thinks deeply.

EXAMPLE An expressionless research scientist

CASE STUDY 2 ※The example uses adjacent hues.

Solitary with High Ideals

ltg14 ✕ v15

Use delicately colored hair with vivid eyes for a character that is prideful and works hard toward their goals. The color combination can also be used for a character that gives the impression of being hard to get close to, a solitary character who moves on their own.

EXAMPLE A prim career woman

Rational and Reliable

CASE STUDY 3

dk14 ✕ v14

This combination of dark and light blue-greens can be used for a character that always makes the right decision. It's recommended for a character that is rational, holds their emotions in check, and draws the trust of those around them as the right-hand person for the leader of an organization.

EXAMPLE The talented right-hand man of a military commander

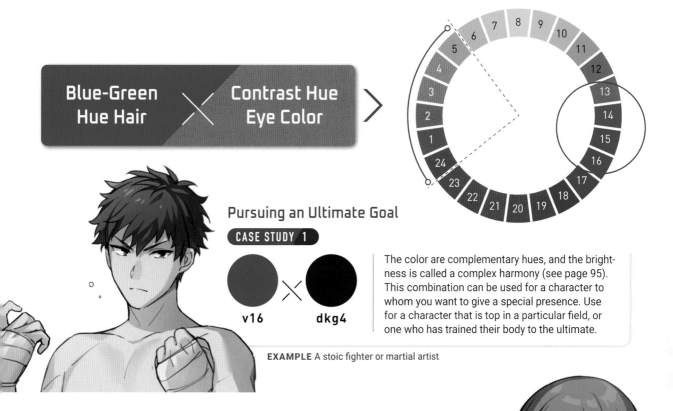

Blue-Green Hue Hair ✕ Contrast Hue Eye Color

Pursuing an Ultimate Goal

CASE STUDY 1

v16 ✕ **dkg4**

The color are complementary hues, and the brightness is called a complex harmony (see page 95). This combination can be used for a character to whom you want to give a special presence. Use for a character that is top in a particular field, or one who has trained their body to the ultimate.

EXAMPLE A stoic fighter or martial artist

Characteristics that Contrast

CASE STUDY 2

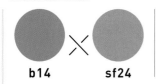

b14 ✕ **sf24**

This is a combination of hues with contrasting impressions. This combination can be used for characters that have attractive contrasts, such as one who has top grades but has absent-minded qualities, or one who has superhuman abilities in one area but lacks practical skills.

EXAMPLE A high school girl who has a high IQ but is sloppy

Possesses Freedom and Dignity

CASE STUDY 3

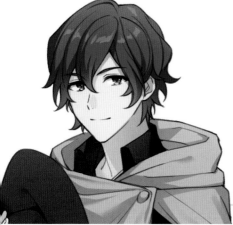

v15 ✕ **d2**

Turquoise-hued hair combined with a calm red can be used for a character who thinks on a large scale, is free and full of curiosity. It's also recommended for a unique character who may be high born or an old-fashioned aristocrat.

EXAMPLE An aristocratic youth who is hiding his status

※ For the data on each color, please refer to the PCCS list on pages 180–184.

07 Blue Hues

The words associated with blue are clean, conservative, reliable, infinite and ideal. It's recommended for characters that have a strong sense of justice and stand by their beliefs or ones with a strong core who ardently pursue their goals.

keyword Justice

Blue conjures the boundlessness of the sea and sky, but it also has negative associations with loneliness, depression and setback.

Let's Look at Blue Used as Hair and Eye Colors!

CASE STUDY 1

Cobalt Blue (JIS)
Just x Single Minded
[Note: JIS stands for Japan Industry Standards]

Cobalt blue is the name of the pigment made by combining cobalt oxide with aluminum oxide. It was a color beloved by the Impressionist painters. This strong blue can bring out an impression of one who is committed to a cause, and strives toward their goals.

C100 M50 Y0 K0
R0 G104 B183
#0068B7

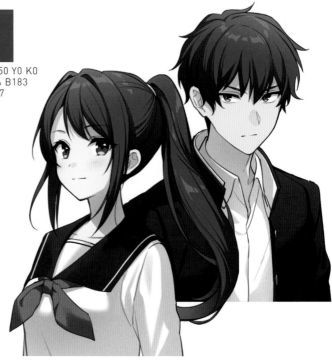

COBALT BLUE CAN BE USED FOR CHARACTERS LIKE THESE!

POSITIVE
- Familiar with information
- Works toward their ideals
- Highly informed

NEGATIVE
- Gets down if they don't get results
- Cowardly and cautious
- Dislikes immoral things

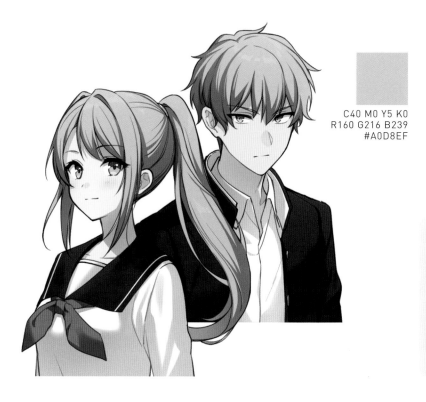

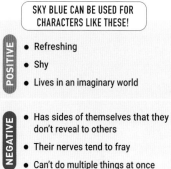

C40 M0 Y5 K0
R160 G216 B239
#A0D8EF

Sky Blue (JIS)
Just x Idealistic

[Note: JIS stands for Japan Industry Standards]

This is the color of a cloudless sky. This is recommended for characters who have high ideals, but have a surprisingly childish side, or have the delicacy to persue their own ideals.

SKY BLUE CAN BE USED FOR CHARACTERS LIKE THESE!

POSITIVE
- Refreshing
- Shy
- Lives in an imaginary world

NEGATIVE
- Has sides of themselves that they don't reveal to others
- Their nerves tend to fray
- Can't do multiple things at once

Prussian Blue (JIS)
Just x Curious

[Note: JIS stands for Japan Industry Standards]

A manufactured pigment that was invented in the early 18th century in Berlin (then Prussia). Also called bero-ai (Berlin indigo) in Japanese, it is a color that was beloved by the great Japanese artist Katsushika Hokusai.

C80 M50 Y0 K50
R21 G69 B119
#154577

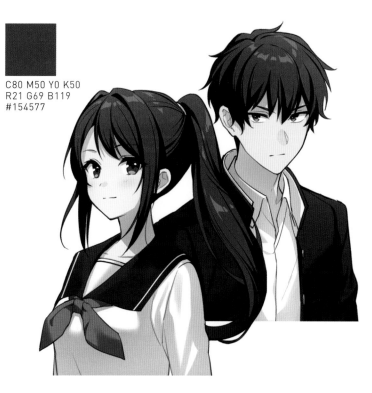

PRUSSIAN BLUE CAN BE USED FOR CHARACTERS LIKE THESE!

POSITIVE
- Goes after the truth
- Sees things through to the end
- A skilled and hardworking artisan

NEGATIVE
- Obstinate and stubborn
- Stays in one's shell
- Judges themselves as well as others harshly

Blue Hues

Examples of Hair and Eye Color Combinations

| Blue Hue Hair | ✕ | Eye Color of the Same Hue | > |

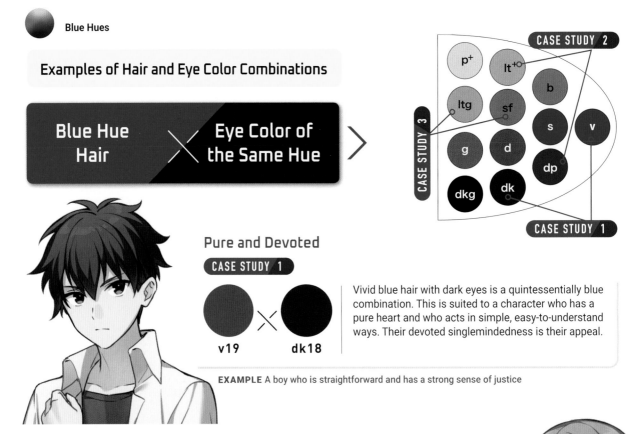

CASE STUDY 2

CASE STUDY 3

p⁺ lt⁺ᵒ

ltg sf b

g d s v

dp

dkg dk

CASE STUDY 1

Pure and Devoted

CASE STUDY 1

⊗

v19 ✕ **dk18**

Vivid blue hair with dark eyes is a quintessentially blue combination. This is suited to a character who has a pure heart and who acts in simple, easy-to-understand ways. Their devoted singlemindedness is their appeal.

EXAMPLE A boy who is straightforward and has a strong sense of justice

CASE STUDY 2

Keeps Control and Is Serious

The hair is colored a gentle blue hue, and the eyes are a sharp dark blue—a combination used to express a character who is serious and follows the rules. You can use this combination to express a character who isn't good at cutting loose but is upstanding and reliable.

lt18⁺ ✕ **dp18**

EXAMPLE A stickler for the rules

Particular and Introverted

CASE STUDY 3

✕

sf18 ✕ **ltg18**

This combination of grayish blues in two brightnesses is suited to expressing a romantic character who protects their own inner world. This character follows the habits and schedules that are important to them, and is concerned with small details.

EXAMPLE A bookishly shy type who tends to daydream

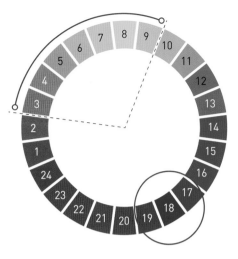

Blue Hue Hair × Contrast Hue Eye Color

A Sense of Justice That's Gone Too Far

CASE STUDY 1

g18 × dkg8

Blue and yellow are contrast colors, but since the hues used here both have low saturation, they create a unique impression together. The combination can be used for a character that is so honest that they cannot forgive others, or a character that has fallen to the dark side because of a sense of justice that's gone too far.

EXAMPLE A businessman who is strict toward himself as well as others

CASE STUDY 2

b18 × v9

Futuristic and Artificial

Highly saturated contrast colors make for a combination that seems artificial. It is recommended for humanoid-shaped robots or characters that have come from the future. They aren't good or bad colors, it's a matter of whether they fit the scenario.

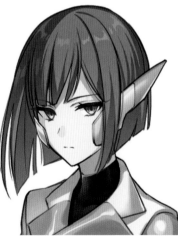

EXAMPLE An emotionless android

Cool and Composed

CASE STUDY 3

v17 × g4

By making the eye color a familiar brown hue, this color combination has a sense of stability. This combination can be used for a character who fulfills his duty and role, or one that has a stable personality, such as an administrator that supports their boss.

EXAMPLE A talented administrator who is not shaken by anything

※For the data on each color, please refer to the PCCS list on pages 180–184.

08

Violet and Purple Hues

The words I associate with blue-purple and purple are noble, classical, refined, and the arts. These are strange hues with a dual nature in that although they give the impression of elegance and classiness, they can also suggest flashiness and vulgarity.

The purple hues possess a duality: royal elegance and refinement or racy behavior and personal abandon: you decide!

keyword **Sensitivity**

Let's Look at Violet and Purple Used as Hair and Eye Colors!

CASE STUDY 1

Pansy (JIS)
Sensitive x Single Minded
[Note: JIS stands for Japan Industry Standards]

This is the color of the flower. It mixes passionate red with calm and collected blue in equal amounts, and gives off a mystical air. Use this color when you want to make a strong impact.

C80 M90 Y0 K0
R81 G49 B143
#51318F

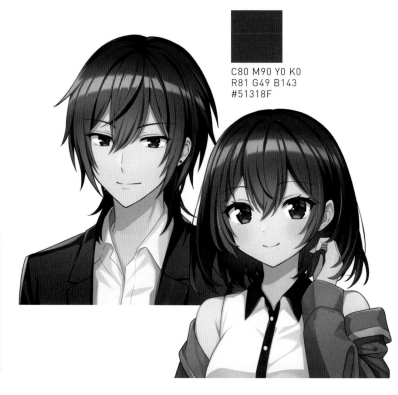

PANSY CAN BE USED FOR CHARACTERS LIKE THESE!

POSITIVE
- Strong yet possesses kindness
- Aesthetically inclined
- Has charisma

NEGATIVE
- Does not reveal themselves
- Does not get along with others
- Is very particular

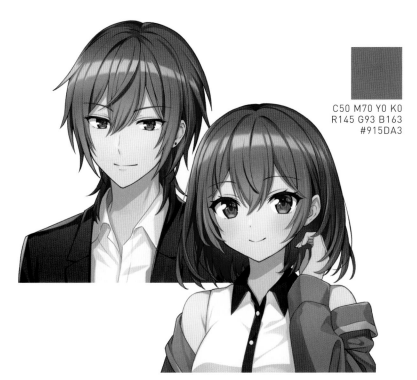

Mauve (JIS)
Sensitive x Dignified

[Note: JIS stands for Japan Industry Standards]

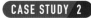

C50 M70 Y0 K0
R145 G93 B163
#915DA3

A color like that of the mallow flower. It's also the name of the first artificially manufactured pigment in history. It brings out an elegant and stylish atmosphere, as well as a soft attractive appeal.

MAUVE CAN BE USED FOR CHARACTERS LIKE THESE!

POSITIVE
- Has an excellent sense of aesthetics
- Elegant and stylish
- Very spiritual

NEGATIVE
- Vain
- Lives in an idealized world
- Obsessive

Wisteria (JIS)
Sensitive x Intuitive

[Note: JIS stands for Japan Industry Standards]

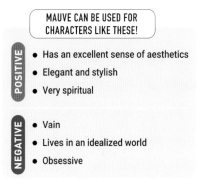

C50 M45 Y0 K0
R142 G139 B194
#8E8BC2

This is the color of the wisteria. By using this light blue-purple, you can depict a character who is a sensitive romantic, a lonesome person who craves love, a person who is guided by their emotions rather than logic.

WISTERIA CAN BE USED FOR CHARACTERS LIKE THESE!

POSITIVE
- Is flexible to circumstances
- Romantic
- Sensitivite

NEGATIVE
- Capricious and flirtatious
- Has changeable moods
- Toys with the people around them

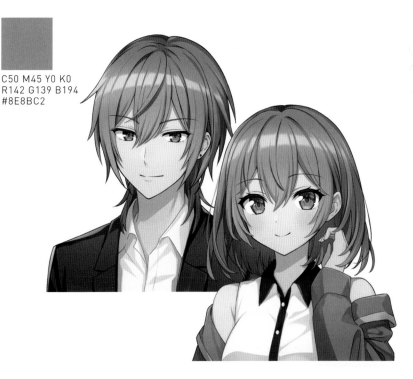

● **Violet and Purple Hues**

Examples of Hair and Eye Color Combinations

| Violet and Purple Hue Hair | ✕ | Eye Color of the Same Hue | 〉 |

CASE STUDY 1
CASE STUDY 3
CASE STUDY 2

p+ lt+ b ltg sf s v g d dp dkg dk

Original and Artistic

CASE STUDY 1

lt20+ ✕ b20

Use a combination of light and dark violets for a character that is artistic and creative, or an original character that is confident in their own sense of style. This combination goes surprisingly well with eccentric fashions.

EXAMPLE An art student who is very particular

Intuitive with a Vain Streak

CASE STUDY 2

dp20 ✕ v21

This combination of dark violet hair with purple eyes is suited to a character who doesn't listen to those around them, the rebel. It can also bring out an intuitive, highly aesthetic, narcissistic side.

EXAMPLE A narcissistic stylist

Gifted but Just This Side of Insanity

CASE STUDY 3

v20 ✕ v23

This combined two v (vivid) hues, with violet hair and very reddish purple eyes. Use this combination for a character who is unconcerned with the rules of society, and has an intense personality that seems to be in between genius and insanity.

EXAMPLE A scientist with dangerous ideas

Violet and Purple Hue Hair ✕ Contrast Hue Eye Color

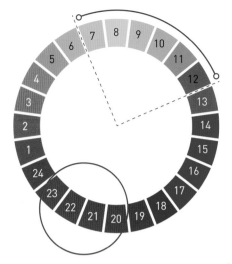

A Mysterious Ambience

CASE STUDY 1

b22 ✕ lt12⁺

This pairing of purple hair with green eyes is a contrasting combination of neutral colors. It is suited to a character who has an elusive, bewitching personality or one with a mysteriouis ambience.

EXAMPLE A mysterious woman

CASE STUDY 2

An Old-Fashioned Refined Beauty

v21 ✕ dkg8

This combination of vivid blue-purple with dark eyes can be used for a character who pursues beauty stoically, and has a refined elegance. It can also be used for a character who is old fashioned and graceful.

EXAMPLE A courtesan who can boast of great popularity

An Unworldly Celestial Presence

CASE STUDY 3

ltg22 ✕ p10⁺

This combination of high brightness and low saturation hues has a limpid charm. It is recommended for a character who has a transcendent presence, or who has been touched by the hands of a deity. Their unreal, otherworldly ambience can be expressed with light tones.

EXAMPLE A young boy who is beloved of the gods

※For the data on each color, please refer to the PCCS list on pages 180–184.

09 Pink Hues

Pink is a color that symbolizes love. Purplish rose hues bring to mind passion and sexual attraction, while yellowish coral hues are associated with motherly love or love for humanity. The keyword I chose is pretty. Use pink hues for characters whose cuteness you want to emphasize, or ones that are overflowing with love.

Pink doesn't give you the feeling of strong flashiness that red does and offers a suprisingly subtle array of hues.

keyword **Pretty**

Let's Look at Pink Used as Hair and Eye Colors!

CASE STUDY 1

Rose Pink (JIS)
Pretty x Delicate
[Note: JIS stands for Japan Industry Standards]

C0 M50 Y25 K0
R242 G156 B159
#F29C9F

A purplish pink the color of roses. Use this color when you want to give your character a vulnerable innocence or a wide-eyed childlike appeal. The soft hues are reflected in a softness of manner.

ROSE PINK CAN BE USED FOR CHARACTERS LIKE THESE!

POSITIVE
- Brave and tries hard
- Sincere and cute
- Surprisingly tenacious

NEGATIVE
- Delicate and hard to handle
- Wants to control others
- Childish

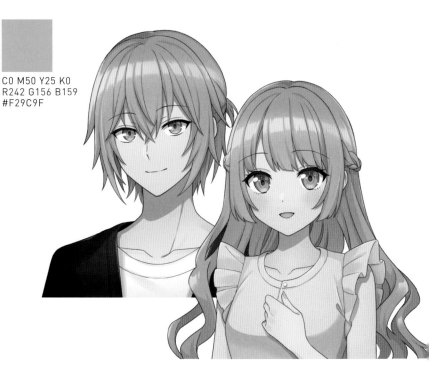

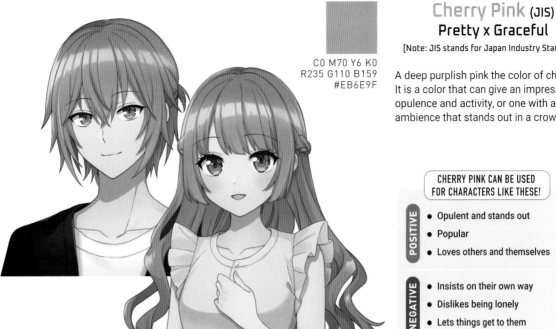

Cherry Pink (JIS)
Pretty x Graceful

[Note: JIS stands for Japan Industry Standards]

C0 M70 Y6 K0
R235 G110 B159
#EB6E9F

A deep purplish pink the color of cherries. It is a color that can give an impression of opulence and activity, or one with a regal ambience that stands out in a crowd.

CHERRY PINK CAN BE USED FOR CHARACTERS LIKE THESE!

POSITIVE
- Opulent and stands out
- Popular
- Loves others and themselves

NEGATIVE
- Insists on their own way
- Dislikes being lonely
- Lets things get to them

Coral Pink (JIS)
Pretty x Maternal

[Note: JIS stands for Japan Industry Standards]

A peachy pink the color of coral. Coral, which spawns when the moon is full, has been said to preserve order in the seas. It is recommended when you want to depict a character with tolerance and maternal instincts.

C0 M42 Y28 K0
R244 G173 B163
#F4ADA3

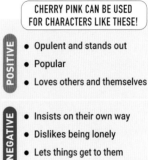

CORAL PINK CAN BE USED FOR CHARACTERS LIKE THESE!

POSITIVE
- Has a laidback attitude
- Caring
- Surrounds others with warmth

NEGATIVE
- Is not convinced by reasoning alone
- Is really bad at confrontation
- Indecisive

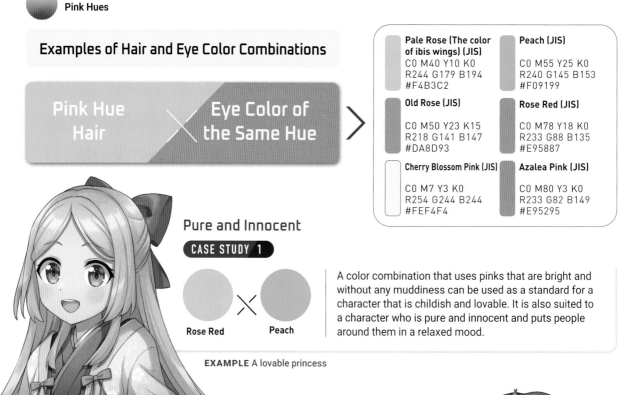

Pink Hues

Examples of Hair and Eye Color Combinations

Pink Hue Hair ✕ Eye Color of the Same Hue ➤

Pale Rose (The color of ibis wings) (JIS)
C0 M40 Y10 K0
R244 G179 B194
#F4B3C2

Old Rose (JIS)
C0 M50 Y23 K15
R218 G141 B147
#DA8D93

Cherry Blossom Pink (JIS)
C0 M7 Y3 K0
R254 G244 B244
#FEF4F4

Peach (JIS)
C0 M55 Y25 K0
R240 G145 B153
#F09199

Rose Red (JIS)
C0 M78 Y18 K0
R233 G88 B135
#E95887

Azalea Pink (JIS)
C0 M80 Y3 K0
R233 G82 B149
#E95295

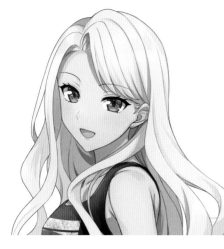

Pure and Innocent

CASE STUDY 1

Rose Red ✕ Peach

A color combination that uses pinks that are bright and without any muddiness can be used as a standard for a character that is childish and lovable. It is also suited to a character who is pure and innocent and puts people around them in a relaxed mood.

EXAMPLE A lovable princess

Elegant and Charming

CASE STUDY 2

Old Rose ✕ Rose Red

This dusty rose color is called old rose. It has an elegant and European flair recommended for use on a charming character who easily enchants others.

EXAMPLE A fairy tale persona

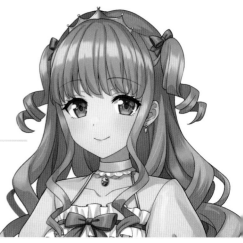

Tenacious and Open

CASE STUDY 3

Cherry Blossom Pink ✕ Azalea Pink

Two pink hues with a strong contrast in saturation are suited to situations where you want to give a tenacious character a soft impression at first. It can also be used for a character who is open minded and sensual.

EXAMPLE A popular older sister type

※ According to the PCCS (pages 16–17) system, the p+ (pale) tones 2, 4, 24; the lt+ (light) tones 2, 4, 24; and the b (bright) tones 2, 4 24 are pink hues.

※ These colors also appear in red hues (page 30 and orange hues (page 34), so here we have used the JIS conventional color names (page 186) as the base for introducing the color combinations.

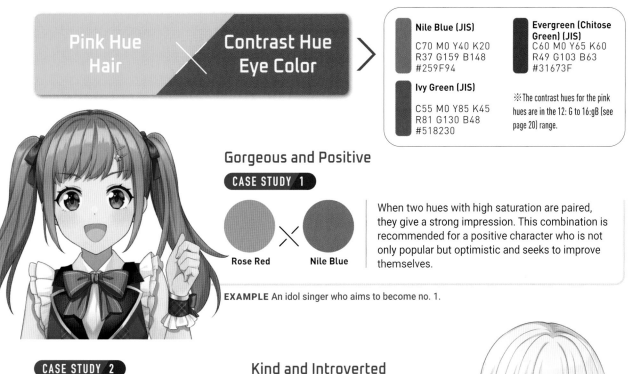

Pink Hue Hair ✕ **Contrast Hue Eye Color** ＞

Nile Blue (JIS)
C70 M0 Y40 K20
R37 G159 B148
#259F94

Ivy Green (JIS)
C55 M0 Y85 K45
R81 G130 B48
#518230

Evergreen (Chitose Green) (JIS)
C60 M0 Y65 K60
R49 G103 B63
#31673F

※ The contrast hues for the pink hues are in the 12: G to 16:gB (see page 20) range.

Gorgeous and Positive

CASE STUDY 1

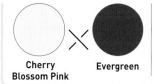

Rose Red ✕ **Nile Blue**

When two hues with high saturation are paired, they give a strong impression. This combination is recommended for a positive character who is not only popular but optimistic and seeks to improve themselves.

EXAMPLE An idol singer who aims to become no. 1.

CASE STUDY 2

Kind and Introverted

Cherry Blossom Pink ✕ **Evergreen**

The combination of soft pink with deep forest green is perfect for a kind, quiet, introverted character who is not good at asserting themselves. It's also good for a vulnerable character.

EXAMPLE A younger brother type character who one wants to protect

Calm and Stable

CASE STUDY 3

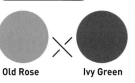

Old Rose ✕ **Ivy Green**

The combination of dusty pink and calm green depicts a character who has a stable personality. This character deals with everyone equally, and surrounds people with quiet love. Use for a character who isn't aggressive but still has a strong will.

EXAMPLE A steadfast, reliable childcare worker.

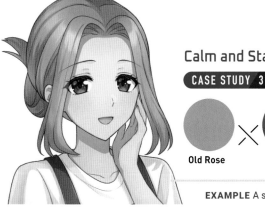

10

Brown Hues

Brown is the color of the earth. It's a color that forms the foundations of what's necessary for us to live, so the keyword I've chosen is stable. It brings to mind impressions like a sense of security, a natural presence, and being yourself, and is an easy color to use for characters.

> Brown was very popular during the Edo period (1603–1868) in Japan. During that time, a combination of brown and gray was thought to be stylish and cool!

keyword **Stable**

Let's Look at Brown Used as Hair and Eye Colors!

CASE STUDY 1

Cocoa Brown (JIS)
Stable x Secure

[Note: JIS stands for Japan Industry Standards]

C0 M45 Y45 K55
R142 G94 B74
#8E5E4A

This is the color of a cup of cocoa. It lends a stabilizing presence to characters, one that is not showy but works diligently, or someone who has their own convictions and is not unduly influenced by others.

COCOA BROWN CAN BE USED FOR CHARACTERS LIKE THESE!

POSITIVE
- Advances things methodically
- Tries diligently
- Has a stable character

NEGATIVE
- Can't keep up with quick changes
- Inflexible
- Lacks humor

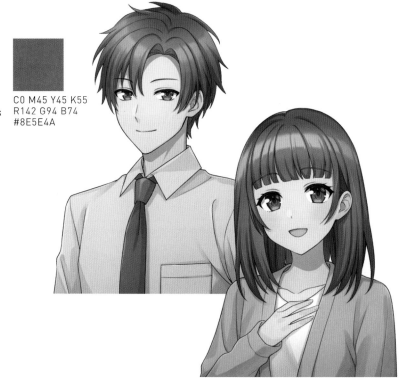

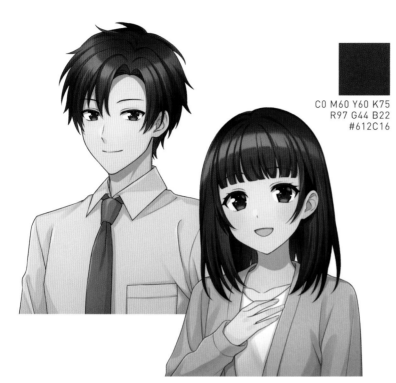

Chocolate (JIS)
Stable x Responsibile

[Note: JIS stands for Japan Industry Standards]

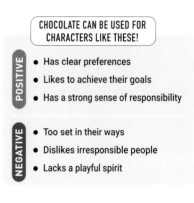

C0 M60 Y60 K75
R97 G44 B22
#612C16

The color of a chocolate bar. This red-hued dark brown is a good one to use when you want to emphasize honesty and sincerity or a strong sense of responsibility.

CHOCOLATE CAN BE USED FOR CHARACTERS LIKE THESE!

POSITIVE
- Has clear preferences
- Likes to achieve their goals
- Has a strong sense of responsibility

NEGATIVE
- Too set in their ways
- Dislikes irresponsible people
- Lacks a playful spirit

Beige (JIS)
Stable x Natural

[Note: JIS stands for Japan Industry Standards]

Beige is a word that originates from French, and originally meant woollen cloth that has not been bleached or dyed. It is a color that can represent a soothing character, or one that makes those around them calm.

C0 M10 Y30 K10
R238 G220 B179
#EEDCB3

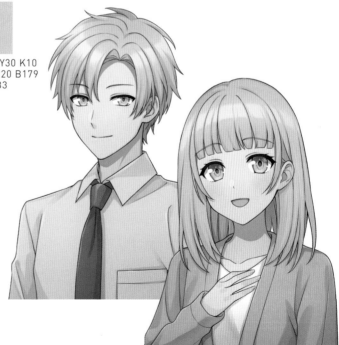

BEIGE CAN BE USED FOR CHARACTERS LIKE THESE!

POSITIVE
- Down to earth
- Makes those around them relaxed
- Likes comfortable things

NEGATIVE
- Dislikes getting put off stride
- Is not good at spontaneous things
- Can't forgive sloppiness

● **Brown Hues**

Examples of Hair and Eye Color Combinations

Brown Hue Hair	X	Eye Color of the Same Hue	>

Sepia (JIS)

C0 M36 Y60 K70
R111 G78 B39
#6F4E27

Raw Umber (JIS)

C0 M30 Y75 K55
R145 G111 B36
#916F24

Bordeaux (JIS)

C0 M70 Y50 K75
R97 G31 B28
#611F1C

Maroon (JIS)

C0 M80 Y60 K70
R106 G24 B22
#6A1816

Cork (JIS)

C0 M30 Y50 K30
R196 G154 B105
#C49A69

Buff (JIS)

C0 M24 Y50 K25
R207 G171 B114
#CFAB72

Trustworthy and Positive

CASE STUDY 1

Sepia X Raw Umber

This color combination is recommended for a character who is trustworthy and honest, works diligently, and never cuts corners. The brown hue used for the eyes is light with a yellow tint, and makes it possible to give the impression of positivity and optimism.

EXAMPLE A butler who does his work precisely

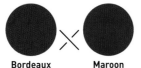

CASE STUDY 2

Bordeaux X Maroon

Stable and Accepting

This combination of deep browns with red tints is suited to a character whose stability and accepting nature are their charms. You get the feeling that if this person is around it's O.K., as if one were riding a large, safe ship.

EXAMPLE A reliable knight of a castle

Natural and Down to Earth

CASE STUDY 3

Cork X Buff

This combination of natural beige hues can be used for a character who is always themselves, living on their own terms. Use this combination for a character who is genuine, upfront and well-liked.

EXAMPLE A down-to-earth parent

※ According to the PCCS (pages 16–17) system, the dk (dark) tones 2, 4, 6; the g (grayish) tones 2, 4, 6; and the d (dull) tones 2,4 are brown hues.
※ These colors also appear in red hues (page 30 and orange hues (page 34), so here we have used the JIS conventional color names (page 186) as the base for introducing the color combinations.

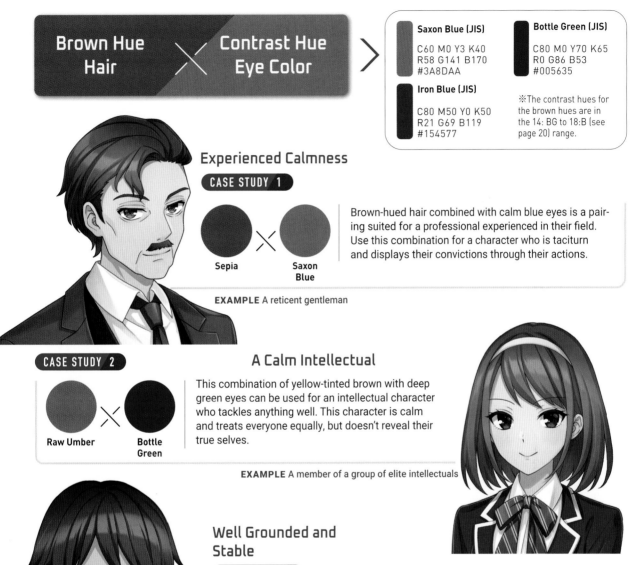

Brown Hue Hair ✕ Contrast Hue Eye Color

Saxon Blue (JIS)
C60 M0 Y3 K40
R58 G141 B170
#3A8DAA

Iron Blue (JIS)
C80 M50 Y0 K50
R21 G69 B119
#154577

Bottle Green (JIS)
C80 M0 Y70 K65
R0 G86 B53
#005635

※ The contrast hues for the brown hues are in the 14: BG to 18:B (see page 20) range.

Experienced Calmness

CASE STUDY 1

Sepia ✕ Saxon Blue

Brown-hued hair combined with calm blue eyes is a pairing suited for a professional experienced in their field. Use this combination for a character who is taciturn and displays their convictions through their actions.

EXAMPLE A reticent gentleman

CASE STUDY 2

A Calm Intellectual

Raw Umber ✕ Bottle Green

This combination of yellow-tinted brown with deep green eyes can be used for an intellectual character who tackles anything well. This character is calm and treats everyone equally, but doesn't reveal their true selves.

EXAMPLE A member of a group of elite intellectuals

Well Grounded and Stable

CASE STUDY 3

Bordeaux ✕ Iron Blue

Brown hair and blue eyes. This combination of low saturations hues is recommended for a character who has a stable nature like the ground below us and a strong spirit, as well as professional pride. Use for a last line of defense type of protective role.

EXAMPLE A bodyguard with a strong professional code

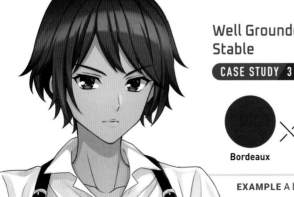

11 White Hues

White to light grays bring to mind cleanliness and neatness, nobility, and mysteriousness. The keyword I've chosen is pure. It can be used for a character with unfathomable capabilities in the sense that they are not dyed in any color. In contrast, it can also be used for a presence that is not of this world.

White really is mysterious. White animals are said to be the servants of the gods in Japanese mythology: white snakes, for example, or white deer.

keyword Pure

Let's Look at White Used as Hair and Eye Colors!

CASE STUDY 1

Snow White (JIS)
Pure x Unsullied

[Note: JIS stands for Japan Industry Standards]

C3 M0 Y0 K0
R250 G253 B255
#FAFDFF

This is a snow-like white with a blue tint. Use this for a perfectionist type character who has strength and purity. Of the achromatic colors white suggests coldness, while black is said to give a sense of warmth.

SNOW WHITE CAN BE USED FOR CHARACTERS LIKE THESE!

POSITIVE
- Strong willed
- Dislikes unfair things
- Pursues perfection

NEGATIVE
- Has two sides to their character
- Is unforgiving toward anything they dislike
- Fastidious

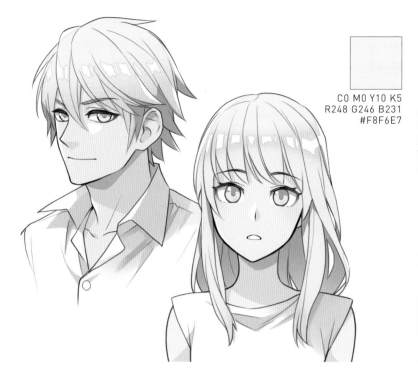

Oyster White
Pure x Cooperative

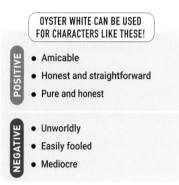

C0 M0 Y10 K5
R248 G246 B231
#F8F6E7

A white like the shell of an oyster, with a slight gray and yellow tint. It's recommended when you want to give a character the impression of purity and an aura of kindness.

OYSTER WHITE CAN BE USED FOR CHARACTERS LIKE THESE!

POSITIVE
- Amicable
- Honest and straightforward
- Pure and honest

NEGATIVE
- Unworldly
- Easily fooled
- Mediocre

CASE STUDY **3**

Pearl White
Pure x Refined

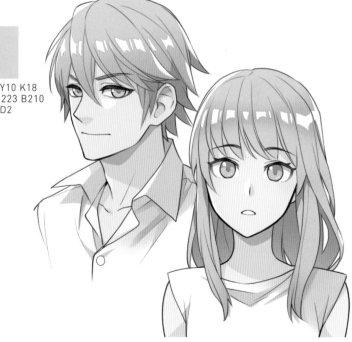

C0 M0 Y10 K18
R225 G223 B210
#E1DFD2

A white that brings the glow of pearls to mind—you can call it a gray that is close to white. It strengthens the impression of a sensitive character with a sharpened artistic sense, who is fashionable and stylish.

PEARL WHITE CAN BE USED FOR CHARACTERS LIKE THESE!

POSITIVE
- Values their own world
- Shy and cool
- Stylish

NEGATIVE
- Not good at getting along with people
- Introverted
- Has many mysterious points

Examples of Hair and Eye Color Combinations

| White Hue Hair | ✕ | Eye Color of the Same Hue | ⟩ |

Ivory (JIS)
C0 M1 Y12 K5
R248 G245 B227
#F8F5E3

Pearl White
C0 M0 Y10 K18
R225 G223 B210
#E1DFD2

Snow White (JIS)
C3 M0 Y0 K0
R250 G253 B255
#FAFDFF

Fog
C10 M0 Y5 K18
R206 G216 B216
#CED8D8

Pale Pink (Ikkonzome)
C0 M15 Y9 K0
R252 G228 B225
#FCE4E1

Ecru (Kinariiro) (JIS)
C0 M0 Y5 K3
R251 G250 B243
#FBFAF3

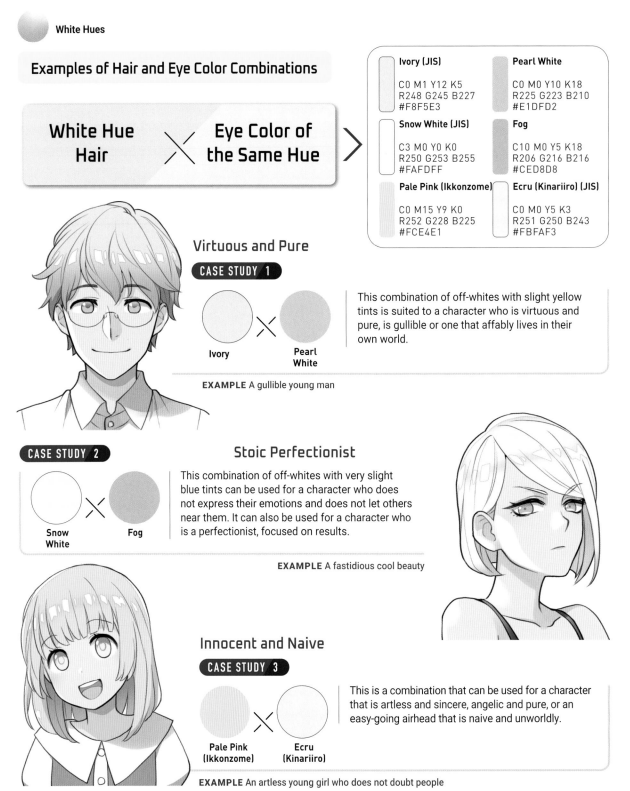

Virtuous and Pure

CASE STUDY 1

Ivory ✕ Pearl White

This combination of off-whites with slight yellow tints is suited to a character who is virtuous and pure, is gullible or one that affably lives in their own world.

EXAMPLE A gullible young man

CASE STUDY 2

Stoic Perfectionist

Snow White ✕ Fog

This combination of off-whites with very slight blue tints can be used for a character who does not express their emotions and does not let others near them. It can also be used for a character who is a perfectionist, focused on results.

EXAMPLE A fastidious cool beauty

Innocent and Naive

CASE STUDY 3

Pale Pink (Ikkonzome) ✕ Ecru (Kinariiro)

This is a combination that can be used for a character that is artless and sincere, angelic and pure, or an easy-going airhead that is naive and unworldly.

EXAMPLE An artless young girl who does not doubt people

※According to the PCCS (pages 16–17) system, the brightest of the achromatic hues is white (W), and its brightness value is 9.5.

※Here we have used the JIS conventional color names (page 186) as the base for introducing the color combinations.

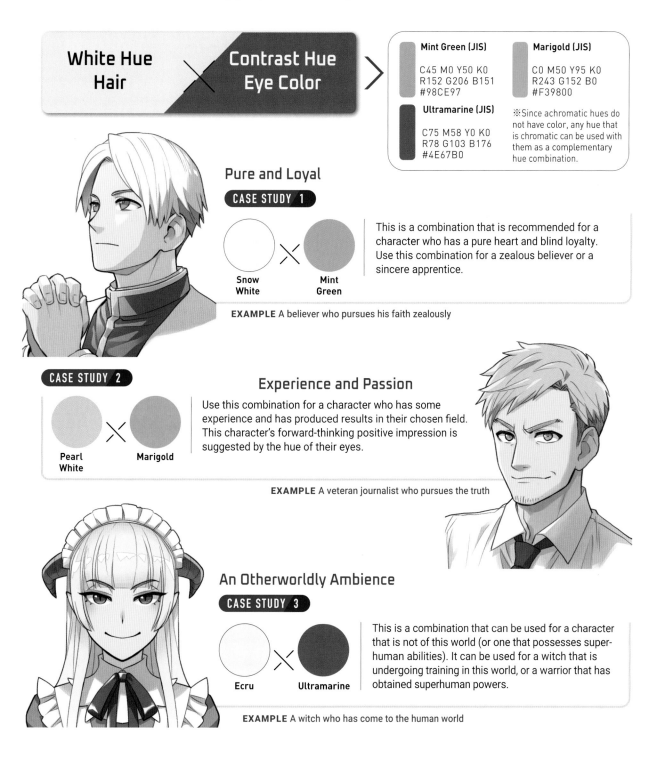

White Hue Hair × Contrast Hue Eye Color

Mint Green (JIS)
C45 M0 Y50 K0
R152 G206 B151
#98CE97

Marigold (JIS)
C0 M50 Y95 K0
R243 G152 B0
#F39800

Ultramarine (JIS)
C75 M58 Y0 K0
R78 G103 B176
#4E67B0

※Since achromatic hues do not have color, any hue that is chromatic can be used with them as a complementary hue combination.

Pure and Loyal

CASE STUDY 1

Snow White × Mint Green

This is a combination that is recommended for a character who has a pure heart and blind loyalty. Use this combination for a zealous believer or a sincere apprentice.

EXAMPLE A believer who pursues his faith zealously

CASE STUDY 2

Experience and Passion

Pearl White × Marigold

Use this combination for a character who has some experience and has produced results in their chosen field. This character's forward-thinking positive impression is suggested by the hue of their eyes.

EXAMPLE A veteran journalist who pursues the truth

An Otherworldly Ambience

CASE STUDY 3

Ecru × Ultramarine

This is a combination that can be used for a character that is not of this world (or one that possesses super-human abilities). It can be used for a witch that is undergoing training in this world, or a warrior that has obtained superhuman powers.

EXAMPLE A witch who has come to the human world

12 Gray Hues (Including Silver)

My gray association include equality, fairness and ambiguity. The keyword I'm going with is neutral. Depending on how it is employed, it can be cool or uncool, and the colors used with it influence the impression it creates. The lighter the gray, the more delicate it seems, and the darker it is, the stronger it seems.

You can say that gray is a great supporting player. The impression it gives changes depending on the colors used with it, so it's a flexible helper!

keyword **Neutral**

Let's Look at Gray as Hair and Eye Colors!

CASE STUDY 1

Silver Gray (JIS)
Neutral x Fair

[Note: JIS stands for Japan Industry Standards]

When you want a flashy silver, use this hue as the base adding shine and dimensionality. This gray, which is neither bright nor dark, can be used to suggest a fair objective attitude.

C0 M0 Y0 K43
R175 G175 B176
#AFAFB0

SILVER GRAY CAN BE USED FOR CHARACTERS LIKE THESE!

POSITIVE
- Regards things objectively
- Sensible and conventional
- Always has a calm attitude

NEGATIVE
- Lacks a sense of fun
- Cares too much about what people around them think
- Does not have much presence

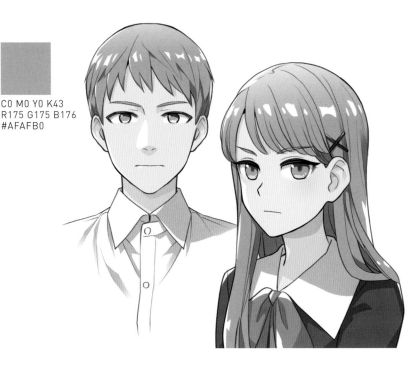

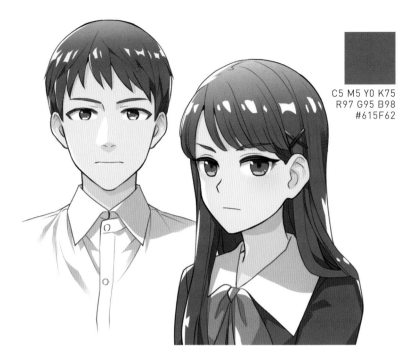

Slate Gray (JIS)
Neutral x Independent

[Note: JIS stands for Japan Industry Standards]

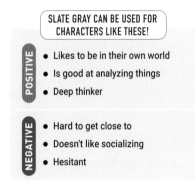

C5 M5 Y0 K75
R97 G95 B98
#615F62

The color of slate used as roofing. This dark gray gives the impression of a character who operates independently, and is perfect for expressing a complicated character who has darkness in their heart.

SLATE GRAY CAN BE USED FOR CHARACTERS LIKE THESE!

POSITIVE
- Likes to be in their own world
- Is good at analyzing things
- Deep thinker

NEGATIVE
- Hard to get close to
- Doesn't like socializing
- Hesitant

Sky Gray (JIS)
Neutral x Artistic

[Note: JIS stands for Japan Industry Standards]

This hue suggests the color of a cloudy sky. It can be used to express a character who is sensitive and delicate or someone who is happy being in their own world.

C3 M0 Y0 K25
R206 G209 B211
#CED1D3

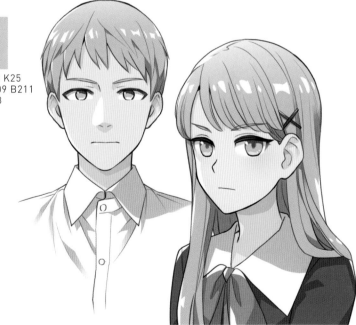

SKY GRAY CAN BE USED FOR CHARACTERS LIKE THESE!

POSITIVE
- Gives off a cool aura
- Has a great sense of style
- Delicate

NEGATIVE
- Dislikes being restricted by boundaries placed by others
- Worries about the smallest things
- Moody

Gray Hues

Examples of Hair and Eye Color Combinations

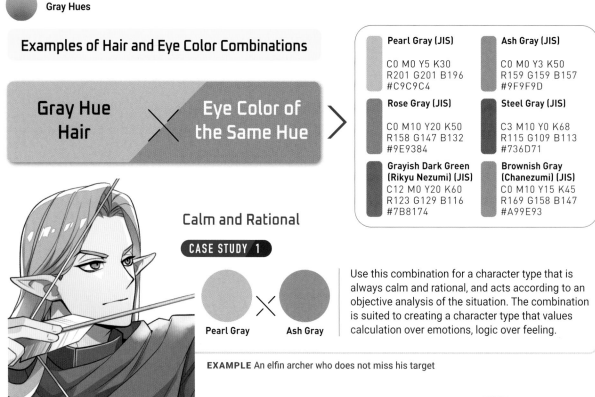

| Gray Hue Hair | × | Eye Color of the Same Hue | > |

Pearl Gray (JIS)
C0 M0 Y5 K30
R201 G201 B196
#C9C9C4

Ash Gray (JIS)
C0 M0 Y3 K50
R159 G159 B157
#9F9F9D

Rose Gray (JIS)
C0 M10 Y20 K50
R158 G147 B132
#9E9384

Steel Gray (JIS)
C3 M10 Y0 K68
R115 G109 B113
#736D71

Grayish Dark Green (Rikyu Nezumi) (JIS)
C12 M0 Y20 K60
R123 G129 B116
#7B8174

Brownish Gray (Chanezumi) (JIS)
C0 M10 Y15 K45
R169 G158 B147
#A99E93

Calm and Rational

CASE STUDY 1

Pearl Gray × Ash Gray

Use this combination for a character type that is always calm and rational, and acts according to an objective analysis of the situation. The combination is suited to creating a character type that values calculation over emotions, logic over feeling.

EXAMPLE An elfin archer who does not miss his target

Doesn't Let Others Know What They're Thinking

CASE STUDY 2

Rose Gray × Steel Gray

Use this combination for a character who is easy to get along with and capable, but has darkness within them, or has a secret they cannot reveal. The key is to use a warm gray for the hair and a cold, dark gray for the eyes.

EXAMPLE A globe-trotting spy

Graceful and Delicate

CASE STUDY 3

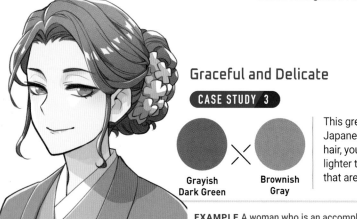

Grayish Dark Green × Brownish Gray

This green-tinted gray hair is perfect for a traditional Japanese artisan. By making the eyes lighter than the hair, you can express a delicate grace. Eyes that are lighter than the hair express delicateness, while eyes that are darker than the hair suggest strength.

EXAMPLE A woman who is an accomplished ikebana practitioner

※According to the PCCS (pages 16–17) system, the achromatic hues minus white and black are all considered to be gray. The brightness range is from 2.0 to 9.0.

※Here we have used the JIS conventional color names (page 186) as the base for introducing the color combinations.

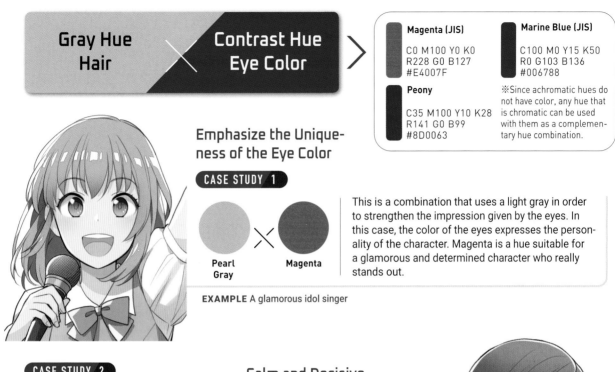

Gray Hue Hair ╳ **Contrast Hue Eye Color**

Magenta (JIS)
C0 M100 Y0 K0
R228 G0 B127
#E4007F

Marine Blue (JIS)
C100 M0 Y15 K50
R0 G103 B136
#006788

Peony
C35 M100 Y10 K28
R141 G0 B99
#8D0063

※Since achromatic hues do not have color, any hue that is chromatic can be used with them as a complementary hue combination.

Emphasize the Uniqueness of the Eye Color

CASE STUDY 1

Pearl Gray ╳ Magenta

This is a combination that uses a light gray in order to strengthen the impression given by the eyes. In this case, the color of the eyes expresses the personality of the character. Magenta is a hue suitable for a glamorous and determined character who really stands out.

EXAMPLE A glamorous idol singer

CASE STUDY 2

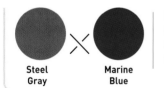

Steel Gray ╳ Marine Blue

Calm and Decisive

Medium-value grays can be used for characters that are cool and collected. Use this combination for a leader or director who is decisive and reliable or someone good at bringing out the best in others.

EXAMPLE A politician with a dignified presence

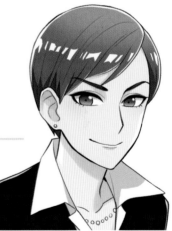

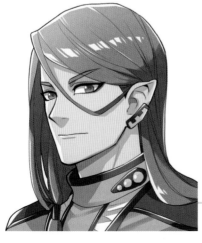

Overwhelmingly Intense Individuality

CASE STUDY 3

Rose Gray ╳ Peony

The eye color, which is neither red nor purple, can be used for a superhuman character with a strong personality. The key is to use a gray with a reddish hue to balance the eye color.

EXAMPLE An alien who is disguised as a human

13

Black Hues

Dark gray to black are colors associated with dignity, strength, fear and the darkness of night. The keyword is will. These hues can be used for a character with a strong sense of purpose or an intense person who is prideful and formal.

Black brings to mind darkness and death, and at the same time it expresses overwhelming strength. It's a symbol of absolute power, right?

keyword **Will**

Let's Look at Black as Hair and Eye Colors!

CASE STUDY 1

Lamp Gray (JIS)
Will x Tough

[Note: JIS stands for Japan Industry Standards]

This is the hue of the pigment produced when lamp oil is burned. If you use this color, you can suggest a character with a powerful physical presence and a strong will.

C0 M10 Y10 K100
R36 G19 B13
#24130D

LAMP GRAY CAN BE USED FOR CHARACTERS LIKE THESE!

POSITIVE
- Possesses unrivalled strength
- Opens up new worlds
- Has strong convictions

NEGATIVE
- Shuts out information coming in from the outside
- Lives in isolation
- Does not accept people

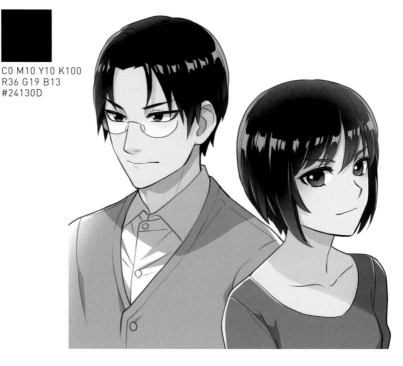

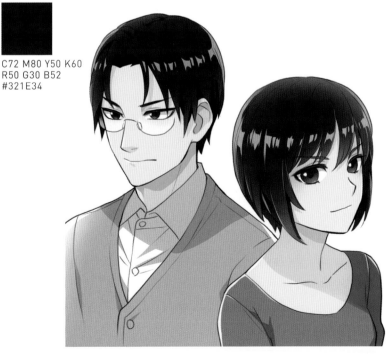

Taupe
Will x Humanity

C70 M85 Y100 K47
R68 G38 B22
#442616

The name of this hue derives from the French word for mole. A reddish black, it can bring out the passion of red multiplied with the strength of black.

TAUPE CAN BE USED FOR CHARACTERS LIKE THESE!

POSITIVE
- Lives for the sake of others
- Tenacious
- Loyal

NEGATIVE
- Has a soft-hearted side
- Lacks confidence
- Straightlaced

Gunmetal
Will x Calm

This is the color of a metal alloy made by combining copper and tin, a gray that is close to black. It can be used to express a personality that is perpetually calm or a lonely spirit.

C72 M80 Y50 K60
R50 G30 B52
#321E34

GUNMETAL CAN BE USED FOR CHARACTERS LIKE THESE!

POSITIVE
- Calm and collected
- Can analyze things objectively
- Can make something out of nothing

NEGATIVE
- Can be hard to please
- Tends to be anti-social
- Unforgiving

 Black Hues

Examples of Hair and Eye Color Combinations

Gray Hue Hair ✕ **Eye Color of the Same Hue** ❯

Charcoal Gray (JIS)
C5 M15 Y0 K83
R78 G68 B73
#4E4449

Lamp Black (JIS)
C0 M10 Y10 K100
R36 G19 B13
#24130D

Black Brown (Kurocha) (JIS)
C0 M40 Y50 K85
R75 G45 B22
#4B2D16

Bamboo Soot (Susutake, a reddish dark brown) (JIS)
C0 M30 Y30 K72
R107 G81 B70
#6B5146

Jet Black (Shikkoku)
C70 M50 Y50 K100
R0 G0 B0
#000000

Ink Black (Sumi-iro) (JIS)
C0 M0 Y0 K95
R47 G39 B37
#2F2725

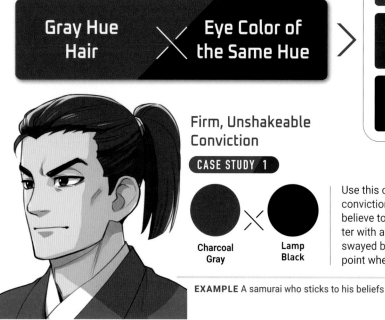

Firm, Unshakeable Conviction

CASE STUDY 1

Charcoal Gray ✕ Lamp Black

Use this combination for a character who has strong convictions, and moves straight toward the things they believe to be right. It's also useful in creating a character with a strong sense of self-affirmation who is not swayed by the opinions of others or is obstinate to the point where people around them get fed up.

EXAMPLE A samurai who sticks to his beliefs

CASE STUDY 2

Black Brown ✕ Bamboo Soot

A Sense of Loneliness That Isn't Overbearing

When you want to give a character a look that isn't too heavy and overbearing, or when you want to give them a Western nuance, dark brown is recommended. This combination is suited to an independent character who always operates on their own.

EXAMPLE A youth who prefers to travel alone

Old Fashioned and Quiet

CASE STUDY 3

Jet Black ✕ Ink Black

This combination is recommended for characters with black hair. By making the eye color just a bit lighter, you can express softness and kindness. This combination can be used for a quiet and serious personality.

EXAMPLE A serious, kind presence

※According to the PCCS (pages 16–17) system, the darkest of the achromatic hues is considered to be black. The brightness is 1.5.
※Here we have used the JIS conventional color names (page 186) as the base for introducing the color combinations.

Black Hue Hair × Contrast Hue Eye Color

Crimson (Karakurenai) (JIS)
C0 M80 Y45 K0
R233 G84 B100
#E95464

Lavender (JIS)
C23 M30 Y0 K5
R192 G179 B211
#C5B3D3

Ultramarine Blue (JIS)
C82 M70 Y0 K0
R64 G82 B162
#4052A2

※Since achromatic hues do not have color, any hue that is chromatic can be used with them as a complementary hue combination.

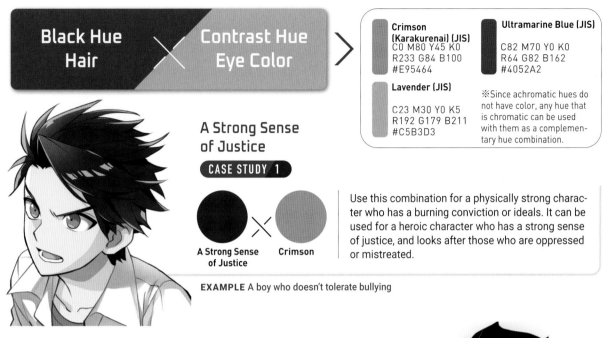

A Strong Sense of Justice
CASE STUDY 1

A Strong Sense of Justice × Crimson

Use this combination for a physically strong character who has a burning conviction or ideals. It can be used for a heroic character who has a strong sense of justice, and looks after those who are oppressed or mistreated.

EXAMPLE A boy who doesn't tolerate bullying

CASE STUDY 2

Lamp Black × Ultramarine Blue

Kind and Introverted

This combination can be used for a frightening character who will mercilessly make someone their enemy. The combination can also be used for a character who has a cold, ruthless, cruel side.

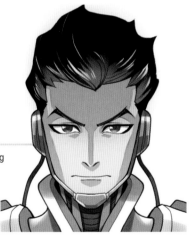

EXAMPLE An emotionless cyborg

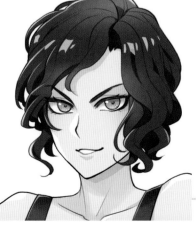

Stoic and Smart
CASE STUDY 3

Charcoal Gray × Lavender

Use this combination for a stoic character who spends their energy on bettering themselves, or one who intensely trains themselves physically and mentally. You can express elegance and stylishness with this combination too.

EXAMPLE A Hollywood actress who takes on action roles

02

Try Using Personal Colors for Characters

The Personal Color System Divides All Colors Into 2 Groups.

> **Yellow Base (Colors with a yellow tint)**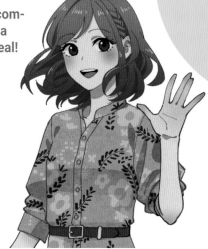

SPRING

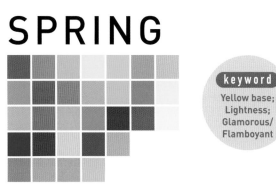

keyword

Yellow base; Lightness; Glamorous/ Flamboyant

Pretty, healthy, relatable!

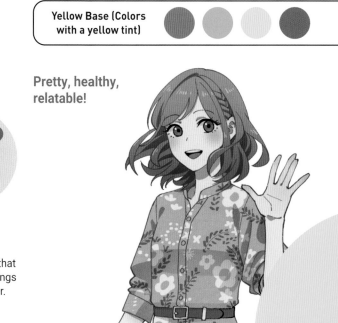

Yellow-based soft and clear colors go well with skin tones that don't have a lot of redness in them. This group of colors brings to mind spring flowers like those of tulips and canola flower.

AUTUMN

keyword

Yellow base; Depth and Strength; Calm

An aura of composure and a natural appeal!

Yellow-based, deep, low-saturation colors go well with healthy-looking tanned skin. These colors bring autumn to mind, but depending on how they are combined they can look glamorous too.

Personal color refers to groupings of colors based on a person's skin tones and what goes well with it. Each group is made up of about 30 hues, and the groups are names after the seasons of the year. Using personal colors that go well with the skin tones of a character's face makes a strong impression, so if you're feeling the color combinations don't look right, try using new pairings until you find the right one.

Blue Base (Colors with a blue tint)

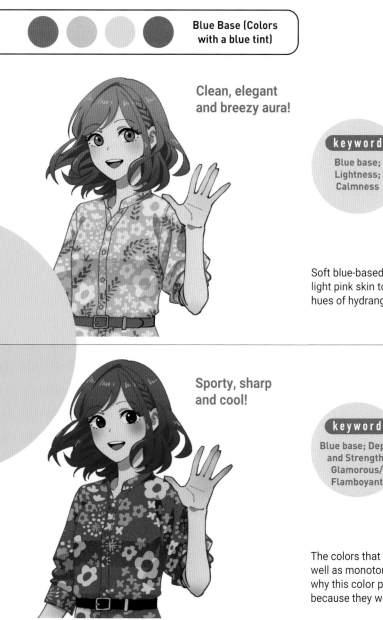

Clean, elegant and breezy aura!

keyword

Blue base; Lightness; Calmness

SUMMER

Soft blue-based pastel colors and grayish hues go well with light pink skin tones. Colors like the graduated purple and pink hues of hydrangeas and blue-gray go well together.

Sporty, sharp and cool!

keyword

Blue base; Depth and Strength; Glamorous/ Flamboyant

WINTER

The colors that go well with dark-hued skin are vivid hues as well as monotones such as white, black and gray. The reason why this color palette has hues that are lighter than pastel is because they work well in highly contrasting combinations.

ASK THE EXPERTS 2

Q & A #2:
Problems with Applying Color

Q

When I reach this stage, I'm unsure what colors to start with.
What should I do?

A

Why not try picking up a color with the eyedropper tool from a reference illustration?

If you feel it is difficult to choose a color on your own, try imitating a manga or illustration that you like. If you try picking up a color from a reference illustration with the eyedropper tool, you can learn how certain colors look as you apply them. Another method is to choose "soft colors" or "hard colors" with a color picker tool.

In addition, if you are not used to applying color at all, start by applying shadows to areas of flat color.

Q

I tried applying color, but the combinations don't look cohesive.

A

In order to increase your color range, think of the illustration's intended audience!

When you are increasing the number of colors you are using, if you use the same tones you will end up with cohesive combinations. In addition, it's a good idea to look at your illustration from a distance and think about what color you want to feature in it. Use that color as the base and choose colors in the same tones to come up with something cohesive.

Also, if you tend to reuse the same colors over and over, it's important to look at lots of illustrations by other people, and learn about variations in color combinations.

(We would like to thank Nippon Designer Gakuin and Nihon Kogakuin College for their cooperation with this section.)

The New Science of Color

FOR PEOPLE WHO DRAW

After we have gone over the basics of color science,
we'll explore some advanced color techniques. By having a deep
knowledge of how color affects the viewer, character and back-
ground coloring will become more familiar and fun!

The Power of Primary Colors

When we talk about primary colors, we usually mean bright, bold hues. But in color science, the term refers to the base colors used to create a variety of other hues.

The Colors of Light—The Primary Colors of the RGB Color Model

The RGB color model is the base used for showing color digitally. R is red, G is green, and B is blue. All colors are created by mixing these three colors.

Smartphones, personal computers and television screens show a gamut of colors by adjusting the strength of red, green and blue light!

According to the PCCS system (illustration On right) R is v3, G is v12, and B is v19.

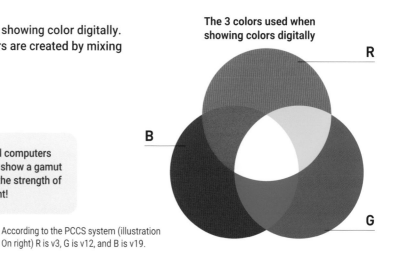

The 3 colors used when showing colors digitally

The Colors of Pigment—The Primary Colors of the CMY Color Model

When full-color pages in books and magazines are printed, basically 4 colors, the primary colors of CMY plus K, are used.

K refers to the key plate, the one that typically contains the details. Usually inked in black, the key plate is associated with that color.

According to the PCCS system (illustration on right) G is v16, M is v24, and Y is v8.

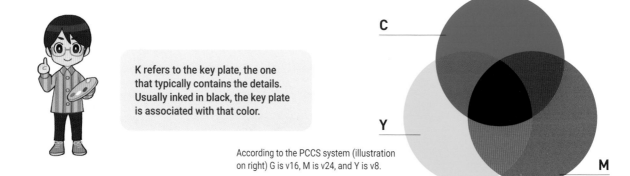

The 3 colors used in printing

The Primary Colors of Color Perception

When we perceive colors, the four base colors that are transmitted from our eyes to our brains are red, yellow, blue and green. These are called the primary colors of color perception. These four colors are the easiest for humans to recognize. That's the reason they are often used for baby toys.

The base colors of color perception

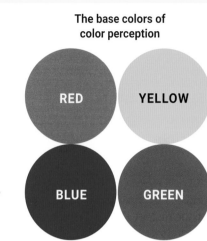

According to the PCCS system (illustration on right) red is v2, yellow is v8, green is v12, and blue is v18.

Let's Look at Primary Colors on the PCCS Color Wheel

The primary colors of both the RGB color model and the CMY color model are represented on the PCCS color wheel with colors that closely resemble them.

The PCCS color wheel represents all the primary colors with other shades that are close to them.

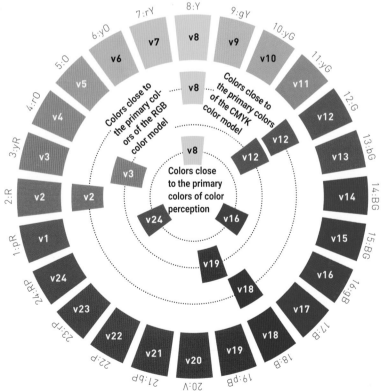

What Are Warm, Cold and Neutral Colors?

Of all the impressions and information we receive from colors, the ones we perceive most deeply are the differences between warm and cold colors. The more vivid the color, the more we can detect its warmness or coldness.

Warm, Cold and Neutral Colors on the PCCS Color Wheel

Purplish red (1:pR) to yellow (8:Y) are warm colors, bluish green (13:bG) to purplish blue (19:pB) are cold colors and the rest are neutral. Neutral colors are ones that are neither warm nor cold and do not give any impression of temperature.

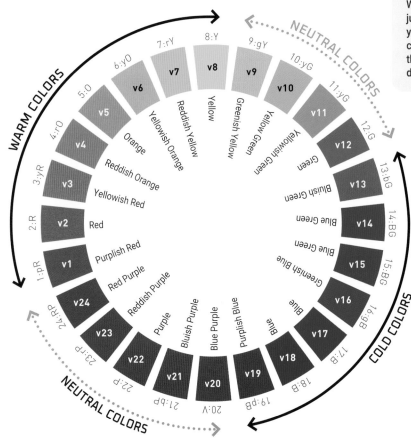

When drawings illustrations, it's OK to just keep in mind that red, orange and yellow are warm colors, blue and the colors around them are cold colors, and the rest are neutral colors where you don't feel a particular temperature.

By the way, an intermediate color is a cloudy color that is created by mixing grey into a pure color (see page 14). It differs from neutral colors!

The Differences Between Warm, Cold and Neutral Colors

Warm Colors

In between red and yellow, these colors give a sensation of atmospheric warmth or heat even to objects. This hat looks warm, right?

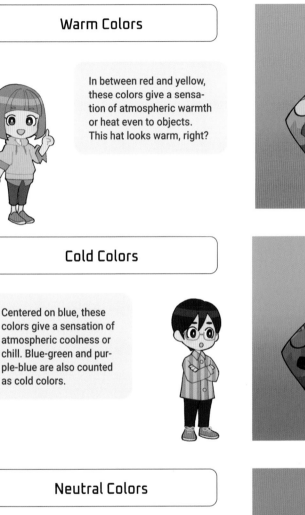

Cold Colors

Centered on blue, these colors give a sensation of atmospheric coolness or chill. Blue-green and purple-blue are also counted as cold colors.

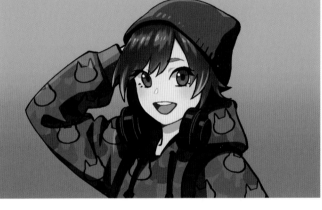

Neutral Colors

In between hot and cold, these colors strike a tonal balance, borrowing from each realm to create visual equilibrium.

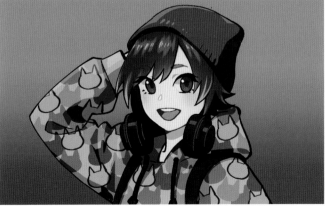

03

Background Colors and Contrast Effects

When we look at objects in front of us, the background also enters our view. Athough we may not be conscious of this ordinarily, the color of an object changes based on the colors of its surroundings. So the background color affects the impression given by a character too.

Understanding the Contrast Effect

Normally, color is not perceived in isolation; it's always seen with a background element. The way in which the illustrated object's color changes as it is influenced by the background colors is called the contrast effect. The contrast effect can be divided into the following 3 types.

> **Color Contrast**

The clementines on the left and right here are both the exact same color, but when the background is red they look more yellow, and when the background is yellow they look redder. The effect where the color of the object changes is called color contrast.

If the background color is red, the object takes on a yellow tint!

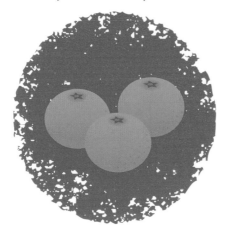

If the background color is yellow, the object takes on a red tint!

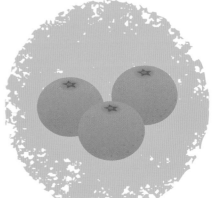

Sometimes the skin tone of your character looks different from what you envisioned. This may be due to the effect the background color is having on it.

Brightness Contrast

The skin colors of the profiles illustrated here are the exact same color, but when the background is white it looks dark, and when the background is black, it looks light. The effect where the brightness of the object changes is called brightness contrast.

If the background is white, the object looks dark!

If the background color is black, the object looks light!

Saturation Contrast

The flowers pictured here are the exact same color, but when the background is pale they look vivid, and when the background is saturated in color, they look dull. This contrast effect where the saturation of the object changes is called saturation contrast.

If the background is pale, the object looks vivid!

If the background color is strong, the object looks dull!

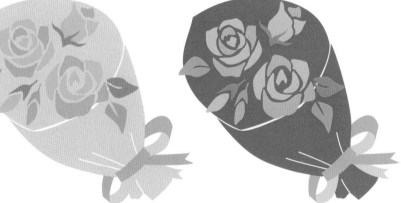

I see! If you make the background color dark the character looks light, and if you make it pale the character's presence becomes more pronounced and vivid. I'll pay attention to that from now on.

The Relationship Between Characters and Background Hues and Tones

Have you ever worried about the backgrounds for your characters? When deciding on color combinations, if you decide from the start that you want to either unify the background or make it stand out, you won't get so lost.

Unifying Techniques

The background and the character influence each other as wholes and transmit a message to the viewer. If you unify the hue or tone of the entire image, it will look cohesive and leave a lasting impression with the viewer.

Unify the Hues

If you use the same, adjacent or analogous hues (see pages 21–22) for the entire image, the impression created by those hues is transmitted as is. For this, just narrow down the hues you use, and employ tones (brightness, saturation) freely.

Here the analogous colors from 18:B to 20:V on the PCCS color wheel are used, and 6:yO is used as an accent.

Unify the Tones

If you use the same or adjacent tones (see page 18) for the entire image, the impression created by those tones is transmitted as is. For this, just narrow down the tones you use, and employ hues freely.

Here the ltg (light gray) tone is used throughout, with the dk (dark) tone as an accent.

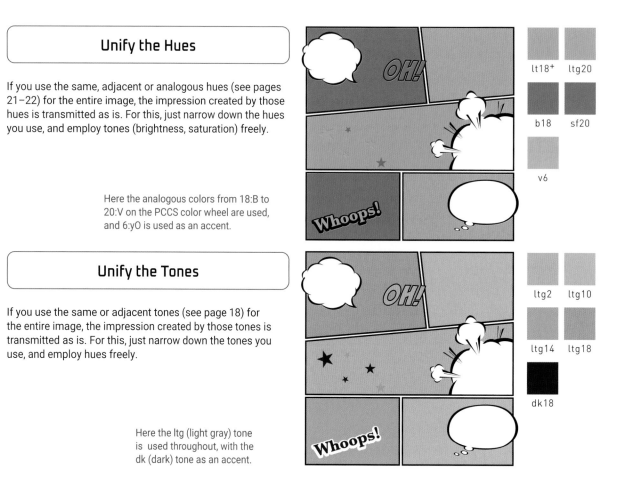

lt18⁺ ltg20

b18 sf20

v6

ltg2 ltg10

ltg14 ltg18

dk18

Techniques for Differentiating the Background and Making It Stand Out

These techniques are more standard color combinations than the ones on the previous page. By using the main color for about 70 percent of the image and balancing this by limiting the use of contrasting hues or tones to 30, you can create a good sense of separation and a compelling color combination.

Differentiating the Hues

The main color points to the color that is used for the majority of the image and is used repeatedly. It is not necessarily the color used for the character's hair or clothing. When considering the color composition of your image, it's easy to figure out if you think of the color used for a large area as the image color of the illustration. If you use the main color as the base, and combine it with contrast and complementary colors (see page 23), you will come up with a combination that uses differentiated hues.

The main color is set to a brown (a darkened version of the hues between 4:rO and 6:yO), so a green (12:G) is used for contrast.

Differentiating the Tones

By using the tone of the main color as the base and combining it with contrasting tones (see page 19), you will have a combination with differentiated tones. Many colors are used in an illustration, so there is no need to strictly dissect each one. If the whole illustration has light, pale tones, dark, saturated tones will become accents, and if the whole illustration has vivid tones, pale or achromatic colors will provide a comfortable visual contrast.

The main tone is b (bright), so g (grayish) tones are used to soften the impact.

05

Color Combinations That Affect Characters

When applying color to an illustration, you usually think about the overall image before-hand. If you decide on the direction to take the color combinations in advance as well, you can effectively convey the atmosphere and mood you want to capture.

The Relationship Between Hues and the Character

By aligning the hues uses for the background and the character, they will look much more unified (left illustration). On the other hand, if you make the hues of the character contrast the background hues, the character will stand out (right illustration). What's the impression you're aiming for?

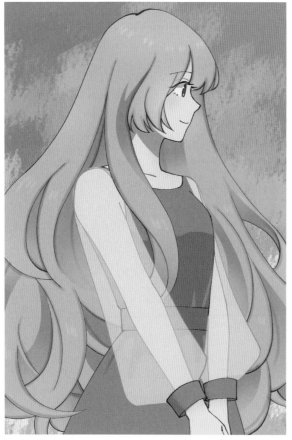

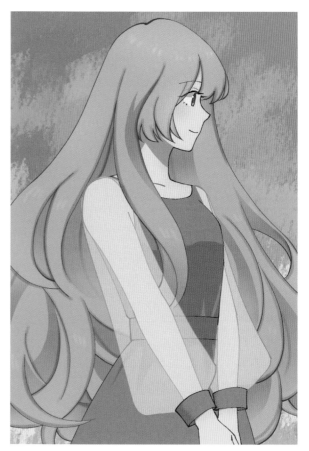

When the hair and the background have the same hue, they look unified.

When the hair and the background employ contrasting hues, the character stands out.

The Relationship Between Color Tones and the Character

If the same tones are used for the character and the background, a greater sense of balance and visual unity is created. If you use contrasting tones for the character and the background, the character's presence or their emotional message is emphasized. For the impressions that each tone gives, refer to the lists on pages 16–17.

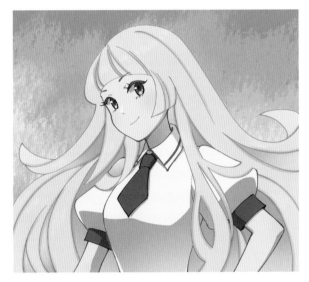

Since lt+ (light) to p+ (pale) tones are used here, a soft, clear impression is made by this image.

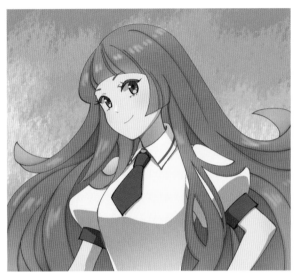

In contrast to the mid- to low-saturation background, a high-saturation v (vivid) tone is used for the character, to bring contrast to the tones.

Examples of unifying the tones used for the character and the background

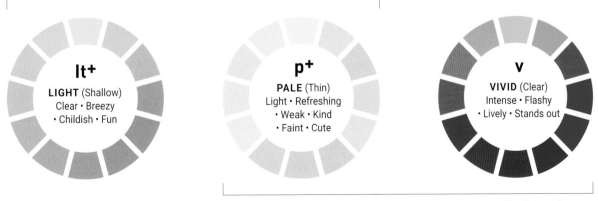

lt+
LIGHT (Shallow)
Clear · Breezy
· Childish · Fun

p+
PALE (Thin)
Light · Refreshing
· Weak · Kind
· Faint · Cute

v
VIVID (Clear)
Intense · Flashy
· Lively · Stands out

Examples of contrasting tones used for the character and background

※ For more about tones, refer to pages 16–17.

Impressions Made by Light and Color Combinations

When we are drawing illustrations we are aware of the relationships between lights and shadows. A red observed in a light situation and one observed in a dark situation not only look different in term of brightness, the color also looks different. Let's use this knowledge for color schemes.

Colors Look Different Depending on Whether Light Is Present

The colors of objects change subtly based on whether light is hitting them or not. The colors in lighted sections look yellowish, while those in darker sections look blueish.

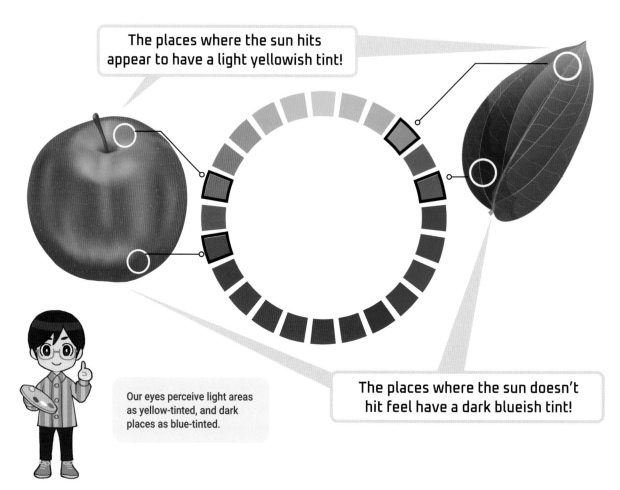

The places where the sun hits appear to have a light yellowish tint!

The places where the sun doesn't hit feel have a dark blueish tint!

Our eyes perceive light areas as yellow-tinted, and dark places as blue-tinted.

High and Low Saturations

The illustration below is the PCCS Tones Arranged by Lightness Chart. With all tones, yellow and nearby hues have high lightness, while blue and nearby hues have low lightness.

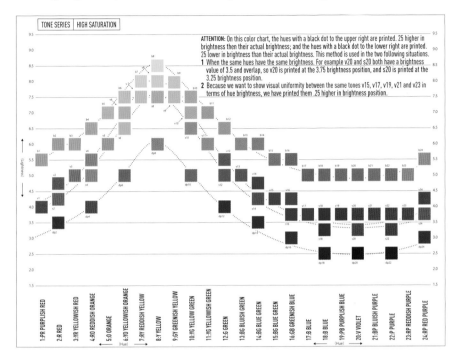

ATTENTION: On this color chart, the hues with a black dot to the upper right are printed. 25 higher in brightness then their actual brightness; and the hues with a black dot to the lower right are printed. 25 lower in brightness than their actual brightness. This method is used in the two following situations.
1 When the same hues have the same brightness. For example v20 and s20 both have a brightness value of 3.5 and overlap, so v20 is printed at the 3.75 brightness position, and s20 is printed at the 3.25 brightness position.
2 Because we want to show visual uniformity between the same tones v15, v17, v19, v21 and v23 in terms of hue brightness, we have printed them .25 higher in brightness position.

TIPS

What is the PCCS Tones Arranged by Lightness Chart?

This chart shows the changes in lightness or brightness with the hues on the horizontal axis and lightness on the vertical axis. It shows that yellow hues have high lightness values, and blue to purple hues have low lightness values.

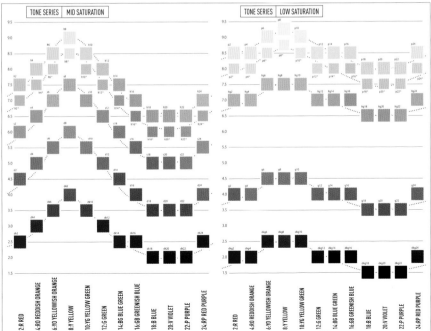

High-saturation hues such as the v (vivid) ones possess a range of lightnesses! Low-saturation hues don't change much.

Natural Harmonies: Familiar Colors That Give a Sense of Security

When combining colors, if you make the hues that are close to yellow on the color wheel bright and the ones that are close to blue on the color wheel dark, they look natural and balanced. These are called natural harmonies or natural color schemes.

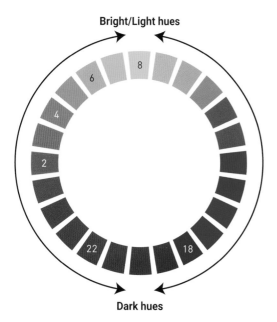

Bright/Light hues

Dark hues

Examples of Natural Harmonies

| dk22 | d2 | sf4 | lt6+ |

| b8 | d18 |

Starting with purple (22:P) and moving toward orange (6:yO), the hues become gradually lighter, which reflects the way hues are perceived naturally.

When we compare yellow (8:Y) and blue (18:B), yellow is a brighter hue so it creates a natural harmony.

The brightness of the yellow hues is heightened while the brightness of the blue is lowered to strike the right overall visual balance.

Complex Harmonies: Stylish Color Schemes With a Twist

Complex harmonies, as opposed to natural harmonies, are ones where the hues close to yellow on the color wheel are made dark while the ones close to blue are lightened. Since the relationship between hue and brightness is the opposite of what is seen in nature, these color schemes look stylish or mysterious. No matter what: they pop!

**Hues that are usually light
are made dark**

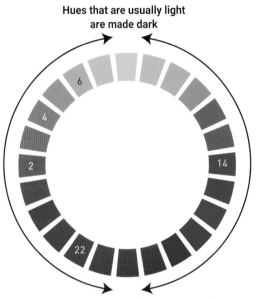

Hues that are usually dark are made light

Examples of Complex Harmonies

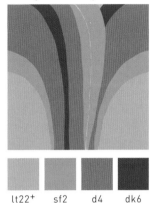

lt22+ sf2 d4 dk6

Starting with purple (22:P) and moving toward orange (6:yO), the hues become gradually darker, which is opposite the way we perceive hues naturally.

lt14+ dkg6

When we compare blue-green (14:BG) and reddish orange (4:rO), blue-green is a lighter hue, so a complex harmony is created.

The hues close to yellow are made dark, and the hues close to blue are lightened. An unnatural scheme is used on purpose for a striking effect.

07 How to Distribute Colors: Useful for Page Design & Layouts!

The distribution of colors when laying out an illustration influences the overall impression. If you know what base, subordinate and accent colors you're using, you can make your illustration more compelling and clear.

Apply the Main Color to Large Areas, and Tighten Things Up with Differing Support Colors

Colors perform different roles depending on how much area they cover. When applying color to an illustration, it's easy if you decide on the base color first, then consider the accent color, and end by adjusting with a subordinate color or colors that connect the two.

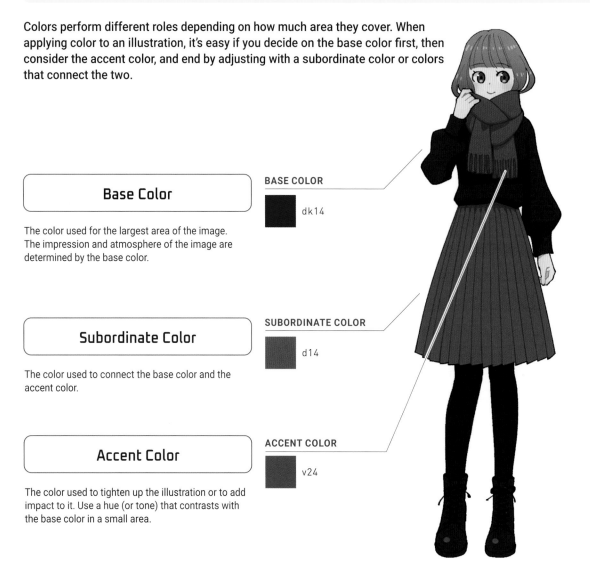

Base Color

BASE COLOR

dk14

The color used for the largest area of the image. The impression and atmosphere of the image are determined by the base color.

Subordinate Color

SUBORDINATE COLOR

d14

The color used to connect the base color and the accent color.

Accent Color

ACCENT COLOR

v24

The color used to tighten up the illustration or to add impact to it. Use a hue (or tone) that contrasts with the base color in a small area.

Consider the Role Balance Plays

The role of each color used changes depending on how much area it covers. When applying color to illustrations or characters there are no exact proportions or rules to follow, so you can arrange them according to your preferences.

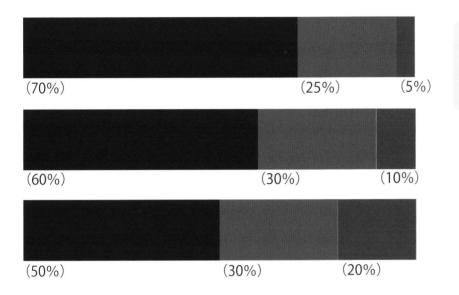

(70%) (25%) (5%)

(60%) (30%) (10%)

(50%) (30%) (20%)

When applying color to characters, you can increase the amount of accent color used. It can be around 20 percent of the whole.

Adjust the Image with Subordinate Colors

If you make the subordinate color close to the base color, the overall image will have a calm cohesiveness. If you make it close to the accent color, a lively atmosphere or movement will be created.

When the subordinate color is close to the base color

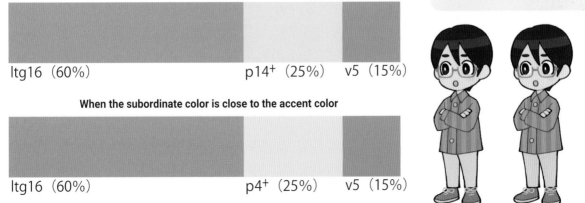

ltg16 (60%) p14+ (25%) v5 (15%)

When the subordinate color is close to the accent color

ltg16 (60%) p4+ (25%) v5 (15%)

I see! So that's why it's a good idea to decide on the base and accent colors first, and to adjust the subordinate color last.

How Colors Are Perceived: Adjusting the Impressions Colors Make

The psychological ways in which colors are perceived, are connected with the three attributes of color: hue, brightness and saturation.

Warm (Heated • Hot), Cool (Chilly • Cold)

On the PCCS color wheel (pages 16–17) v1 to v8 are warm hues, v13 to v19 are cold hues, and everything else is considered neutral. Neutral hues are ones that don't give a sense of warmth or cold. They point to the green and purple hues.

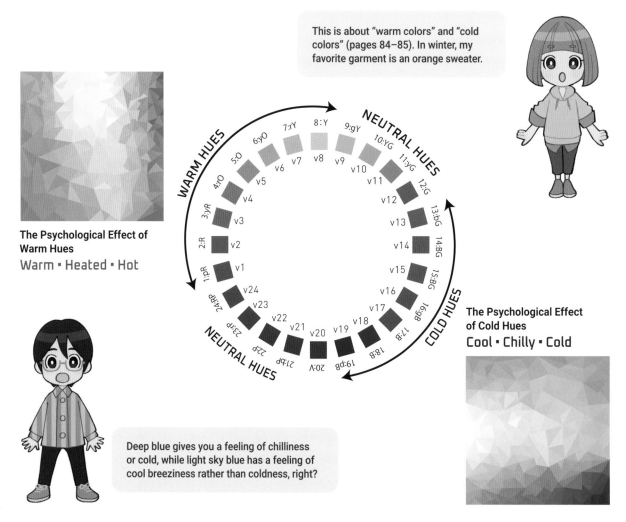

This is about "warm colors" and "cold colors" (pages 84–85). In winter, my favorite garment is an orange sweater.

The Psychological Effect of Warm Hues
Warm • Heated • Hot

The Psychological Effect of Cold Hues
Cool • Chilly • Cold

Deep blue gives you a feeling of chilliness or cold, while light sky blue has a feeling of cool breeziness rather than coldness, right?

Approaching or Receding

Objects with warm colors feel closer than they actually are, and ones with cold colors feel farther away than they really are. The more saturated the color is, the more obvious the difference.

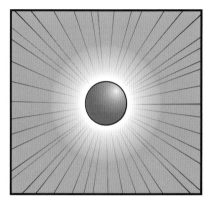

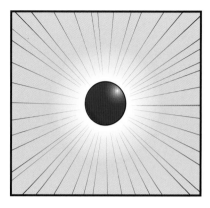

The red ball feels like it's coming toward us, and the blue ball looks like it's moving farther away. The two balls are exactly the same size, but due to their colors they look like they differ in size too.

Light, Heavy

The lighter the color of an object, the lighter in weight it feels; the darker the color the heavier it feels. The brightest hue of all is white, and the darkest hue is black.

A white box appears light.

A black box looks heavy.

White clothes are said to be expansive and make you look larger, but if the background is white too, the silhouette doesn't stand out much.

Black clothes are said to make you look slimmer, but if the background is white, the silhouette really stands out clearly against it.

Soft, Hard

Light colors look soft, and dark colors look firm and sturdy.

Light colors can look like soft fluffy cotton or cotton candy.

Dark colors give the impression of sturdiness and heaviness, like a dumbbell.

Pastel-colored clothes look weightless and soft, while dark-colored clothes look sharp and stark, right?

Flashy and Active, Drab and Quiet

High-saturation colors have more visual appeal, while low-saturation colors contribute more drab tones. The saturation of the colors used for a character affects the impressions they create, not just the hue.

If high-saturation colors are used as for the character on the left, the impression given is that of an active personality. If all the colors are low in saturation, as for the character on the right, you create an impression of quietness.

Transparent, Muddy

If you use light, high-saturation hues, you can express an atmosphere of clear transparency and freshness. On the contrary, when you want to express a murky, dark vibe, use an intermediate hue (see page 14) as the main color, and low-saturation colors as accent colors.

This color scheme is centered on lt+ (light), p+ (pale) and ltg (light grayish) tones.

This color scheme is based on d (dull), g (grayish) and dk (dark) tones.

Natural, Artificial

If you use mid- to low-saturation hues that are seen in nature, the image will look calm and natural, while if you combine metallic, high-saturation hues look more artificial.

A color scheme with mid- to low-saturation hues in the blue to green range.

A color scheme that combines vivid high-saturation, metallic-looking hues.

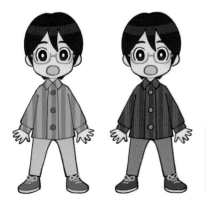

The color of the clothing alone can make it look like ones personality has changed. Do I look quiet on the left, and highspirited on the right?

The Mystery of Color Assimilation: Colors Mixed in Front of Your Eyes?

When the colors of an object look different because of the influence of its background it's called the contrast effect, but when the object is small a contrast is not created, and the two colors look as if they are mixed together. This is called color assimilation.

Color Assimilation Occurs With Fine Patterns

If you look at a finely detailed pattern from a distance, you can't identify the individual colors in it as they all blend together. This is what is called color assimilation. Impressionist artists such as Georges Seurat and Paul Signac used this effect to create their paintings. Their paintings are done only with very small dots in a technique called pointillism.

Georges Seurat, "A Sunday Afternoon on the Island of La Grande Jatte", Art Institute of Chicago.

Wow, the blue and yellow mix together and look like yellow-green. Color printing is done with this method too.

When small points of yellow and blue are gathered together . . .

. . . they are assimilated into a shade of green!

The Mysterious Illusion That Occurs with Color Assimilation

If you use color assimilation skillfully, you can create some interesting effects. The illustrations below have backgrounds of the same color, but because of the pattern they look as though the colors have changed.

Hue Assimilation

In contrast to the yellow-green background, the left side of this illustration has a yellow pattern, and the right side has a blue pattern. The green on the left side looks more yellow-green, while the green on the right side looks blue-green.

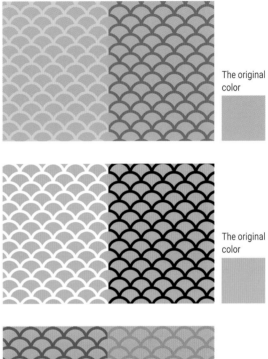

The original color

Brightness Assimilation

In contrast to the peach background, the left side of this illustration has a white pattern, and the right side has a black pattern. The background on the left side looks lighter, while the background on the right side looks darker.

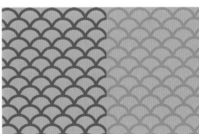

The original color

Saturation Assimilation

In contrast to the sky blue background, the left side of this illustration has a high-saturation blue pattern, and the right side has a low-saturation blue pattern. The background on the left side looks more saturated, while the background on the right side looks less saturated.

The original color

TIPS

Why Clementines Come in Red Net Bags

The net bags that hold clementines employ a form of color assimilation. Clementines packed into red net bags look sweeter and fresher and thus more tempting to the consumer.

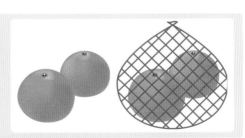

Tricks Using Color Effects

Here we'll look at four techniques that use color effects. The impressions made by the colors you choose change depending on their proportions and balance.

Separation

When applying color to illustrations, one of the useful techniques you can use is separation. When two colors are fighting each other and don't go together well, or if the applied colors look unfocused, you can employ this technique. Separation is easy to apply—just add a line of white, black or gray to the borders between the colors.

By applying a white border to the words, they become easier to read.

By applying a black border around the silhouette, the shape become clear.

You should put in a pretty thick line between colors. White is good when there are two vivid colors!

By applying a line around the waist of the character, definition is created.

Proportion

Proportion means ratio or percentage. Even if the same three colors are used together, by changing the area each color covers the overall impression is altered. When creating illustrations, deciding on the ratio of the base color, subordinate color and accent color (see page 96) goes hand in hand with deciding on the proportions.

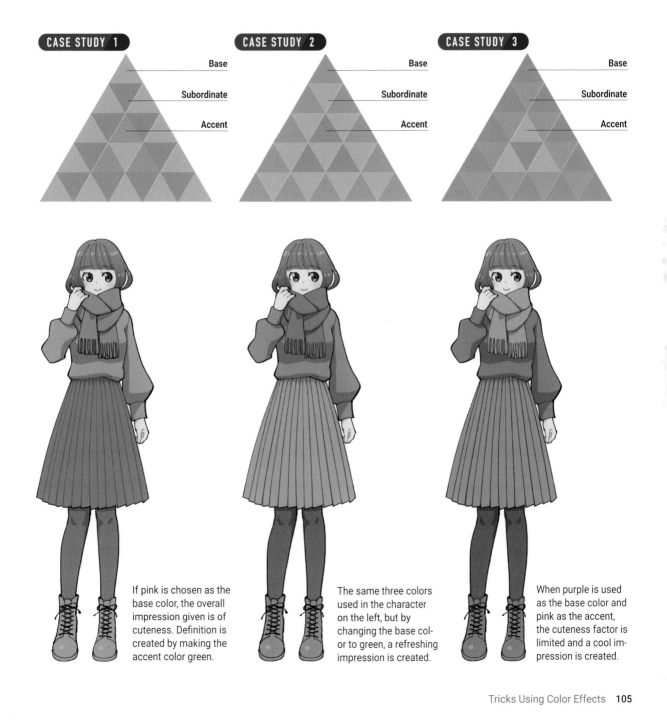

CASE STUDY 1

Base
Subordinate
Accent

CASE STUDY 2

Base
Subordinate
Accent

CASE STUDY 3

Base
Subordinate
Accent

If pink is chosen as the base color, the overall impression given is of cuteness. Definition is created by making the accent color green.

The same three colors used in the character on the left, but by changing the base color to green, a refreshing impression is created.

When purple is used as the base color and pink as the accent, the cuteness factor is limited and a cool impression is created.

Balance

This is an effect that uses the fact that bright/light colors look light and dark ones look heavy. If a dark color is used for a large area and on the bottom, the object looks heavy and stable. If this is flipped over it looks unbalanced, but when this is used in the background it is felt as "movement", and when it's used for a character's clothing it can give an active impression.

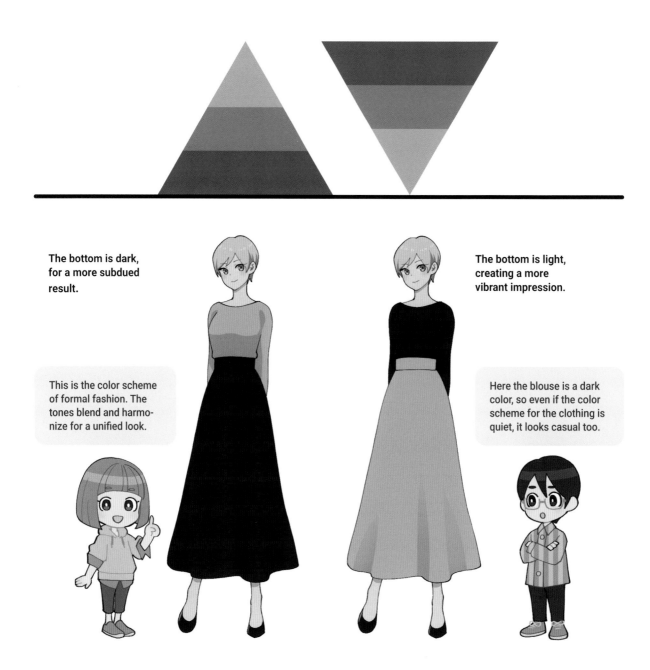

The bottom is dark, for a more subdued result.

This is the color scheme of formal fashion. The tones blend and harmonize for a unified look.

The bottom is light, creating a more vibrant impression.

Here the blouse is a dark color, so even if the color scheme for the clothing is quiet, it looks casual too.

Repetition

Even when the color combination is not cohesive, if you repeat it vertically and horizontally, a sense of unity and harmony will still be created.

**An example of combining
two sets of complementary**

**An example of combining a color with
its contrasting and complementary colors**

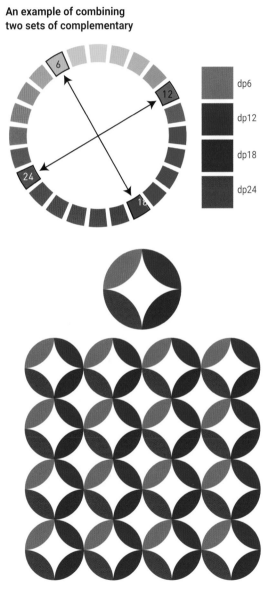

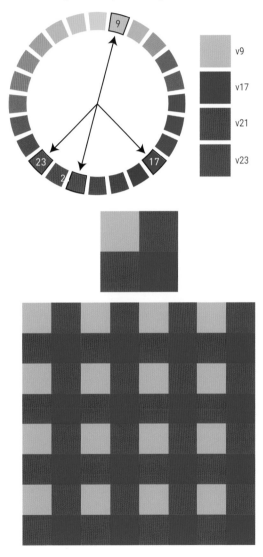

An example of a four-color scheme that combines two sets of complementary colors (page 23).

An example of a four-color scheme where greenish yellow (9:gY) is combined with two of its contrast colors and its complementary color (page 23).

A Useful Catalog of Gradients

In color science, a change in hue, brightness and saturation (page 13) is called a gradient. Generally speaking, it can also indicate an area where there's no border between the colors.

Hue Gradients

The colors of the rainbow are divided in seven: red, orange, yellow, green, blue, indigo and purple. In the PCCS system (pages 16–17) the v (vivid) tones from 2:R to 20:V are equivalent. The hues 21:bP to 1:pR are ones that connect the two ends of the spectrum to create the color wheel. It's a technique you can use for backgrounds, the colors of a character's clothing or hair, or anywhere in your illustration you choose.

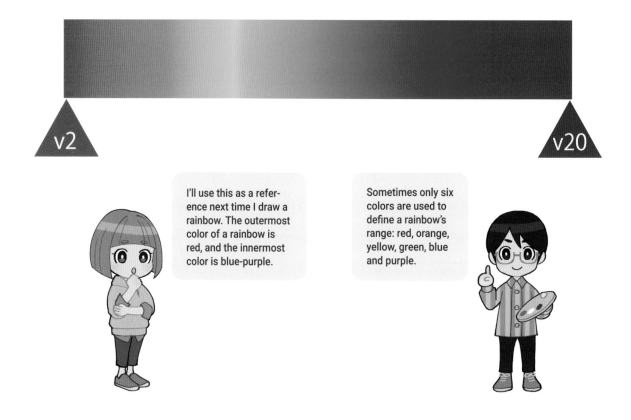

v2

v20

I'll use this as a reference next time I draw a rainbow. The outermost color of a rainbow is red, and the innermost color is blue-purple.

Sometimes only six colors are used to define a rainbow's range: red, orange, yellow, green, blue and purple.

Bold Gradients

If the color changes are big, the gradient makes a dynamic impression.

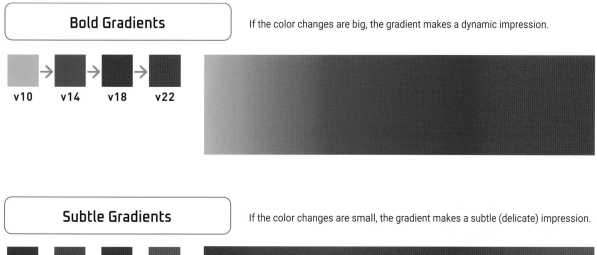

v10 v14 v18 v22

Subtle Gradients

If the color changes are small, the gradient makes a subtle (delicate) impression.

s18 s20 s22 s24

Soft Gradients

If the hue is kept the same and the tone is change to lt+ (light), it creates a soft impression.

lt18+ lt20+ lt22+ lt24+

Dynamic Gradients

If both the hue and the tone are changed at the same time, it creates movement and depth.

lt18+ sf20 d22 dk24

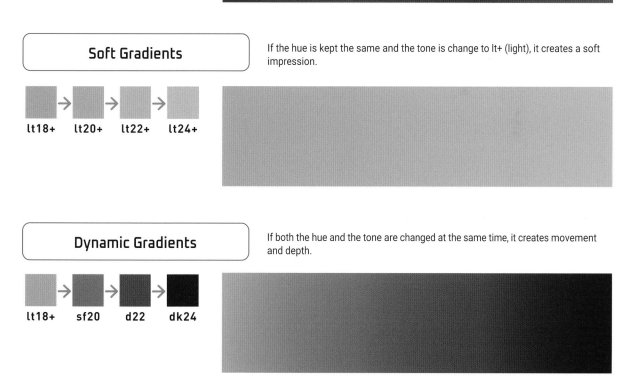

Brightness Gradient

This is a gradient where the hue and saturation are kept constant, and only the brightness is changed. It is simple, but a sense of depth and movement is created.

p2⁺ → ltg2 → g2 → dkg2

Try Using Brightness Gradients For Backgrounds!

By using brightness gradients as backgrounds, you can highlight the atmosphere you're creating or emphasize the character's presence. Since our vision responds more sensitively to changes in brightness than changes in hue, by paying attention to the brightness of colors we can increase our scope for expression.

An example where the brightness is lowered around the face of the character. This creates a dark impression, so it is used to create an impression of unease or instability.

An example where the brightness is raised around the face of the character. The effect suggests the character has had an inspiration or is facing a turning point.

Saturation Gradient

This is a gradient where the hue and brightness are kept constant and the saturation is changed. As we learned with complex harmonies (pages 94–95), if the hue changes even slightly, the saturation also changes with it, so we don't see this type of gradient often.

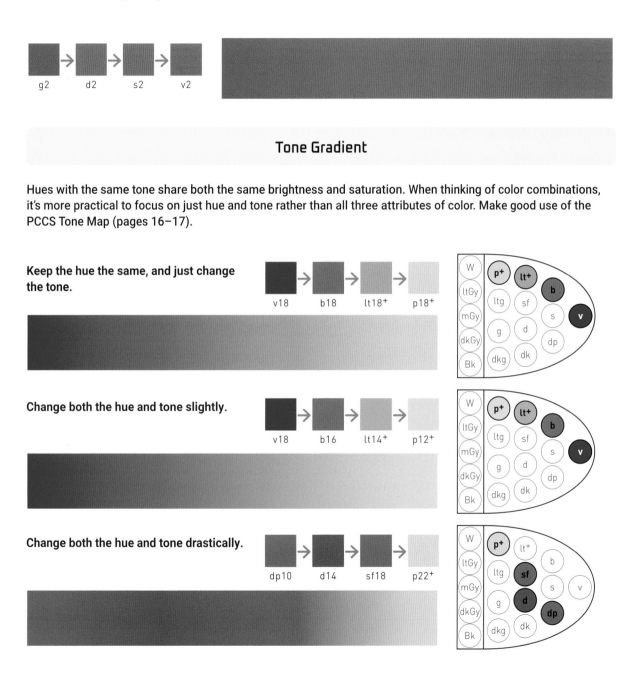

g2 d2 s2 v2

Tone Gradient

Hues with the same tone share both the same brightness and saturation. When thinking of color combinations, it's more practical to focus on just hue and tone rather than all three attributes of color. Make good use of the PCCS Tone Map (pages 16–17).

Keep the hue the same, and just change the tone.

v18 b18 lt18+ p18+

Change both the hue and tone slightly.

v18 b16 lt14+ p12+

Change both the hue and tone drastically.

dp10 d14 sf18 p22+

World Views Expressed with Color: Seasons, Time, Places, Flavors

Now we'll explore color schemes that are useful for communicating a sense of the season or time of day. We've altered the colors in the illustrations to make the variations easier to grasp, but try playing with these schemes in your own work.

A Sense of the Season

The main colors that represent each season are arranged in color palettes.

SPRING **SUMMER** **AUTUMN** **WINTER**

SPRING **SUMMER**

AUTUMN **WINTER**

※ The hues on the color palettes are listed on page 116.

A Sense of the Time of Day

The early morning color scheme consists of pale colors. During the day, colors are vibrant. In the evening, the colors become warm and deep. In the middle of the night, the scheme consists of colors that are neutral to cold and dark grayish.

EARLY MORNING

DAY

EVENING

NIGHT

EARLY MORNING

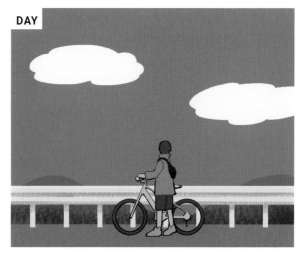

DAY

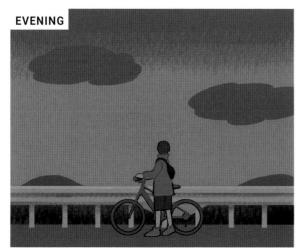

EVENING

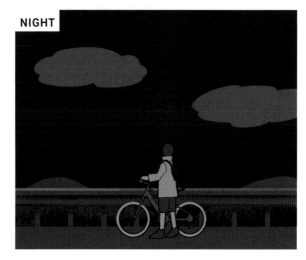

NIGHT

A Sense of Region or Place

Urban colors are cold and grayish. Pastoral ones are a little muddy and soft. For a Japanese look, use vermilion, matcha green and mouse gray judiciously.

URBAN

SMALL TOWN

JAPANESE

WESTERN

URBAN

SMALL TOWN

JAPANESE

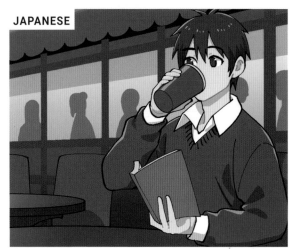

WESTERN

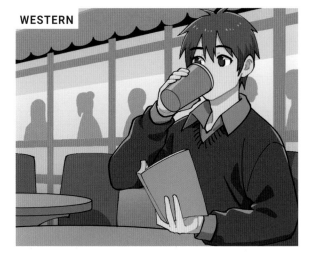

A Sense of Flavor

Color schemes that look sweet are the pinks, whites and browns; ones that look sour are in the yellow range. For spicy shades, basically combine reds and blacks. For bitter flavors, use greens and blues.

SWEET

SOUR

SPICY

BITTER

SWEET

SOUR

SPICY

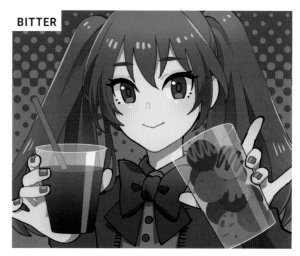

BITTER

Page 112 "Seasonal Feel" Color Palettes

SPRING

C23 M17 Y60 K0
R208 G201 B121
#D0C979

C53 M0 Y23 K0
R122 G201 B204
#7AC9CC

C0 M53 Y80 K0
R242 G146 B57
#F29239

C0 M5 Y100 K0
R255 G234 B0
#FFEA00

C0 M65 Y33 K0
R237 G121 B131
#ED7983

C0 M23 Y15 K0
R250 G213 B206
#FAD5CE

C30 M0 Y80 K0
R195 G217 B78
#C3D94E

C50 M0 Y100 K0
R143 G195 B31
#8FC31F

SUMMER

C0 M70 Y0 K0
R235 G110 B165
#EB6EA5

C0 M0 Y0 K35
R191 G192 B192
#BFC0C0

C0 M3 Y100 K0
R255 G237 B0
#FFED00

C0 M87 Y45 K0
R232 G63 B95
#E83F5F

C63 M0 Y0 K0
R68 G192 B240
#44C0F0

C100 M27 Y0 K0
R0 G132 B207
#0084CF

C63 M7 Y43 K0
R93 G181 B161
#5DB5A1

C35 M0 Y37 K0
R178 G218 B179
#B2DAB3

AUTUMN

C3 M25 Y100 K0
R247 G198 B0
#F7C600

C20 M80 Y100 K0
R203 G82 B25
#CB5219

C43 M53 Y80 K30
R129 G100 B53
#816435

C0 M0 Y35 K10
R240 G234 B176
#F0EAB0

C55 M35 Y90 K40
R94 G105 B39
#5E6927

C15 M37 Y63 K0
R221 G172 B103
#DDAC67

C0 M45 Y77 K17
R217 G145 B58
#D9913A

C45 M65 Y77 K50
R99 G63 B38
#633F26

WINTER

C30 M35 Y100 K0
R193 G163 B10
#C1A30A

C13 M0 Y0 K53
R136 G146 B152
#889298

C3 M0 Y0 K0
R250 G253 B255
#FAFDFF

C0 M100 Y100 K0
R230 G0 B18
#E60012

C85 M45 Y83 K17
R28 G103 B70
#1C6746

C83 M65 Y0 K0
R55 G89 B167
#3759A7

C43 M25 Y0 K0
R156 G177 B219
#9CB1DB

C20 M15 Y0 K0
R210 G213 B236
#D2D5EC

Page 113 "Time of Day" Color Palettes

EARLY MORNING

C15 M5 Y0 K0
R223 G234 B248
#DFEAF8

C10 M7 Y0 K5
R227 G229 B239
#E3E5EF

C0 M50 Y65 K0
R243 G154 B89
#F39A59

C50 M27 Y0 K0
R137 G168 B216
#89A8D8

C5 M40 Y33 K0
R237 G174 B157
#EDAE9D

C23 M20 Y0 K0
R203 G202 B229
#CBCAE5

C20 M43 Y0 K0
R207 G161 B201
#CFA1C9

C33 M20 Y5 K0
R181 G193 B220
#B5C1DC

DAY

C0 M0 Y0 K50
R159 G160 B160
#9FA0A0

C63 M33 Y10 K35
R75 G112 B147
#4B7093

C85 M7 Y5 K0
R0 G164 B222
#00A4DE

C65 M5 Y70 K13
R82 G164 B101
#52A465

C35 M5 Y70 K0
R182 G207 B104
#B6CF68

C0 M17 Y80 K0
R254 G215 B63
#FED73F

C10 M65 Y70 K0
R222 G118 B74
#DE764A

C0 M60 Y87 K0
R240 G131 B39
#F08327

EVENING

C0 M60 Y100 K17
R213 G116 B0
#D57400

C30 M0 Y15 K57
R104 G127 B127
#687F7F

C20 M40 Y45 K0
R210 G165 B135
#D2A587

C15 M55 Y53 K0
R216 G137 B109
#D8896D

C0 M73 Y90 K0
R236 G102 B32
#EC6620

C75 M30 Y40 K0
R57 G143 B150
#398F96

C0 M57 Y60 K55
R140 G77 B50
#8C4D32

C45 M80 Y15 K0
R157 G76 B138
#9D4C8A

NIGHT TIME

C30 M50 Y0 K75
R75 G49 B75
#4B314B

C43 M23 Y10 K0
R157 G180 B207
#9DB4CF

C80 M75 Y20 K0
R75 G77 B138
#4B4D8A

C83 M57 Y0 K0
R44 G101 B176
#2C65B0

C15 M20 Y20 K0
R222 G207 B198
#DECFC6

C17 M17 Y0 K20
R187 G184 B203
#BBB8CB

C0 M10 Y0 K73
R106 G98 B101
#6A6265

C45 M90 Y60 K27
R129 G43 B64
#812B40

※ This part uses colors that are more subdivided than his PCCS introduced in this book. We use subdivided colors.

Page 114 "Region and Place" Color Palettes

URBAN

C13 M0 Y0 K85
R66 G70 B73
#424649

C20 M0 Y0 K60
R112 G127 B135
#707F87

C30 M33 Y0 K0
R187 G174 B212
#BBAED4

C83 M30 Y0 K53
R0 G83 B127
#00537F

C10 M0 Y0 K27
R190 G200 B206
#BEC8CE

C23 M0 Y0 K13
R187 G214 B230
#BBD6E6

C17 M0 Y0 K45
R146 G161 B169
#92A1A9

C65 M17 Y25 K0
R87 G168 B185
#57A8B9

SMALL TOWN

C0 M10 Y30 K15
R229 G212 B172
#E5D4AC

C0 M40 Y40 K60
R132 G92 B75
#845C4B

C15 M67 Y65 K0
R214 G112 B82
#D67052

C60 M45 Y75 K17
R109 G115 B75
#6D734B

C25 M10 Y40 K15
R183 G192 B152
#B7C098

C27 M13 Y80 K0
R201 G201 B75
#C9C94B

C55 M30 Y70 K0
R132 G155 B99
#849B63

C15 M35 Y50 K10
R207 G165 B122
#CFA57A

JAPANESE

C70 M37 Y85 K20
R79 G117 B64
#4F7540

C50 M0 Y85 K30
R111 G157 B57
#6F9D39

C20 M15 Y100 K0
R216 G202 B0
#D8CA00

C45 M55 Y7 K0
R155 G124 B175
#9B7CAF

C77 M60 Y15 K10
R69 G94 B149
#455E95

C0 M0 Y0 K80
R89 G87 B87
#595757

C0 M0 Y0 K0
R255 G255 B255
#FFFFFF

C0 M90 Y90 K0
R232 G56 B32
#E83820

WESTERN

C10 M0 Y0 K7
R224 G236 B243
#E0ECF3

C43 M25 Y0 K0
R156 G177 B219
#9CB1DB

C87 M70 Y0 K0
R44 G81 B162
#2C51A2

C20 M70 Y0 K23
R171 G85 B139
#AB558B

C45 M0 Y100 K0
R157 G200 B20
#9DC814

C77 M0 Y20 K0
R0 G177 B205
#00B1CD

C5 M23 Y0 K0
R240 G211 B229
#F0D3E5

C10 M65 Y13 K0
R221 G118 B157
#DD769D

Page 115 "Flavor" Color Palettes

SWEET

C50 M77 Y60 K20
R128 G70 B76
#80464C

C63 M70 Y100 K37
R88 G64 B28
#58401C

C3 M0 Y10 K0
R250 G251 B237
#FAFBED

C0 M60 Y15 K0
R238 G134 B161
#EE86A1

C0 M3 Y30 K0
R255 G247 B197
#FFF7C5

C0 M37 Y73 K0
R247 G179 B78
#F7B34E

C0 M25 Y7 K0
R249 G210 B217
#F9D2D9

C0 M50 Y13 K0
R241 G157 B177
#F19DB1

SOUR

C30 M55 Y100 K5
R184 G125 B22
#B87D16

C45 M5 Y80 K0
R156 G196 B83
#9CC453

C7 M0 Y45 K0
R244 G243 B164
#F4F3A4

C0 M15 Y100 K0
R255 G217 B0
#FFD900

C27 M0 Y100 K0
R203 G218 B0
#CBDA00

C0 M25 Y60 K0
R251 G203 B114
#FBCB72

C3 M0 Y100 K0
R255 G239 B0
#FFEF00

C13 M0 Y95 K0
R234 G230 B0
#EAE600

SPICY

C27 M70 Y100 K0
R193 G101 B27
#C1651B

C0 M7 Y100 K15
R232 G208 B0
#E8D000

C3 M23 Y100 K0
R248 G201 B0
#F8C900

C0 M80 Y100 K0
R234 G85 B4
#EA5504

C0 M10 Y0 K95
R47 G34 B34
#2F2222

C3 M70 Y95 K0
R233 G108 B18
#E96C12

C0 M100 Y100 K13
R211 G0 B14
#D3000E

C0 M77 Y85 K85
R73 G2 B0
#490200

BITTER

C55 M45 Y0 K0
R129 G135 B194
#8187C2

C90 M65 Y0 K0
R13 G87 B167
#0D57A7

C60 M40 Y100 K0
R123 G136 B46
#7B882E

C47 M60 Y100 K6
R150 G108 B37
#966C25

C0 M13 Y100 K37
R186 G162 B0
#BAA200

C50 M50 Y60 K30
R116 G101 B82
#746552

C75 M50 Y100 K20
R72 G99 B45
#48632D

C30 M0 Y50 Y40
R135 G157 B108
#879D6C

COLOR COMBINATION TECHNIQUES

The Mysterious Ways We Perceive Colors Due to Optical Illusions

Employing an optical illusions is one way of creating a memorable and compelling image. For example, the three-dimensional effect of color when drawing objects, the perspective effect when showing depth in a scene, and the Liebmann effect are all useful when adding visual complexity to your work.

The Various Optical Illusions Created by Color

The Three-Dimensional Effect of Color

We are used to seeing objects lit from the top ordinarily. The illustrations on the right show how this effect can be used to bring three dimensionality to a two-dimensional image.

The center looks as if it's indented

The center part looks as if it is indented.

The center looks as if it's protruding

The center part looks as if it is protruding.

The Perspective Effect of Color (Atmospheric Perspective)

When we gaze at a landscape, the farther away an object is the more blurred its outline is with a blue-gray haze. This is due to the way colors change because of the nature of the atmosphere. Leonardo da Vinci famously studied this phenomenon avidly, and used it for his paintings to create a sense of depth.

If you make the colors of faraway object light, you can show perspective.

Perceptual Transparency

If you apply a color to the area where two objects overlap, that area looks as though it is transparent. If you shift the objects even a little bit, with the optical illusion that's created, that perception of transparency is lost.

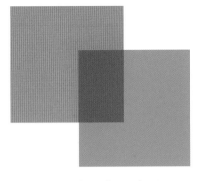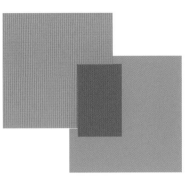

If you apply a color to the overlapping part of the two objects, it looks like each color can be seen through the other object.

Each object has the same color as the ones in the illustration on the left, but when their positions are shifted, the perception of transparency is lost.

Liebmann Effect

When you combine two elements with a similar brightness, even if the hues are far apart, the borderline between each color becomes uncertain, creating a sense of instability. This is called the Liebmann effect. Although this is a combination you usually want to avoid, it can be used when you want to create a particular effect or background.

① ②

Even though the hues contrast, the brightness levels are the same, so it looks like the colors are flickering. It's a very intense effect.

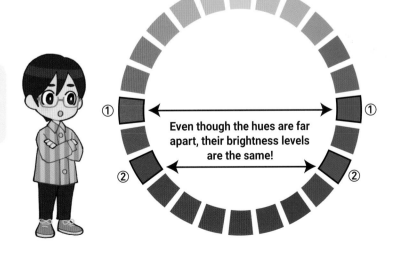

Even though the hues are far apart, their brightness levels are the same!

ASK THE EXPERTS 3

Q & A #3: Problems with Applying Color

WE ASK THE EXPERTS!

Q When I am learning how to apply color, what should I start with?

A Try starting your studies with black, white and gray monochromatic colors!

Before you use a variety of colors, we recommend applying black, white and gray monochromatic colors first to become aware of their contrast. Try applying white to an illustration that you have drawn only with black first. Then divide the grays into dark gray and light gray, and apply these four colors to your illustration.

If you only use black and white for an illustration, the contrast will be too great. By adding just a little dark gray and light gray, the black and white will become more harmonious, thus both will look more effective.

Q I want to start practicing drawing monochromatic illustrations. What methods do you recommend?

A Try drawing your backgrounds and characters with black, white and gray only. You'll learn how to create contrast.

By learning how to show an illustration with monochromatic colors, you can learn about the importance of contrast. If you apply monochromatic colors without being aware of differences in brightness, you'll end up with a lot of white. Even if you use a full-color palette to apply color, the whole image will contain pale colors and may look blurry, which means there isn't enough difference in brightness.

If you start by practicing lights and darks with monochromes, you'll be able to apply differences in brightness to your illustrations. Once you become skilled at applying monochromes, you'll be able to apply full color with contrast.

(We would like to thank Nippon Designer Gakuin and Nihon Kogakuin College for their cooperation with this section.)

How Colors Communicate Emotions

COLOR PSYCHOLOGY FOR COLORING CHARACTERS (PART TWO)

You can use color science when you want to express the feelings and mental state of a character and not just their physical appearance. In this chapter we will explain color schemes that conjure complex moods and emotional states.

01 How Colors Communicate Emotions

The impressions made by colors can be clues to communicating a range of emotions. To express the complex emotions a character is feeling, it's important to use a combination of colors rather than a single one.

Impressions and Associations Created with Colors

There are no rules for expressing emotions. If you know what each color commonly represents, you can use them as the basis for expressing the emotions of your characters. The illustration below attempts to chart the intersection of color and the more amorous feelings your characters might experience. In this chapter, we'll indicate small changes in emotion by subtly changing the color combinations.

The Color Impressions and Associations with Love (page 124) and Affection (page 126)

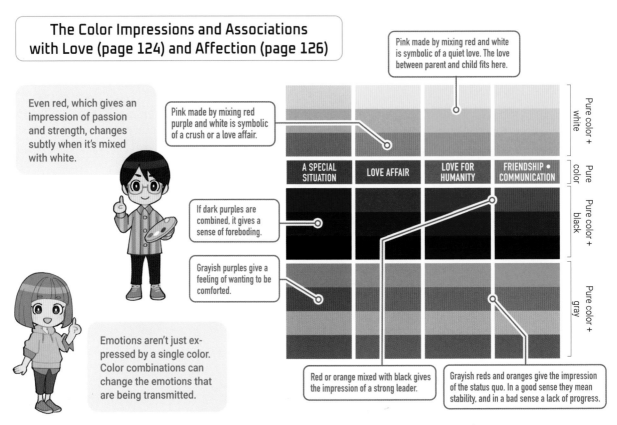

Pink made by mixing red and white is symbolic of a quiet love. The love between parent and child fits here.

Even red, which gives an impression of passion and strength, changes subtly when it's mixed with white.

Pink made by mixing red purple and white is symbolic of a crush or a love affair.

If dark purples are combined, it gives a sense of foreboding.

Grayish purples give a feeling of wanting to be comforted.

A SPECIAL SITUATION

LOVE AFFAIR

LOVE FOR HUMANITY

FRIENDSHIP • COMMUNICATION

Pure color + white

Pure color

Pure color + black

Pure color + gray

Emotions aren't just expressed by a single color. Color combinations can change the emotions that are being transmitted.

Red or orange mixed with black gives the impression of a strong leader.

Grayish reds and oranges give the impression of the status quo. In a good sense they mean stability, and in a bad sense a lack of progress.

※This color chart arranges the ones listed on page 148 to explain emotions and colors.

HOW TO USE THIS SECTION

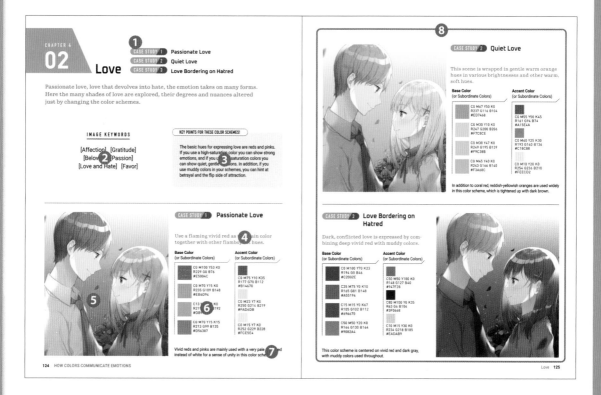

❶ The Emotional Theme
The emotion that the illustration wants to convey. The emotions love, affection, fun, joy, surprise, anger, sadness, fear, worry and fatigue are highlighted.

❷ Keywords for the Image
The keywords that are included in the emotional theme.

❸ Keys for the Color Scheme
The impressions made by the colors associated with the emotional theme are introduced, and some key points that will help you combine them are explained.

❹ An Example of the Emotion That the Illustration Wants to Convey
From the emotions associated with the emotional theme, this shows a specific emotion that can be used for a manga character.

❺ Example Illustration
An example illustration that uses the color scheme that goes with the theme.

❻ Color Palette
The colors used for the illustration that are recommended for the theme and their data values. They are divided into base color and accent color (see page 96).

❼ Explanation
Here we explain how colors can be used so that the illustration will fit the theme.

❽ Example of Another Color Scheme
An example of changing just the colors of the same illustration when you want to convey a different emotion.

※This part uses colors that are more subdivided than the PCCS introduced in this book. We use subdivided colors

02

Love

CASE STUDY 1 — Passionate Love

CASE STUDY 2 — Quiet Love

CASE STUDY 3 — Love Bordering on Hatred

Passionate love, love that devolves into hate, the emotion takes on many forms. Here the many shades of love are explored, their degrees and nuances altered just by changing the color schemes.

IMAGE KEYWORDS

[Affection] [Gratitude]
[Beloved] [Passion]
[Love and Hate] [Favor]

KEY POINTS FOR THESE COLOR SCHEMES!

The basic hues for expressing love are reds and pinks. If you use a high-saturation color you can show strong emotions, and if you use low-saturation colors you can show quiet, gentle emotions. In addition, if you use muddy colors in your schemes, you can hint at betrayal and the flip side of attraction.

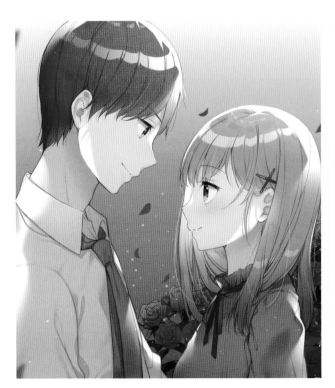

CASE STUDY 1 — **Passionate Love**

Use a flaming vivid red as the main color together with other flamboyant hues.

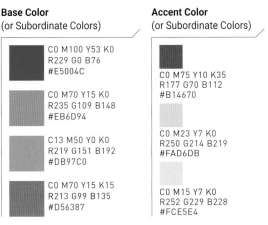

Base Color
(or Subordinate Colors)

C0 M100 Y53 K0
R229 G0 B76
#E5004C

C0 M70 Y15 K0
R235 G109 B148
#EB6D94

C13 M50 Y0 K0
R219 G151 B192
#DB97C0

C0 M70 Y15 K15
R213 G99 B135
#D56387

Accent Color
(or Subordinate Colors)

C0 M75 Y10 K35
R177 G70 B112
#B14670

C0 M23 Y7 K0
R250 G214 B219
#FAD6DB

C0 M15 Y7 K0
R252 G229 B228
#FCE5E4

Vivid reds and pinks are mainly used with a very pale pink used instead of white for a sense of unity in this color scheme.

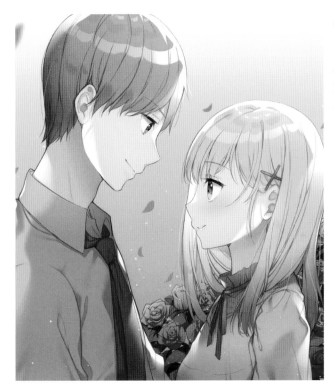

This scene is wrapped in gentle warm orange hues in various brightnesses and other warm, soft hues.

Base Color
(or Subordinate Colors)

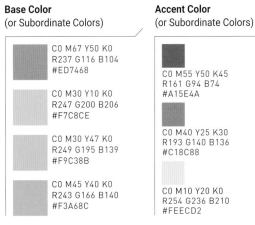

C0 M67 Y50 K0
R237 G116 B104
#ED7468

C0 M30 Y10 K0
R247 G200 B206
#F7C8CE

C0 M30 Y47 K0
R249 G195 B139
#F9C38B

C0 M45 Y40 K0
R243 G166 B140
#F3A68C

Accent Color
(or Subordinate Colors)

C0 M55 Y50 K45
R161 G94 B74
#A15E4A

C0 M40 Y25 K30
R193 G140 B136
#C18C88

C0 M10 Y20 K0
R254 G236 B210
#FEECD2

In addition to coral red, reddish-yellowish oranges are used widely in this color scheme, which is tightened up with dark brown.

CASE STUDY 3 · **Love Bordering on Hatred**

Dark, conflicted love is expressed by combining deep vivid red with muddy colors.

Base Color
(or Subordinate Colors)

C0 M100 Y70 K23
R194 G0 B46
#C2002E

C35 M75 Y0 K10
R165 G81 B148
#A55194

C15 M15 Y0 K67
R105 G102 B112
#696670

C50 M50 Y20 K0
R144 G130 B164
#9082A4

Accent Color
(or Subordinate Colors)

C50 M50 Y100 K0
R148 G127 B40
#947F28

C80 M100 Y0 K35
R63 G6 B104
#3F0668

C10 M15 Y30 K0
R234 G218 B185
#EADAB9

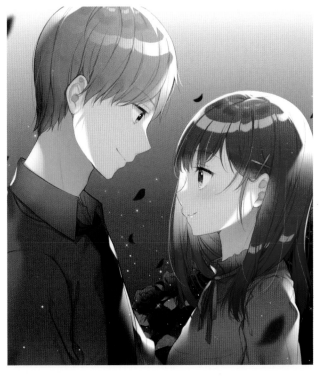

This color scheme is centered on vivid red and dark gray, with muddy colors used throughout.

03

Affection

CASE STUDY **1** Unrequited Love

CASE STUDY **2** The Night Before a Date

CASE STUDY **3** Heartbreak

Here the dawning of the first flickers of love are hinted at: a budding crush, a first date, the anticipation as love's vague future formulates. Vague feelings can be suggested and referenced with these color schemes.

IMAGE KEYWORDS

[Awakening of Love] [First love]
[Absorption] [Anticipation]
[Obsession]
[Sentiment] [Unrequited love]

KEY POINTS FOR THESE COLOR SCHEMES!

Here the palette is centered on pale colors. So the use of accent colors becomes key. For a bright prospect, use yellows or greens, but if the character has cause for concern, such as the existence of a rival, use dark, muddy colors as accents instead.

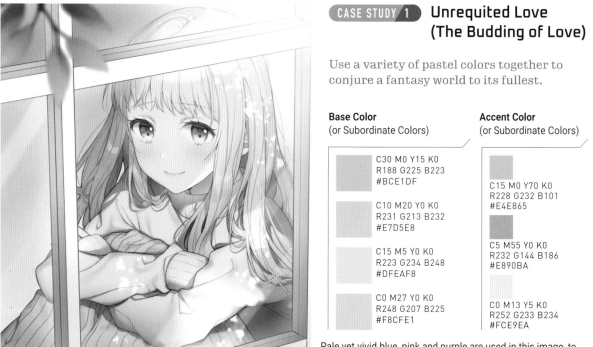

CASE STUDY **1** ## Unrequited Love (The Budding of Love)

Use a variety of pastel colors together to conjure a fantasy world to its fullest.

Base Color
(or Subordinate Colors)

C30 M0 Y15 K0
R188 G225 B223
#BCE1DF

C10 M20 Y0 K0
R231 G213 B232
#E7D5E8

C15 M5 Y0 K0
R223 G234 B248
#DFEAF8

C0 M27 Y0 K0
R248 G207 B225
#F8CFE1

Accent Color
(or Subordinate Colors)

C15 M0 Y70 K0
R228 G232 B101
#E4E865

C5 M55 Y0 K0
R232 G144 B186
#E890BA

C0 M13 Y5 K0
R252 G233 B234
#FCE9EA

Pale yet vivid blue, pink and purple are used in this image, to which a rather strong yellow-green is added.

The Night Before a Date (Anticipation and Nervousness)

Contrasting red and blue hues are used to express unsteady emotions.

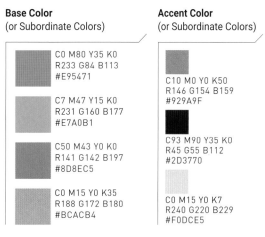

Base Color
(or Subordinate Colors)

	C0 M80 Y35 K0 R233 G84 B113 #E95471
	C7 M47 Y15 K0 R231 G160 B177 #E7A0B1
	C50 M43 Y0 K0 R141 G142 B197 #8D8EC5
	C0 M15 Y0 K35 R188 G172 B180 #BCACB4

Accent Color
(or Subordinate Colors)

	C10 M0 Y0 K50 R146 G154 B159 #929A9F
	C93 M90 Y35 K0 R45 G55 B112 #2D3770
	C0 M15 Y0 K7 R240 G220 B229 #F0DCE5

Dark and pale red and blue hues play a starring role in this color scheme. Gray and off-white are used to fill in the gaps.

Heartbreak (the Wavering Path of Love)

Gloomy emotions, from which there seems no escape, create a world view dominated by grayish colors.

Base Color
(or Subordinate Colors)

	C5 M20 Y3 K25 R199 G179 B190 #C7B3BE
	C15 M5 Y0 K45 R149 G157 B166 #959DA6
	C30 M45 Y10 K0 R188 G151 B184 #BC97B8
	C13 M7 Y0 K5 R220 G226 B239 #DCE2EF

Accent Color
(or Subordinate Colors)

	C27 M45 Y0 K40 R138 G108 B141 #8A6C8D
	C35 M0 Y0 K27 R140 G181 B202 #8CB5CA
	C7 M23 Y17 K0 R237 G208 B201 #EDD0C9

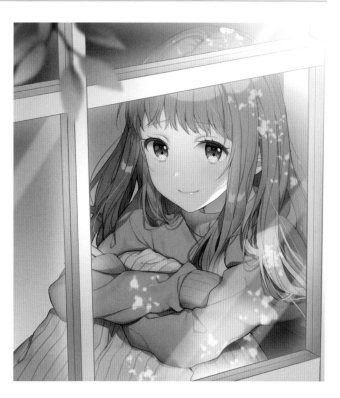

Various light and dark grays are combined with purple hues. The shadows are expressed rather darkly.

04

Fun

CASE STUDY 1 — Grooving to the Music
CASE STUDY 2 — A Good Time
CASE STUDY 3 — Making Everyone Laugh with a Joke

When depicting a fun scene or when exultation with colors, should you just use flashy colors? Actually not. How you construct the colors together becomes very important.

IMAGE KEYWORDS

[Fun] [Relaxed] [Exulted]
[Joy] [Laughter] [Smile]
[Humor] [Pleasure]

KEY POINTS FOR THESE COLOR SCHEMES!

The hard-and-fast rule is to use vivid or bright tones as the main color. If you use reds, blues, yellows, a variety of hues together, it gives the impression of a scene overflowing with activity, while if you use warm hues like reds and oranges, you can express an impression of heated excitement.

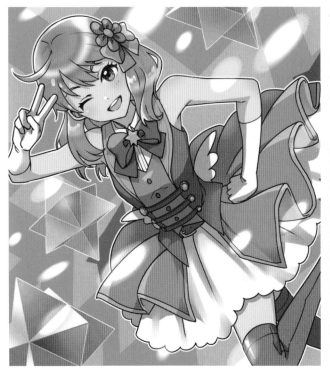

CASE STUDY 1 — Grooving to the Music

Use bright versions of the red, green and yellow hues of a traffic light to express a heightened sense of activity!

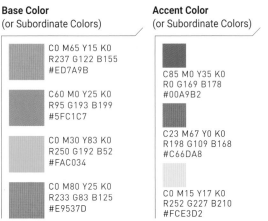

Base Color
(or Subordinate Colors)

C0 M65 Y15 K0
R237 G122 B155
#ED7A9B

C60 M0 Y25 K0
R95 G193 B199
#5FC1C7

C0 M30 Y83 K0
R250 G192 B52
#FAC034

C0 M80 Y25 K0
R233 G83 B125
#E9537D

Accent Color
(or Subordinate Colors)

C85 M0 Y35 K0
R0 G169 B178
#00A9B2

C23 M67 Y0 K0
R198 G109 B168
#C66DA8

C0 M15 Y17 K0
R252 G227 B210
#FCE3D2

The key to a bright, saturated multihued color scheme is to consciously use white for variety.

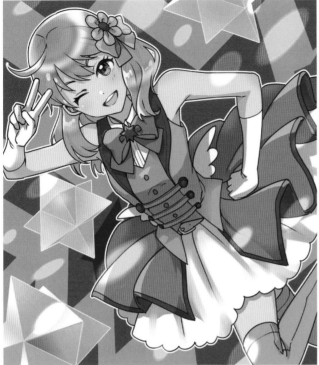

CASE STUDY 2 A Good Time (Having Fun with Friends)

A high-voltage, heated scene is expressed with a suffusion of warm colors.

Base Color
(or Subordinate Colors)

C0 M75 Y95 K0
R235 G97 B18
#EB6112

C0 M53 Y100 K0
R242 G145 B0
#F29100

C10 M100 Y50 K0
R215 G0 B81
#D70051

C0 M55 Y35 K0
R240 G144 B138
#F0908A

Accent Color
(or Subordinate Colors)

C10 M0 Y83 K0
R240 G234 B57
#F0EA39

C43 M0 Y95 K0
R162 G203 B39
#A2CB27

C0 M17 Y30 K0
R252 G222 B184
#FCDEB8

Red and orange hues star in this color scheme, with bright yellow thrown in as an accent color.

CASE STUDY 3 Making Everyone Laugh with a Joke

To express a changeable atmosphere, use the contrast hues of yellow and purple together dramatically.

Base Color
(or Subordinate Colors)

C0 M0 Y90 K10
R243 G226 B0
#F3E200

C45 M60 Y0 K0
R155 G114 B176
#9B72B0

C65 M0 Y60 K0
R84 G185 B131
#54B983

C13 M63 Y33 K0
R217 G122 B133
#D97A85

Accent Color
(or Subordinate Colors)

C0 M0 Y0 K55
R148 G148 B149
#949495

C0 M0 Y0 K20
R220 G221 B221
#DCDDDD

C0 M30 Y10 K0
R247 G200 B206
#F7C8CE

Yellow is used here to reflect the character's playful and bright personality, and her goofy behavior too.

Joy

CASE STUDY 1	On Top of the World
CASE STUDY 2	Meeting Up with a Best Friend
CASE STUDY 3	The Small Joys of Everyday Life

Now let's depict various states of joy with color schemes. The more vivid the color used, the stronger the emotion shown. A good rule to follow: the higher the saturation, the stronger the emotions being conveyed.

IMAGE KEYWORDS

[Delight] [Excitement] [Grateful]
[Trust] [Bond] [Happy]
[Satisfied] [Fulfilled]

KEY POINTS FOR THESE COLOR SCHEMES!

The key is to use bright, clear colors with a sense of transparency. For a feeling like one is on top of the world, use oranges and yellows that bring sunlight to mind. To suggest the joy of spending time with friends or family, use pinks associated with familial or friendly bonds or fresh blues as the stars. For everyday joyful moments, use pastel hues.

CASE STUDY 1 — On Top of the World

The color of light and celebration that makes it seem as if you can hear the character exclaiming, "I did it!"

Base Color
(or Subordinate Colors)

C0 M5 Y85 K0
R255 G235 B39
#FFEB27

C0 M5 Y27 K0
R255 G244 B201
#FFF4C9

C0 M35 Y87 K0
R248 G182 B37
#F8B625

C0 M65 Y100 K0
R238 G120 B0
#EE7800

Accent Color
(or Subordinate Colors)

C0 M5 Y7 K0
R254 G247 B239
#FEF7EF

C0 M95 Y60 K0
R231 G33 B71
#E72147

C0 M20 Y25 K0
R251 G217 B191
#FBD9BF

It's recommended to use oranges and yellows for most of the image, and to use vivid red sparingly.

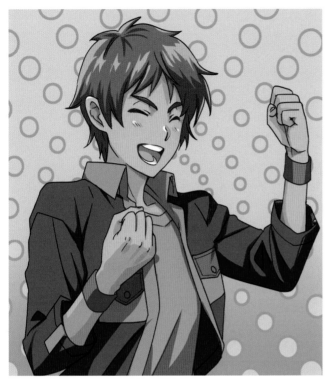

Meeting Up with a Best Friend

Use a transparent sky blue that brings to mind expansiveness and eternity as the background.

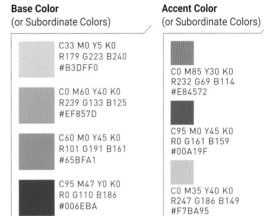

Base Color
(or Subordinate Colors)

C33 M0 Y5 K0
R179 G223 B240
#B3DFF0

C0 M60 Y40 K0
R239 G133 B125
#EF857D

C60 M0 Y45 K0
R101 G191 B161
#65BFA1

C95 M47 Y0 K0
R0 G110 B186
#006EBA

Accent Color
(or Subordinate Colors)

C0 M85 Y30 K0
R232 G69 B114
#E84572

C95 M0 Y45 K0
R0 G161 B159
#00A19F

C0 M35 Y40 K0
R247 G186 B149
#F7BA95

Light and dark versions of just three hues—blue, blue-green and pink—are used.

The Small Joys of Everyday Life

The keywords for beiges and coral pinks are stability and a sense of security.

Base Color
(or Subordinate Colors)

C15 M25 Y40 K0
R222 G196 B157
#DEC49D

C25 M10 Y60 K0
R204 G210 B124
#CCD27C

C0 M55 Y40 K0
R240 G144 B130
#F09082

C0 M20 Y60 K0
R252 G212 B117
#FCD475

Accent Color
(or Subordinate Colors)

C0 M43 Y60 K20
R211 G145 B90
#D3915A

C0 M0 Y0 K43
R175 G175 B176
#AFAFB0

C0 M30 Y55 K0
R249 G195 B123
#F9C37B

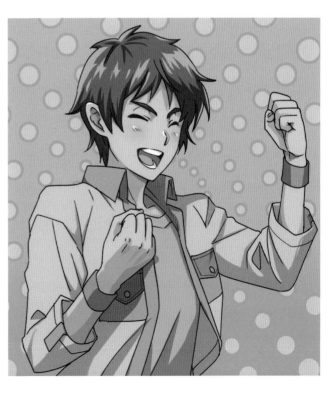

Use a warm pastel color scheme when you want to express precious feelings, enduring love and gentle joys.

06

Surprise

CASE STUDY 1	A Sudden Jolt
CASE STUDY 2	An Unexpected Pleasant Surprise
CASE STUDY 3	Encountering a Shocking Scene

Surprise comes in a variety of registers, some accompanied by joy or shock. Here we'll show you how to capture the nature of a character's surprise by subtly changing color combinations.

IMAGE KEYWORDS

[Astonishment] [Marvel] [Stunned]
[Ecstasy] [Wonderment]
[Stupefied] [Upset] [Shaken]

KEY POINTS FOR THESE COLOR SCHEMES!

Use contrasting hue combinations such as yellows with blues, greens with reds,] and reds with blues. Make one of the hues very dark or add in white or black to increase the brightness contrast. The whole image will consist of contrasting hues and brightnesses.

CASE STUDY 1 A Sudden Jolt

A strong impact, as if lightning has struck, is expressed by maximizing the brightness contrast.

Base Color
(or Subordinate Colors)

	C3 M0 Y0 K0 R250 G253 B255 #FAFDFF
	C0 M0 Y0 K60 R137 G137 B137 #898989
	C10 M10 Y100 K0 R238 G218 B0 #EEDA00
	C100 M100 Y0 K25 R22 G21 B115 #161573

Accent Color
(or Subordinate Colors)

	C30 M15 Y15 K0 R189 G203 B210 #BDCBD2
	C30 M25 Y20 K70 R83 G81 B84 #535154
	C0 M7 Y10 K0 R254 G243 B231 #FEF3E7

This is a color scheme where yellow, which is already a bright color, is used with dark blue for a contrasting brightness.

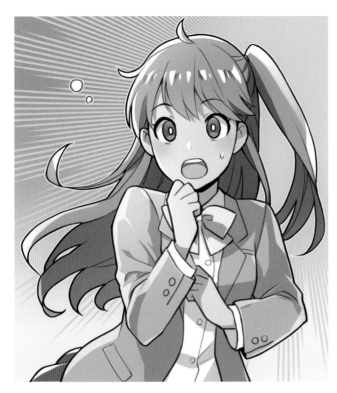

An Unexpected Pleasant Surprise

Surprise accompanied by joy is expressed with refreshing greens and yellows.

Base Color
(or Subordinate Colors)

C0 M0 Y100 K0
R255 G241 B0
#FFF100

C23 M0 Y100 K0
R212 G221 B0
#D4DD00

C53 M0 Y45 K0
R126 G198 B161
#7EC6A1

C7 M0 Y15 K0
R242 G247 B227
#F2F7E3

Accent Color
(or Subordinate Colors)

C0 M55 Y87 K0
R241 G142 B39
#F18E27

C0 M90 Y25 K0
R231 G50 B115
#E73273

C0 M15 Y27 K0
R252 G226 B192
#FCE2C0

A pleasant surprise (like a party) can be expressed with greens and yellows.

Encountering a Shocking Scene

A mind-blowing shock where one's brain stops functioning can only be expressed with an intense color scheme.

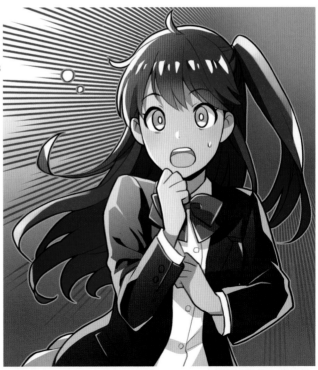

Base Color
(or Subordinate Colors)

C100 M23 Y0 K40
R0 G99 B154
#00639A

C0 M0 Y0 K100
R35 G24 B21
#231815

C0 M100 Y40 K33
R176 G0 B68
#B00044

C0 M0 Y0 K75
R102 G100 B100
#666464

Accent Color
(or Subordinate Colors)

C0 M0 Y0 K3
R251 G251 B251
#FBFBFB

C0 M0 Y0 K43
R175 G175 B176
#AFAFB0

C5 M20 Y33 K0
R242 G213 B175
#F2D5AF

A red-hued background with a blue-hued character is effective too. Use strong blacks or dark grays.

07

Anger

It's a shame to just assign red to the emotion of rage. A lot of a character's emotions can be expressed with a nuanced color scheme. The key is to use dark, muddy versions of red hues.

IMAGE KEYWORDS

[Frustration] [Dissatisfaction]
[Indignation] [Exasperation]
[Rage] [Fury] [Frenzy]

KEY POINTS FOR THESE COLOR SCHEMES!

To suggest a character's irriration or anger, use low-saturation muddy colors. For strong explosive rage, vivid red can be used, but if you use it in a limited area in contrast to dark, muddy reds, it is more effective.

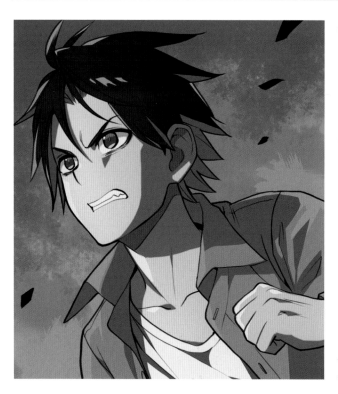

CASE STUDY **1** Irritation

Distressing emotions are expressed with a contrasting grayish color scheme, and the emotion of anger is concentrated in the eyes.

Base Color
(or Subordinate Colors)

C0 M25 Y13 K50
R156 G130 B130
#9C8282

C20 M15 Y0 K45
R140 G143 B158
#8C8F9E

C23 M45 Y45 K0
R203 G153 B131
#CB9983

C50 M15 Y0 K57
R71 G105 B131
#476983

Accent Color
(or Subordinate Colors)

C0 M90 Y70 K37
R171 G35 B40
#AB2328

C0 M15 Y0 K90
R63 G50 B53
#3F3235

C0 M23 Y7 K10
R234 G200 B206
#EAC8CE

This is a color scheme where a dark blue gray is the main color, contrasted with a muddy pink beige.

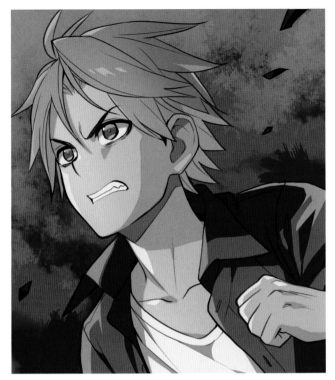

A situation where the character is desperately suppressing his anger is expressed with mid- to low-saturation reds and grays.

Base Color
(or Subordinate Colors)

	C15 M80 Y50 K30 R167 G62 B74 #A73E4A
	C45 M60 Y40 K30 R124 G89 B100 #7C5964
	C10 M85 Y5 K80 R79 G0 B43 #4F002B
	C37 M45 Y17 K0 R173 G147 B174 #AD93AE

Accent Color
(or Subordinate Colors)

	C0 M0 Y0 K75 R102 G100 B100 #666464
	C0 M0 Y0 K47 R166 G166 B167 #A6A6A7
	C0 M35 Y13 K10 R230 G177 B184 #E6B1B8

By centering the color scheme on an array of reds combined with light gray, anger that's yet to explode is suggested.

CASE STUDY 3 **Uncontrollable Fury**

A strong muddy red is used as the main color together with vivid red and black to express an explosive rage.

Base Color
(or Subordinate Colors)

	C0 M100 Y100 K17 R204 G0 B13 #CC000D
	C0 M50 Y50 K95 R46 G10 B0 #2E0A00
	C20 M100 Y27 K55 R118 G0 B58 #76003A
	C53 M70 Y0 K40 R99 G61 B118 #633D76

Accent Color
(or Subordinate Colors)

	C0 M37 Y100 K27 R201 G144 B0 #C99000
	C55 M20 Y0 K60 R59 G93 B122 #3B5D7A
	C15 M33 Y20 K0 R220 G183 B185 #DCB7B9

Although the main colors are red hues, the hair is a blue gray and the eyes are gold, making this a red, blue and yellow color scheme.

08

Sadness

CASE STUDY 1 — **Painful Melancholy**

CASE STUDY 2 — **Deep Shock and Sorrow**

CASE STUDY 3 — **Disappointment and Lethargy**

Sadness wears many faces. The right color scheme brings clarity and precision to the moody moments and gray states you're summoning in your illustrations.

IMAGE KEYWORDS

[Melancholy] [Loneliness]
[Disappointment] [Depressed]
[Despondent] [Discouraged]
[Despair] [Gloom]

KEY POINTS FOR THESE COLOR SCHEMES!

Gray and blue hues are mainly used for the nuances of this emotion. Think of brightness as an indication of the intensity of the situation; the darker the image the deeper the sadness. This applies to other emotions too, but for sadness the color of the skin is important. If the character is in a lethargic state, it's effective to use a colorless, muddy skin color.

CASE STUDY 1 — **Painful Melancholy**

The emotion of empty sadness is expressed with low-saturation blue-grays.

Base Color
(or Subordinate Colors)

C30 M0 Y5 K23
R157 G191 B204
#9DBFCC

C10 M3 Y0 K5
R227 G235 B243
#E3EBF3

C20 M2 Y0 K5
R205 G228 B242
#CDE4F2

C35 M20 Y0 K30
R138 G152 B180
#8A98B4

Accent Color
(or Subordinate Colors)

C70 M45 Y10 K30
R67 G99 B144
#436390

C35 M15 Y0 K65
R84 G98 B115
#546273

C0 M10 Y3 K0
R253 G238 B241
#FDEEF1

Use dark blue-gray or navy for a color scheme that is centered on blue-grays.

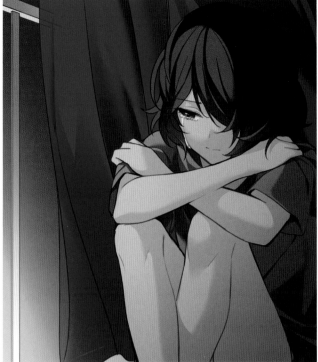

Deep Shock and Sorrow

Use accent colors that suggest or hint at the reason for the shock or sorrow.

Base Color
(or Subordinate Colors)

C87 M50 Y25 K70
R0 G44 B70
#002C46

C100 M40 Y35 K15
R0 G106 B135
#006A87

C33 M0 Y0 K60
R94 G121 B134
#5E7986

C85 M47 Y50 K17
R21 G102 B109
#15666D

Accent Color
(or Subordinate Colors)

C10 M60 Y0 K35
R167 G96 B135
#A76087

C17 M83 Y0 K35
R156 G48 B112
#9C3070

C0 M20 Y3 K10
R234 G206 B215
#EACED7

This color scheme is based on dark blues, which express a deep sorrow. Red, which brings to mind an incident or accident, is also included.

Disappointment and Lethargy

A moody mind shrouded in darkness is expressed by contrasting monochromatic white and black.

Base Color
(or Subordinate Colors)

C7 M0 Y0 K0
R241 G249 B254
#F1F9FE

C13 M0 Y0 K45
R152 G163 B170
#98A3AA

C20 M0 Y0 K90
R48 G54 B58
#30363A

C35 M13 Y5 K10
R164 G190 B213
#A4BED5

Accent Color
(or Subordinate Colors)

C100 M5 Y20 K35
R0 G119 B152
#007798

C50 M30 Y0 K65
R64 G78 B106
#404E6A

C5 M13 Y17 K0
R243 G227 B212
#F3E3D4

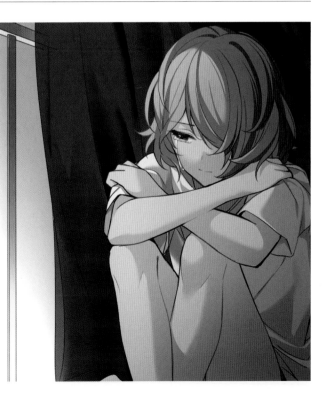

Use monochromatic white and black to express the depth of the darkness. This is a dark scene where the future cannot be contemplated.

Fear

CASE STUDY **1** — Timid Due to Anxiety or Pressure

CASE STUDY **2** — Terrifying and Spine Chilling

CASE STUDY **3** — Under Intense Pressure

An emotion that is difficult to express with colors is fear. Use the color schemes introduced here and arrange them in your own way. If the cause of the terror or misgivings is abstract or otherworldly, a subtler color scheme is called for.

IMAGE KEYWORDS

[Cowardice] [Misgivings]
[Atrophy] [Terror] [Shock]
[Pressure] [Timid] [Anxiety]

KEY POINTS FOR THESE COLOR SCHEMES!

If you use a lot of colors you can express the chaos and irrationality of fear. In contrast, if you choose contrasting colors, you can suggest a conflicted anxiety. Terror is expressed by contrasting brightness rather than hues.

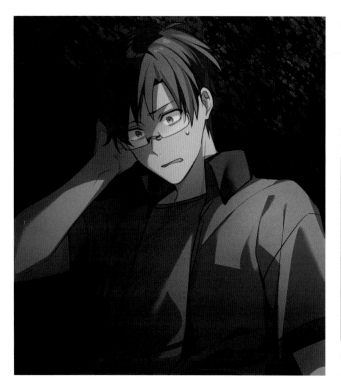

CASE STUDY **1** — **Timid Due to Anxiety or Pressure**

Express unresolved, conflicted feelings and anxieties with dark grayish colors.

Base Color
(or Subordinate Colors)

C40 M13 Y0 K60
R84 G107 B127
#546B7F

C40 M43 Y15 K55
R96 G84 B105
#605469

C15 M0 Y35 K67
R106 G111 B86
#6A6F56

C0 M5 Y40 K55
R148 G140 B99
#948C63

Accent Color
(or Subordinate Colors)

C57 M25 Y0 K15
R104 G149 B196
#6895C4

C25 M0 Y53 K80
R69 G78 B44
#454E2C

C10 M25 Y30 K0
R231 G200 B176
#E7C8B0

This color scheme consisting of several dark grayish colors conjuring confusion.

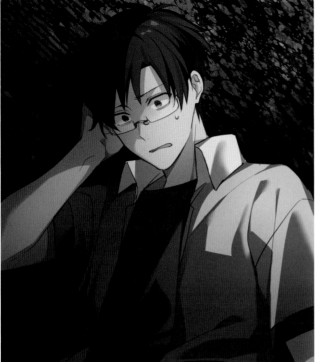

Terrifying and Spine Chilling

To express the depths of blind terror, use contrasting brightnesses.

Base Color
(or Subordinate Colors)

C65 M40 Y25 K63
R45 G67 B85
#2D4355

C65 M33 Y15 K40
R65 G105 B134
#416986

C70 M33 Y0 K80
R4 G44 B74
#042C4A

C30 M0 Y0 K23
R157 G192 B210
#9DC0D2

Accent Color
(or Subordinate Colors)

C7 M7 Y0 K0
R240 G238 B247
#F0EEF7

C0 M0 Y0 K100
R35 G24 B21
#231815

C3 M15 Y3 K10
R231 G213 B220
#E7D5DC

The key is to contrast the darkness with the pallid skin tone of the character. You could use dark violet here too.

Under Intense Pressure

Use contrasting hues to express the emotional ups and downs of the character.

Base Color
(or Subordinate Colors)

C35 M87 Y70 K50
R111 G32 B37
#6F2025

C0 M30 Y0 K70
R111 G87 B98
#6F5762

C63 M10 Y0 K55
R39 G106 B137
#276A89

C75 M50 Y0 K70
R20 G45 B85
#142D55

Accent Color
(or Subordinate Colors)

C0 M10 Y0 K35
R189 G179 B185
#BDB3B9

C50 M33 Y20 K0
R141 G158 B181
#8D9EB5

C0 M13 Y15 K23
R212 G195 B183
#D4C3B7

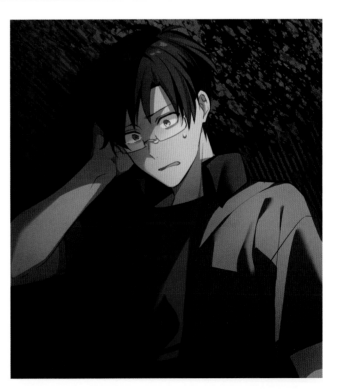

Here we've used red and blue hues, but you can use other tones as long as they're contrasting (see page 23).

10 Worry

CASE STUDY **1** Worrying About Many Things

CASE STUDY **2** An Enduring Worry

CASE STUDY **3** An Inexpressible Worry

It is difficult to discern how much a problem is worrying a person; often even the person can't accurately assess or articulate it. Still, let's take up the challenge and apply color to conveying this complex emotion.

IMAGE KEYWORDS

[Concern] [Bewilderment] [Conflict]
[Ambivalence] [Gloom] [Distress]
[Bitterness] [Secret]

KEY POINTS FOR THESE COLOR SCHEMES!

To capture a pervasive sense of worry, make the whole image a light gray. For more serious situations, not only should you lower the brightness, but it's also effective to make the hues more blue or violet. For a lingering or enduring worry, use a dull, leaden color.

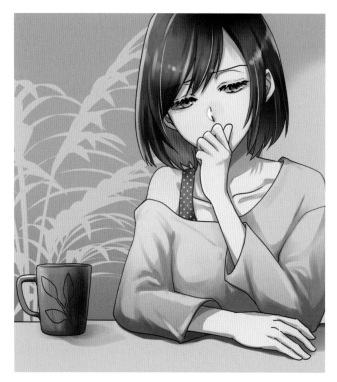

CASE STUDY **1** **Worrying About Many Things**

Express vague, gloomy feelings with light grayish colors.

Base Color
(or Subordinate Colors)

C20 M3 Y10 K5
R206 G225 B225
#CEE1E1

C10 M5 Y25 K5
R229 G229 B198
#E5E5C6

C13 M13 Y5 K5
R220 G216 B225
#DCD8E1

C15 M0 Y5 K30
R176 G191 B193
#B0BFC1

Accent Color
(or Subordinate Colors)

C10 M57 Y0 K15
R201 G123 B165
#C97BA5

C0 M0 Y0 K55
R148 G148 B149
#949495

C0 M15 Y7 K0
R252 G229 B228
#FCE5E4

A uniform color scheme without much contrast is just about right, but use accent colors in small amounts.

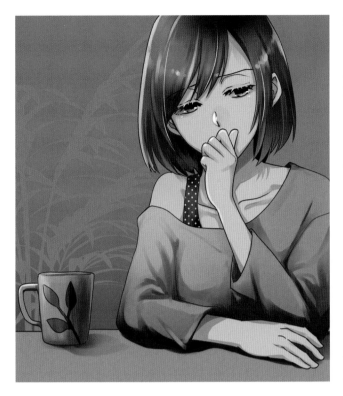

A worry that isn't resolved even with the passing of time is expressed with dull, muddy colors.

Base Color
(or Subordinate Colors)

	C0 M0 Y25 K47 R166 G163 B136 #A6A388
	C35 M10 Y10 K30 R138 G164 B176 #8AA4B0
	C45 M0 Y0 K40 R100 G151 B175 #6497AF
	C0 M17 Y60 K50 R157 G135 B72 #9D8748

Accent Color
(or Subordinate Colors)

	C35 M0 Y35 K65 R84 G107 B90 #546B5A
	C90 M65 Y30 K0 R22 G89 B135 #165987
	C0 M15 Y10 K13 R230 G209 B205 #E6D1CD

An incident that happened last year is still bothering the character even after all this time. Express this symbolically with dull blues and yellows.

Bring the darker colors to the bottom of the page to express the depth of the worry.

Base Color
(or Subordinate Colors)

	C85 M15 Y23 K65 R0 G76 B95 #004C5F
	C100 M45 Y55 K0 R0 G111 B118 #006F76
	C45 M25 Y10 K40 R107 G125 B147 #6B7D93
	C40 M25 Y0 K0 R163 G180 B220 #A3B4DC

Accent Color
(or Subordinate Colors)

	C67 M80 Y0 K40 R78 G43 B110 #4E2B6E
	C100 M45 Y55 K77 R0 G36 B41 #002429
	C5 M10 Y3 K0 R244 G234 B240 #F4EAF0

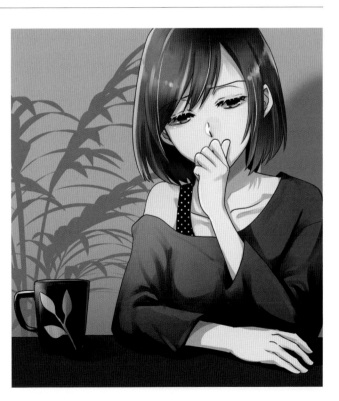

By concentrating the dark colors at the bottom of the image, you can express a heavy spirit that cannot be easily lifted.

11

Fatigue

CASE STUDY 1 Listless

CASE STUDY 2 Emotional Exhaustion

CASE STUDY 3 After-Workout Fatigue

You can express and suggest fatigue with a range color schemes. We unconsciously use colors as communication tools, so harness their power. Is it a spiritual fatigue or a physical exhaustion? Draw distinctions in your palette and choices.

IMAGE KEYWORDS

[Willpower] [Physical Strength]
[Laziness] [Weariness] [Overworked]
[Exhaustion]

KEY POINTS FOR THESE COLOR SCHEMES!

Lower or adjust the brightness to match or reflect the degree of fatigue. If you use a vivid color over a large area, tone down the saturation as much as possible. In contrast, when you're expressing fatigue in a sports-themed scene, use vivid colors.

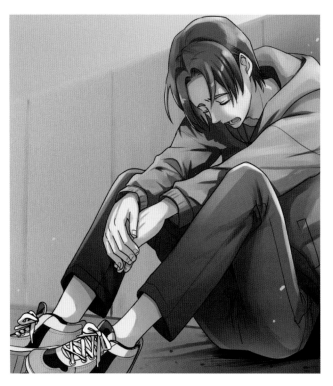

CASE STUDY 1 **Listless**

By just combining nuanced grays, you can express a sense of listlessness.

Base Color
(or Subordinate Colors)

C0 M0 Y15 K33
R195 G194 B176
#C3C2B0

C5 M10 Y10 K45
R163 G156 B153
#A39C99

C10 M3 Y3 K23
R197 G204 B208
#C5CCD0

C25 M10 Y15 K20
R173 G187 B187
#ADBBBB

Accent Color
(or Subordinate Colors)

C25 M20 Y30 K65
R98 G96 B87
#626057

C53 M40 Y50 K85
R33 G34 B28
#21221C

C0 M10 Y3 K0
R253 G238 B241
#FDEEF1

The key here is to make the background lighter and the character colored on the darker side.

Emotional Exhaustion

By making a dark color the base, you can create an atmosphere where a heavy mood predominates.

Base Color
(or Subordinate Colors)

C43 M30 Y33 K0
R160 G167 B164
#A0A7A4

C30 M33 Y45 K50
R118 G106 B87
#766A57

C20 M0 Y40 K80
R73 G79 B56
#494F38

C30 M20 Y0 K45
R125 G131 B154
#7D839A

Accent Color
(or Subordinate Colors)

C20 M0 Y0 K20
R183 G205 B218
#B7CDDA

C17 M0 Y0 K85
R63 G69 B73
#3F4549

C0 M13 Y3 K10
R236 G218 B223
#ECDADF

If you make the background and the character the same brightness, you can create the impression that the character is receding into a dark, personal space.

After-Workout Fatigue

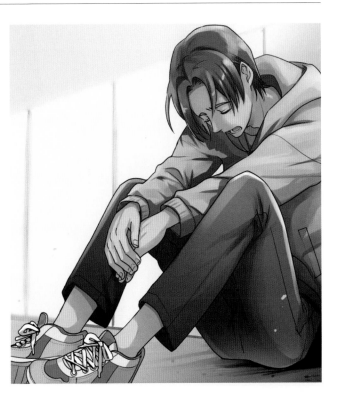

Add vivid colors to highlight the sense of activity and the more casual setting.

Base Color
(or Subordinate Colors)

C27 M3 Y10 K7
R187 G216 B221
#BBD8DD

C23 M10 Y20 K0
R206 G217 B207
#CED9CF

C3 M0 Y10 K0
R250 G251 B237
#FAFBED

C67 M63 Y60 K10
R101 G94 B92
#655E5C

Accent Color
(or Subordinate Colors)

C70 M43 Y0 K0
R83 G129 B194
#5381C2

C87 M0 Y70 K0
R0 G164 B114
#00A472

C0 M20 Y23 K0
R251 G217 B194
#FBD9C2

Use brighter and lighter colors here and hues for the body that indicate it's physical fatigue, a temporary lull.

COLOR COMBINATION TECHNIQUES

Highlights and Shadows

When considering color schemes, pair similar colors or hues for a sense of unity and differing colors or contrasting hues to add impact. When the colors are unified, the illustration is infused with a quiet sense of security; when they're not unified, a sense of movement and impact is highlighted. Choosing between these two modes is the first step to deciding on a color scheme. Highlights and shadows add to the options as you refine your illustration.

HAIR COLOR	C37 M54 Y100 K0 R182 G129 B18 #b68112

CLOTHING COLOR	lt22+

If you're mainly using red-purple hues, the contrasting colors are in the yellow, yellow-green and blue-green range.

When using similar hues

Tone

W · p+ · lt+ · b
ltGy · ltg · sf
mGy · g · d · s · v
dkGy · dkg · dk · dp
Bk

When using contrast hues

Hue

8 · 12 · 14 · 22

If you use similar hues with different degrees of brightness, a gentler impression is made.

HAIR HIGHLIGHTS	p22+
CLOTHING HIGHLIGHTS	p22+
HAIR SHADOWS	d22
CLOTHING SHADOWS	g22 ltg22

An example of using a red-purple hue throughout, changing just the brightness to color highlights and shadows.

Using contrasting hues makes an impact.

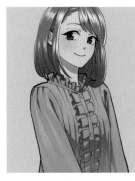

HAIR HIGHLIGHTS	p8+
CLOTHING HIGHLIGHTS	p22+
HAIR SHADOWS	d14
CLOTHING SHADOWS	g12 ltg12

An example of using contrast hues for the highlights and shadows. By offsetting the base hue, a sense of movement is created.

※The same hue has been used for the clothing highlights in both illustrations to show that the base color looks brighter when the light hits it.

Q & A #4:
Problems with Applying Color

 Q I have trouble deciding on the colors for my characters' clothing. Do you have any tips?

 A What material is the clothing made of?
The color of clothing changes depending on the fabrics used, right?

A lot of people get stuck on a single look or approach to their characters' fashion: a white T-shirt, for example. To break bad fashion habits, focus on the materials used for the clothing. A shirt is a shirt, but try to imagine how the color would change if the material changed also. Another method is to try applying color that is of a tone opposite to what you imagined. Break out of the assumptions you hold about color, and have fun with your experiments.

 Q When I start applying colors, everything ends up flat, and I can only use a few of them. What should I do?

 A If you tend to create images with a few colors, try being using a three-color combination and the nuances of shadow.

When you don't know how to apply multiple colors to clothing, start with the base color, then the pale color, the dark color, finally adding shadows. Be aware of the light souce and the shades of the colors you're using, to avoid giving the piece an impression of flatness.

If you want to increase the number of colors used, try increasing as well the items of clothing the character's wearing. If you aren't good at adding colors to garments, you can try putting a pattern on the clothing to increase the color scheme and visual complexity.

Q I find it difficult to create wrinkles on clothing. Do you have any tips?

A

Practice putting shadows onto a plain white shirt. Then mix in colors other than gray.

To put wrinkles on clothing skillfully, it's necessary to correctly understand how shadows are created and how objects are formed in three dimensions. If you practice drawing wrinkles, you can naturally learn about how shadows are created.

Try practicing applying shadows to a white shirt in order to create wrinkles. If you only use gray for this, you'll give the shirt a flatter impression.

So try mixing pinks, purples and blues into the shadows. Colors that are applied to shadows are called hidden colors. Adding hidden colors enriches the color scheme of the entire illustration.

Apply color while thinking about what highlight hues you can use, other than gray.

Q My characters blend into their backgrounds and don't stand out. Help!!

A

By adding hidden colors to the shadows of the clothing, you can differentiate the character and background.

By adding hidden colors to the shadows of the clothing, you can make your character stand out.

To deepen your understanding of hidden colors, try practicing with just two colors, red and black. If you use a yellowish red, you'll create a warm impression, while a blueish red creates a cooler impression.

Even if you use the same red, the impression it gives changes depending on its brightness or saturation, so use hidden colors judiciously depending on what kind of image you want to create.

(We would like to thank Nippon Designer Gakuin and Nihon Kogakuin College for their cooperation with this section.)

World Views Created Through Color

PRACTICE CATALOG

From the real world to the fantasy world, in this chapter
we look more closely at the palettes meant to highlight
and harmonize with fantasy or futuristic worlds.
We've seen the future, and it's in color!

HOW TO USE THIS SECTION

The Theme of the Illustration
The world view that the illustration wants to capture or suggest.

Example illustration
An example of an illustration that shows this world view.

It's effective to use colors that fit the theme and match the particular world view!

Color Palette
The colors used for the illustration that are recommended for the theme and their data values.

Color Chart
A chart that explains where the colors that fit this theme are on the PCCS (page 16) hue and tone (page 13) system. See below for more.

Explanation
An explanation of how the colors should be used to create an illustration that fits the theme.

HOW TO LOOK AT THE COLOR CHARTS

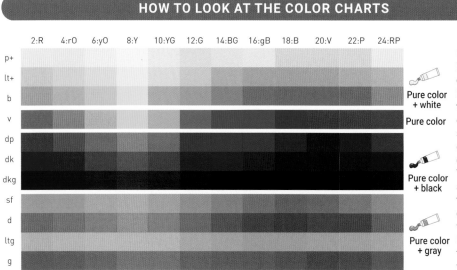

	2:R	4:rO	6:yO	8:Y	10:YG	12:G	14:BG	16:gB	18:B	20:V	22:P	24:RP
p+												
lt+												
b												
v												
dp												
dk												
dkg												
sf												
d												
ltg												
g												

Pure color + white

Pure color

Pure color + black

Pure color + gray

If you understand how the numerous colors used in the illustration are positioned on the color chart, you can better see how to combine complementary color schemes. Vivid colors without anything mixed into them are called pure colors; pure colors with white mixed into them are called tints; pure colors with black mixed in are called shades; and pure colors plus gray are called intermediate colors.

※ The horizontal axis of the chart shows the PCCS (page 16) hue numbers, and the vertical axis shows the abbreviations for the tones.
※ Since achromatic hues (white, black, gray) are used appropriately in illustrations, they are not indicated on this chart.
※ Since s (strong) are similar to v (vivid) tones, they are not indicated on this chart.

※ In order to express the world view realistically, the colors in the color palette are more subdivided than PCCS, but the color chart shows the color connection.
　PCCS Similar to the colors used, PCCS hues/tones have been replaced.

1

Seasonal Scenes and Palettes

As the seasons change, so do the color schemes that represent and suggest them. Soft and sun-kissed, bold and bright, it's time for a color-filled trip through the year.

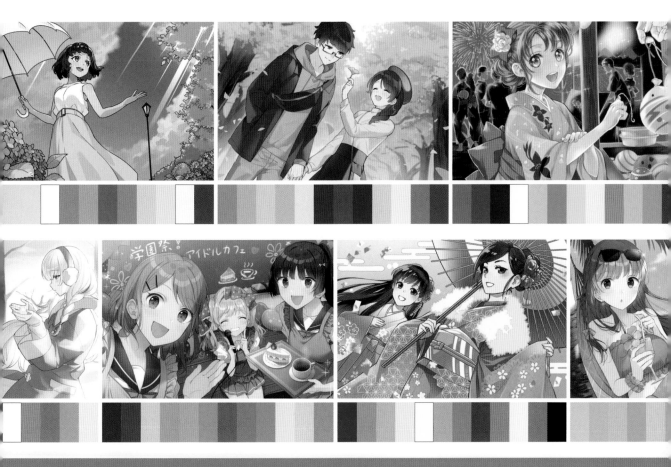

Easter (Springtime)

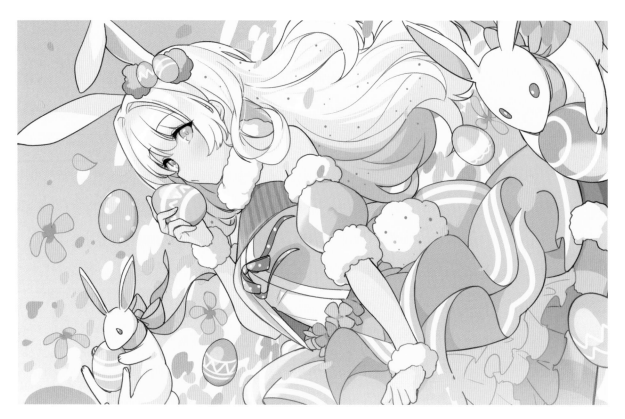

C33 M0 Y40 K0 R184 G219 B173 #B8DBAD	C15 M35 Y0 K0 R218 G181 B212 #DAB5D4
C15 M0 Y53 K0 R228 G234 B145 #E4EA91	C60 M0 Y40 K0 R100 G192 B171 #64C0AB
C0 M0 Y15 K0 R255 G253 B229 #FFFDE5	C0 M15 Y17 K0 R252 G228 B211 #FCE4D3

C35 M0 Y7 K0 R175 G221 B236 #AFDDEC	C0 M65 Y30 K0 R237 G121 B134 #ED7986
C0 M20 Y60 K0 R252 G212 B117 #FCD475	C0 M27 Y15 K0 R248 G205 B201 #F8CDC9
C20 M47 Y47 K0 R208 G151 B126 #D0977E	C0 M25 Y37 K15 R225 G186 B148 #E1BA94

Keys to This Color Scheme!

The coming of spring is expressed using a bright, colorful color palette. The key is to avoid using dark colors and to scatter around as many hues as possible in a well-balanced, cohesive way. If you use black or dark gray, that section can predominate and ruin the ambience, so use a soft brown hue as the accent color to bring a sense of movement and dynamism to the illustration.

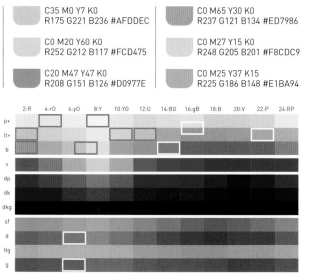

※The outlines of the colors used are gray or white depending on which one makes the color easier to see.

SPRING

Cherry Blossom Season

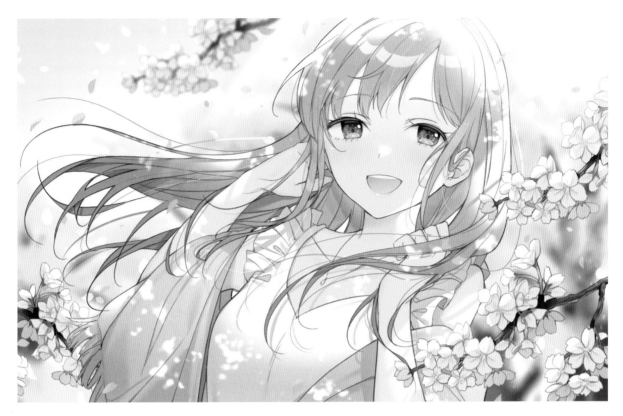

C0 M15 Y0 K0 R251 G230 B239 #FBE6EF	C0 M25 Y0 K0 R249 G211 B227 #F9D3E3
C10 M15 Y10 K0 R232 G221 B221 #E8DDDD	C0 M5 Y0 K30 R200 G195 B198 #C8C3C6
C0 M0 Y5 K0 R255 G254 B247 #FFFEF7	C0 M15 Y3 K0 R252 G230 B235 #FCE6EB

C7 M37 Y10 K0 R233 G181 B197 #E9B5C5	C23 M0 Y0 K0 R204 G234 B251 #CCEAFB
C35 M40 Y53 K0 R180 G155 B122 #B49B7A	C15 M0 Y0 K50 R139 G151 B158 #8B979E
C73 M80 Y100 K0 R99 G74 B50 #634A32	C50 M50 Y43 K0 R145 G129 B130 #918182

Keys to This Color Scheme!

A delicate color scheme centered on the pale pink of cherry blossoms. The key here is to differentiate the grays used for the character's hair and eyes. The gray used for the hair is light and has a lot of red in it, so it seems to blend in with the cherry blossoms. In contrast, the gray used for the eyes is dark and has a lot of blue in it. Not only does it give a sense of dignified beauty, it links the character's eyes to the color of the sky, giving a sense of cohesion to the entire illustration.

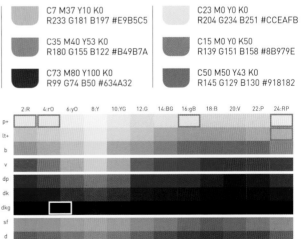

SPRING

Staying Home on a Rainy Day

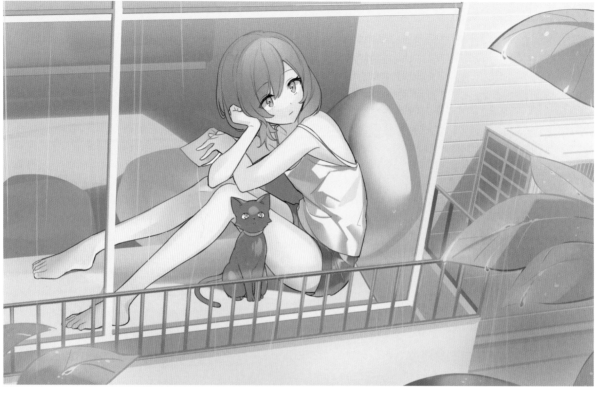

	C35 M30 Y0 K17 R157 G156 B191 #9D9CBF		C65 M40 Y0 K13 R90 G125 B182 #5A7DB6		C30 M0 Y15 K27 R152 G184 B182 #98B8B6		C13 M20 Y50 K0 R228 G205 B140 #E4CD8C
	C33 M17 Y0 K0 R180 G199 B231 #B4C7E7		C25 M37 Y15 K0 R199 G169 B187 #C7A9BB		C15 M0 Y15 K10 R210 G225 B212 #D2E1D4		C13 M10 Y0 K0 R227 G227 B242 #E3E3F2
	C10 M0 Y0 K30 R184 G194 B200 #B8C2C8		C13 M0 Y0 K55 R132 G142 B148 #848E94		C5 M13 Y13 K0 R243 G228 B219 #F3E4DB		C10 M0 Y0 K0 R234 G246 B253 #EAF6FD

Keys to This Color Scheme!

This color scheme has two features. One is that most of the colors used are grayish. The other is that no matter how the colors are combined, there are no major or significant light-dark contrasts. Thus everything comes together softly. Although grayish colors give the impression of being plain and dark, the ones used here are bright grayish colors with little muddiness to them.

SPRING

An Afternoon After the Rain

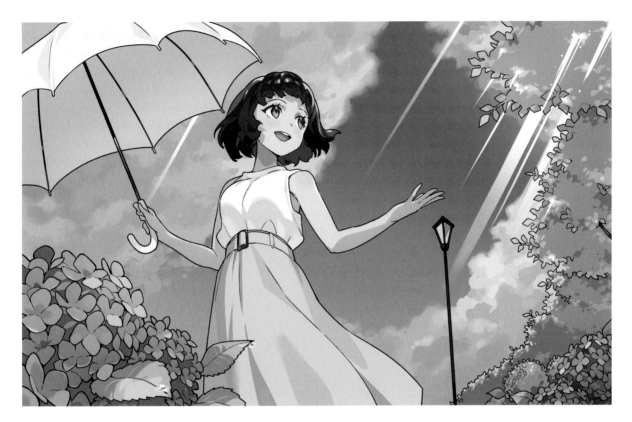

C35 M3 Y15 K0 R176 G217 B220 #B0D9DC	C25 M3 Y0 K0 R199 G228 B247 #C7E4F7	C15 M0 Y25 K0 R226 G239 B206 #E2EFCE	C0 M0 Y0 K0 R255 G255 B255 #FFFFFF
C30 M57 Y0 K0 R186 G127 B181 #BA7FB5	C35 M35 Y0 K0 R177 G167 B209 #B1A7D1	C70 M53 Y0 K0 R91 G114 B182 #5B72B6	C57 M35 Y0 K0 R120 G150 B205 #7896CD
C20 M13 Y0 K0 R210 G217 B238 #D2D9EE	C0 M17 Y15 K0 R251 G224 B212 #FBE0D4	C0 M5 Y0 K0 R254 G247 B250 #FEF7FA	C0 M0 Y0 K83 R81 G78 B78 #514E4E

Keys to This Color Scheme!

If you compare this palette to the one on the previous page, even though the distribution of hues is similar, the tones are very different. To express the bright, refreshing feeling after the rain has stopped, bright, clear colors are used. The key here is to not use muddy blues or greens. Try using dark brown as an accent color.

Fishing for Water Balloons at a Summer Festival

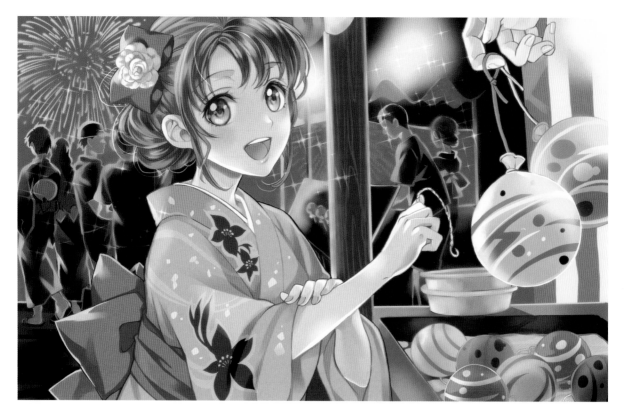

C80 M40 Y0 K0 R24 G127 B196 #187FC4	C85 M50 Y0 K25 R0 G91 B154 #005B9A	C85 M37 Y0 K75 R0 G46 B83 #002E53	C0 M0 Y5 K0 R255 G254 B247 #FFFEF7
C40 M0 Y10 K0 R161 G216 B230 #A1D8E6	C70 M0 Y55 K0 R56 G181 B141 #38B58D	C0 M13 Y70 K0 R255 G224 B95 #FFE05F	C0 M10 Y8 K0 R253 G237 B232 #FDEDE8
C0 M83 Y50 K0 R233 G76 B91 #E94C5B	C3 M45 Y0 K0 R238 G167 B200 #EEA7C8	C0 M45 Y35 K20 R211 G144 B129 #D39081	C0 M10 Y10 K85 R76 G66 B63 #4C423F

Keys to This Color Scheme!

This color palette conjures a lively scene on a midsummer night. At first glance, it may look like a variety of vivid colors were gathered together, but the background has been integrated with dark and light blues, and the people in the background and the main character are unified with red and pinks. Yellow serves the purpose of an accent color, to show the spreading light, as does green, which draws the viewer's eye to the right front.

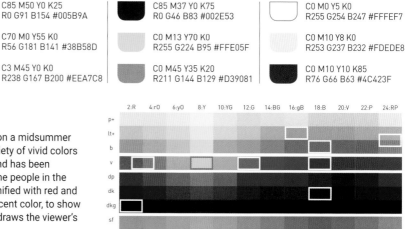

SUMMER

The Beach Resort of One's Dreams

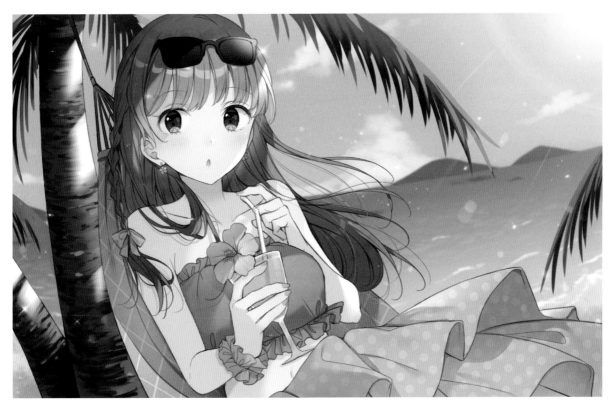

C37 M0 Y10 K0
R170 G219 B230 #AADBE6

C45 M0 Y20 K0
R147 G209 B211 #93D1D3

C40 M9 Y0 K0
R161 G204 B238 #A1CCEE

C57 M0 Y23 K0
R107 G197 B203 #6BC5CB

C5 M30 Y13 K0
R239 G196 B201 #EFC4C9

C0 M47 Y100 K0
R244 G157 B0 #F49D00

C0 M13 Y100 K0
R255 G220 B0 #FFDC00

C80 M10 Y25 K0
R0 G164 B188 #00A4BC

C0 M17 Y15 K0
R251 G224 B212 #FBE0D4

C0 M9 Y0 K0
R253 G240 B246 #FDF0F6

C30 M0 Y0 K77
R67 G85 B95 #43555F

C0 M7 Y10 K40
R180 G172 B165 #B4ACA5

Keys to this Color Scheme!

Greenish blues such as turquoise-blue and emerald green are used for the water elements in order to reference the resort setting. Mixing blue into the grays used for the shadows adds further cohesion to the illustration. Not only are the bright oranges and yellows used for the clothing contrast colors to the "acquatic" base colors, they're also effective for showing perspective.

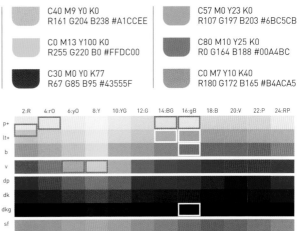

Shining Gingko Trees Lining a Road

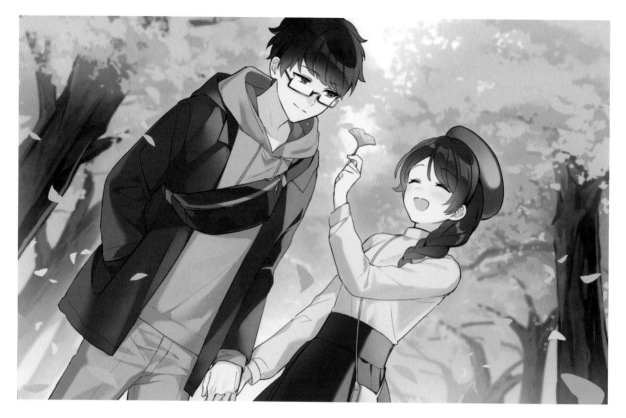

C30 M27 Y100 K0 R193 G176 B1 #C1B001	C0 M17 Y65 K13 R232 G199 B97 #E8C761	C5 M10 Y65 K0 R246 G225 B110 #F6E16E	C0 M0 Y15 K30 R201 G199 B181 #C9C7B5
C0 M0 Y10 K10 R239 G237 B223 #EFEDDF	C75 M80 Y80 Y0 R93 G74 B69 #5D4A45	C55 M37 Y100 K40 R95 G102 B23 #5F6617	C80 M40 Y100 K40 R35 G89 B36 #235924
C5 M23 Y23 K0 R241 G208 B191 #F1D0BF	C0 M13 Y5 K0 R252 G233 B234 #FCE9EA	C0 M0 Y10 K60 R137 G136 B127 #89887F	C0 M0 Y7 K83 R81 G78 B74 #514E4A

Keys to This Color Scheme!

If you darken yellow hues, you can suggest the shine and luster of gold. In this illustration, various yellow hues are used to create the world view, but the key is the brown in the trees. There are various browns that could be integrated, ranging from ones with a lot of red in them to ones that look greenish. In this illustration a darkened yellow brown is used, to create visual cohesion with the leaves. Make the brightness contrast rather strong.

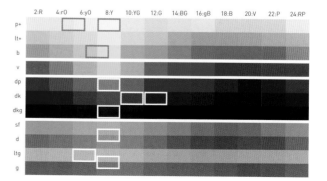

AUTUMN

Idol School Festival

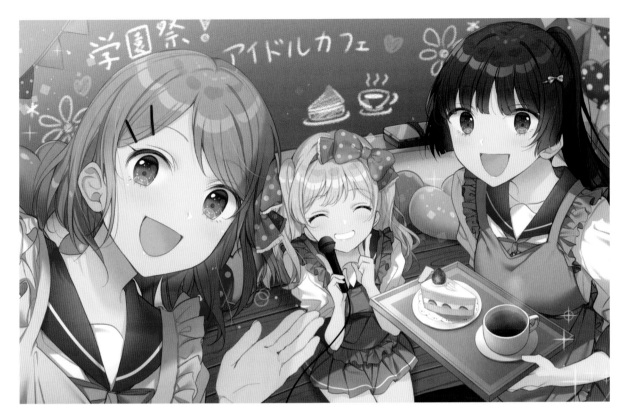

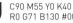 C90 M55 Y0 K40
R0 G71 B130 #004782

C45 M23 Y0 K0
R149 G178 B221 #95B2DD

C40 M50 Y0 K0
R166 G135 B189 #A687BD

C0 M90 Y65 K37
R171 G35 B46 #AB232E

C0 M50 Y25 K20
R209 G135 B138 #D1878A

C0 M15 Y17 K0
R252 G228 B211 #FCE4D3

C0 M8 Y17 K13
R233 G220 B200 #E9DCC8

C0 M10 Y20 K67
R120 G110 B98 #786E62

C0 M17 Y17 K5
R244 G217 B203 #F4D9CB

C25 M33 Y53 K0
R201 G173 B126 #C9AD7E

C25 M50 Y43 K15
R179 G128 B117 #B38075

C25 M0 Y30 K35
R151 G172 B148 #97AC94

Keys to This Color Scheme!

A color palette consisting of quiet colors with dark hues mixed with grays conjures the autumn atmosphere. The only exception is the color used to paint the skin, which is a bright, clear shade. Limiting the hues to reds and blues and adding in purple helps to harmonize the entire image. This is a cohesive color scheme despite the number of colors present.

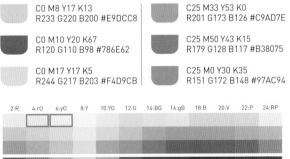

AUTUMN

Halloween Night

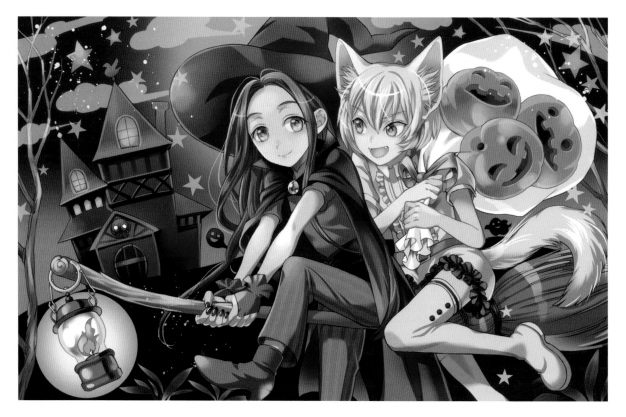

 C5 M65 Y87 K0
R231 G118 B41 #E77629

C0 M30 Y33 K50
R155 G122 B104 #9B7A68

C25 M25 Y0 K95
R33 G22 B33 #211621

C60 M70 Y0 K20
R107 G76 B142 #6B4C8E

C33 M45 Y0 K13
R166 G137 B180 #A689B4

C80 M50 Y80 K20
R54 G97 B68 #366144

C33 M70 Y20 K15
R163 G90 B129 #A35A81

C50 M0 Y30 K15
R119 G184 B173 #77B8AD

C5 M0 Y10 K0
R246 G250 B237 #F6FAED

C95 M100 Y60 K0
R45 G46 B83 #2D2E53

C10 M0 Y0 K10
R219 G230 B237 #DBE6ED

C0 M13 Y7 K13
R231 G213 B212 #E7D5D4

Keys to This Color Scheme!

If you look at the color chart vertically, you can see immediately that the hues used in this color palette are centered on the violet to purple range, followed by orange and then green used as an accent color. Halloween color schemes tend to be all the same; try using mystical blue-greens as well as artificial-looking yellow-greens to add a bit of novelty to the expected tried-and-true palette.

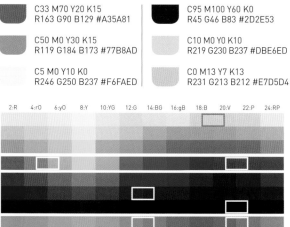

10

A Potluck Party

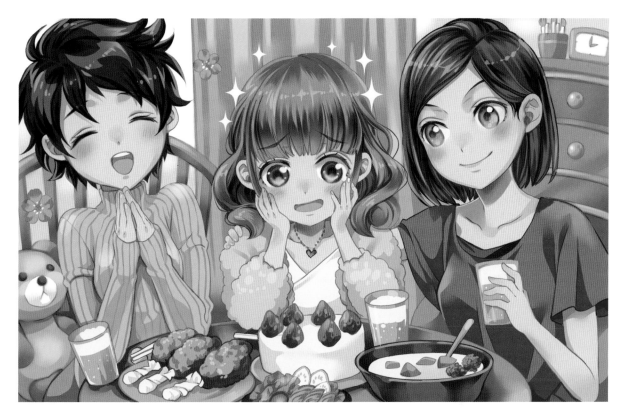

C0 M81 Y64 K2 R232 G81 B73 #E85149	C0 M37 Y50 K5 R239 G176 B124 #EFB07C	C15 M47 Y60 K47 R142 G98 B64 #8E6240	C43 M10 Y60 K0 R160 G193 B125 #A0C17D
C53 M60 Y60 K11 R131 G102 B91 #83665B	C5 M15 Y30 K35 R182 G167 B140 #B6A78C	C10 M15 Y100 K0 R236 G210 B0 #ECD200	C20 M0 Y55 K0 R216 G229 B141 #D8E58D
C0 M23 Y15 K0 R250 G212 B206 #FAD4CE	C0 M17 Y23 K0 R252 G223 B197 #FCDFC5	C0 M0 Y13 K0 R255 G253 B232 #FFFDE8	C0 M0 Y100 K87 R72 G65 B0 #484100

Keys to This Color Scheme!

A palette made up of warm hues with tomato red, mustard yellow and pistachio green as the main colors. Here this palette was used to color the entire image, but even if the scene is entirely different and you want to depict a feast or a bento meal, you can use these three colors partially.

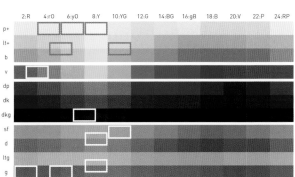

WINTER

A Snowy Quiet Forest

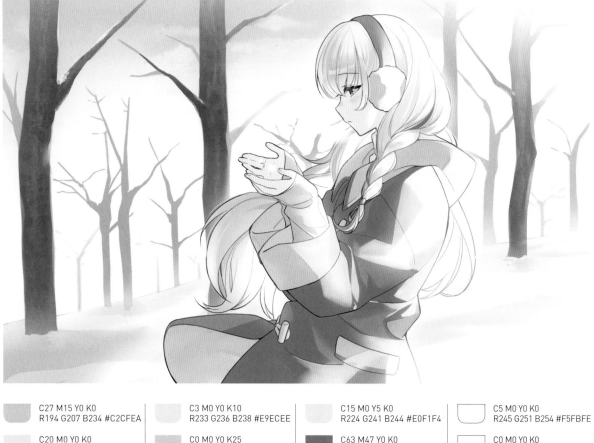

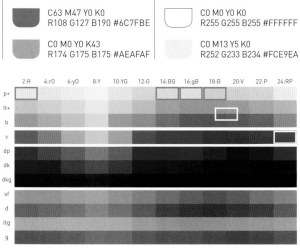

C27 M15 Y0 K0
R194 G207 B234 #C2CFEA

C20 M0 Y0 K0
R211 G237 B251 #D3EDFB

C15 M67 Y0 K0
R212 G111 B168 #D46FA8

C3 M0 Y0 K10
R233 G236 B238 #E9ECEE

C0 M0 Y0 K25
R211 G211 B212 #D3D3D4

C0 M0 Y0 K60
R137 G137 B137 #898989

C15 M0 Y5 K0
R224 G241 B244 #E0F1F4

C63 M47 Y0 K0
R108 G127 B190 #6C7FBE

C0 M0 Y0 K43
R174 G175 B175 #AEAFAF

C5 M0 Y0 K0
R245 G251 B254 #F5FBFE

C0 M0 Y0 K0
R255 G255 B255 #FFFFFF

C0 M13 Y5 K0
R252 G233 B234 #FCE9EA

Keys to this Color Scheme!

A silent winter forest. In order to suggest the silence, solitude and coldness, white and a range of grays are used as the main colors, combined with very pale blues. The only high-saturation hues are the ones used for the character's clothes and eyes. In a color palette like this, the key is how you use a bright hue like the vivid pink. Here it's used as an accent color for the eyes and for parts of the hair and clothes.

WINTER

Traditional Festive Kimonos

C40 M100 Y70 K0 R167 G30 B65 #A71E41	C10 M60 Y55 K0 R223 G129 B102 #DF8166	C0 M25 Y23 K17 R221 G185 B169 #DDB9A9
C0 M0 Y7 K0 R255 G254 B243 #FFFEF3	C30 M0 Y20 K20 R163 G195 B186 #A3C3BA	C40 M35 Y90 K0 R171 G157 B54 #AB9D36
C0 M73 Y35 K13 R216 G93 B110 #D85D6E	C0 M5 Y15 K0 R255 G245 B224 #FFF5E0	C53 M0 Y40 K35 R92 G151 B130 #5C9782

C0 M13 Y15 K0 R253 G231 B216 #FDE7D8

C0 M10 Y0 K83 R81 G72 B74 #51484A

C0 M0 Y0 K100 R34 G24 B21 #221815

Keys to this Color Scheme!

Although this color palette uses red, yellow and green too, it differs from the impression created on page 159. These traditional Japanese colors are called akane (red), konjiki (golden yellow) and rokusho (green-blue). The way slight color differences can change the impression given by the entire image and the aura of the characters is the main difficulty of creating color schemes. But it's what makes manga and anime illustration challenging and fun.

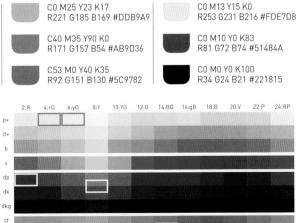

Color Conceptions Around the World

What color one envisions a certain object to be differs from person to person. Place of origin, whether one's country or region, has an influence on this too. If you grew up in Japan, you might think of apples or the sun if you see the color red; but those color associations aren't universal. Applying these notions of color variation exopands your own mental palette, so you can create particular impressions and authentic illustrations, pairing palettes in new ways.

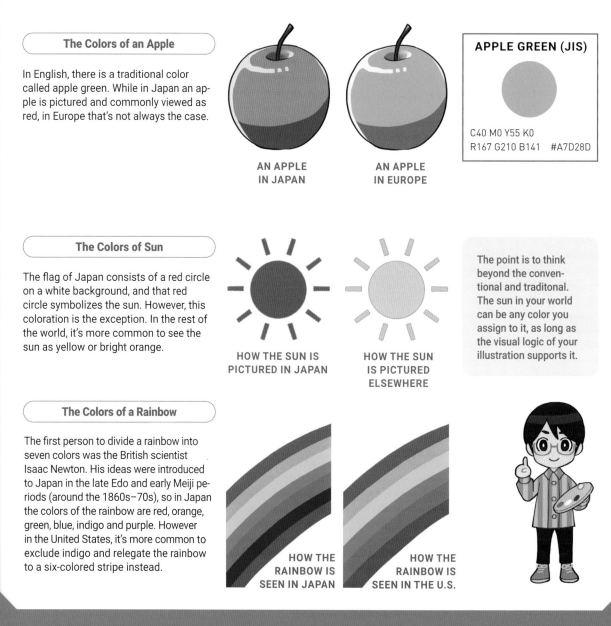

The Colors of an Apple

In English, there is a traditional color called apple green. While in Japan an apple is pictured and commonly viewed as red, in Europe that's not always the case.

AN APPLE IN JAPAN

AN APPLE IN EUROPE

APPLE GREEN (JIS)

C40 M0 Y55 K0
R167 G210 B141 #A7D28D

The Colors of Sun

The flag of Japan consists of a red circle on a white background, and that red circle symbolizes the sun. However, this coloration is the exception. In the rest of the world, it's more common to see the sun as yellow or bright orange.

HOW THE SUN IS PICTURED IN JAPAN

HOW THE SUN IS PICTURED ELSEWHERE

The point is to think beyond the conventional and traditonal. The sun in your world can be any color you assign to it, as long as the visual logic of your illustration supports it.

The Colors of a Rainbow

The first person to divide a rainbow into seven colors was the British scientist Isaac Newton. His ideas were introduced to Japan in the late Edo and early Meiji periods (around the 1860s–70s), so in Japan the colors of the rainbow are red, orange, green, blue, indigo and purple. However in the United States, it's more common to exclude indigo and relegate the rainbow to a six-colored stripe instead.

HOW THE RAINBOW IS SEEN IN JAPAN

HOW THE RAINBOW IS SEEN IN THE U.S.

2 Fantasy and Futuristic Palettes

Manga and anime summon fantastical realms and flash forward to future realities. Color sets the tone and draws the viewer into the worlds you're building. Contrasting realms are pictured on facing pages.

CELESTIAL AND DEMONIC

A Sacred Heaven

C0 M10 Y0 K0 R253 G238 B245 #FDEEF5	C15 M0 Y0 K0 R223 G242 B252 #DFF2FC	C7 M0 Y7 K0 R241 G248 B242 #F1F8F2	C0 M0 Y0 K0 R255 G255 B255 #FFFFFF
C0 M0 Y0 K15 R230 G230 B231 #E6E6E7	C0 M0 Y0 K30 R201 G202 B202 #C9CACA	C0 M0 Y0 K45 R170 G171 B171 #AAABAB	C0 M0 Y0 K60 R137 G137 B137 #898989
C0 M30 Y0 K7 R236 G192 B212 #ECC0D4	C30 M0 Y0 K13 R170 G208 B228 #AAD0E4	C0 M0 Y17 K30 R201 G199 B178 #C9C7B2	C0 M0 Y43 K30 R201 G195 B134 #C9C386

Keys to This Color Scheme!

In a color palette creating a heavenly impression, white and pale blue as used as the main colors, and several carefully applied light grays are used for the shadows. If cloudy yellow hues are used as subordinate colors, they add a lustrous shine and support the divine theme. The key to communicating a heavenly world view is to apply bright colors delicately throughout.

Hell and Demons

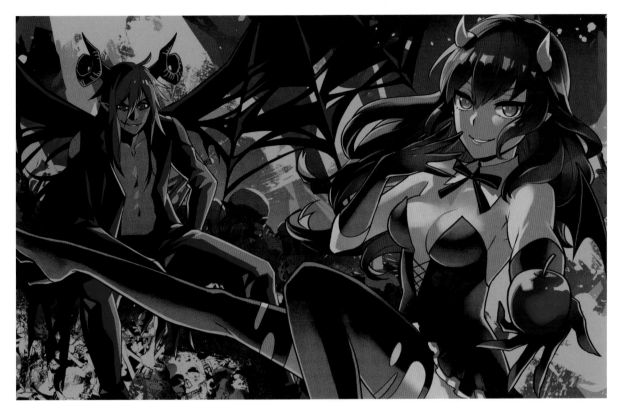

 C0 M70 Y60 K53
R143 G61 B46 #8F3D2E

 C25 M70 Y60 K0
R196 G103 B89 #C46759

C17 M20 Y0 K100
R27 G9 B19 #1B0913

C0 M100 Y65 K60
R125 G0 B21 #7D0015

C0 M100 Y100 K40
R164 G0 B0 #A40000

C25 M0 Y100 K10
R194 G205 B0 #C2CD00

C75 M100 Y35 K55
R54 G0 B60 #36003C

C17 M20 Y0 K85
R64 G56 B65 #403841

C17 M5 Y20 K15
R198 G208 B192 #C6D0C0

C40 M50 Y23 K40
R119 G95 B114 #775F72

C30 M25 Y0 K35
R141 G141 B168 #8D8DA8

C35 M13 Y0 K70
R76 G90 B106 #4C5A6A

Keys to This Color Scheme!

To express a darkly demonic world, use thick, muddy hues as the main colors. Not only are black, violets and purples good to use, dark and muddy reds combined with yellows are effective. In Chapter 1 (page 22) this was introduced as a medium-level (complex) hue combination. The combination of red and yellow is not cohesive like analogous hues and does not have the clear distinction of contrast hues, so they help create a unique world view.

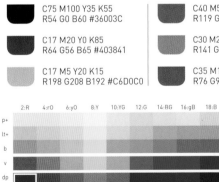

FAIRIES AND WITCHES

A Forest Inhabited by Fairies

C30 M0 Y13 K0 R188 G225 B227 #BCE1E3	C45 M0 Y25 K0 R148 G209 B201 #94D1C9	C60 M0 Y45 K0 R101 G191 B161 #65BFA1
C10 M0 Y20 K0 R236 G244 B217 #ECF4D9	C15 M33 Y60 K0 R222 G179 B111 #DEB36F	C58 M0 Y20 K55 R52 G116 B124 #34747C
C0 M50 Y50 K23 R204 G129 B99 #CC8163	C5 M30 Y20 K0 R239 G195 B189 #EFC3BD	C58 M0 Y20 K70 R34 G88 B95 #22585F

| | | |
|---|---|
| C65 M13 Y90 K0 R97 G168 B70 #61A846 | |
| C75 M40 Y80 K0 R75 G128 B83 #4B8053 | |
| C6 M0 Y0 K0 R243 G250 B254 #F3FAFE | |

Keys to This Color Scheme!

Let's compare the distribution of colors to those on the next page. Here the hues are in the blue-green to yellow-green range, with quiet pinks and oranges used as accent colors. In addition, a pale yellow-green is used for the sunlight filtering through the trees. When looked at in terms of tones, contrast is created by using bright clear colors and dark colors, to emphasize the presence of light.

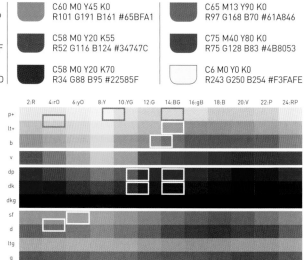

FAIRIES AND WITCHES

The Mansion of a Medieval Witch

C65 M0 Y35 K27 R58 G154 B148 #3A9A94	C43 M0 Y20 K23 R128 G179 B179 #80B3B3
C37 M0 Y17 K47 R109 G143 B144 #6D8F90	C0 M0 Y0 K30 R201 G202 B202 #C9CACA
C60 M0 Y30 K75 R23 G77 B76 #174D4C	C13 M0 Y17 K35 R171 G182 B168 #ABB6A8
C60 M33 Y0 K33 R83 G116 B161 #5374A1	C30 M25 Y0 K10 R175 G175 B208 #AFAFD0
C100 M100 Y0 K15 R26 G26 B124 #1A1A7C	C40 M50 Y25 K37 R123 G99 B116 #7B6374
C10 M0 Y7 K10 R219 G230 B226 #DBE6E2	C40 M30 Y0 K100 R10 G0 B20 #0A0014

Keys to This Color Scheme!

Because the hues used here are in the blue-green to blue range, the silence of night is evoked. The color scheme is centered on grayish colors. The witch's clothing and the shelves lined with dubious-looking tools of magic are in a very dark color to draw the viewer's eye to the center. In addition, a deep blue is used for the potion in the witch's hand and the dark night in the background to add visual impact and a slight sense of contrast.

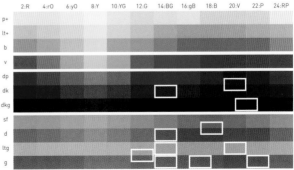

	2:R	4:rO	6:yO	8:Y	10:YG	12:G	14:BG	16:gB	18:B	20:V	22:P	24:RP
p+												
lt+												
b												
v												
dp												
dk												
dkg												
sf												
d												
ltg												
g												

A Training Center for Gladiators

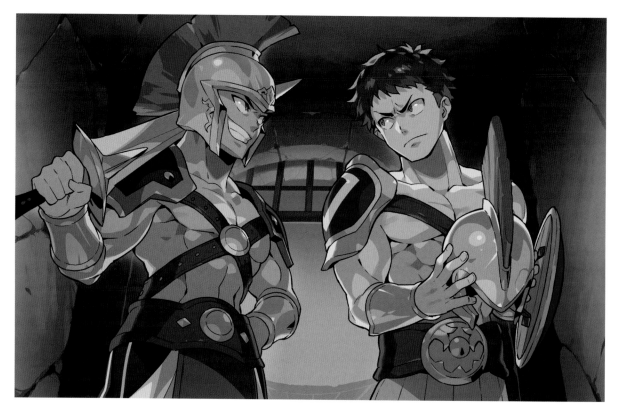

C5 M15 Y80 K30 R192 G170 B50 #C0AA32	C31 M19 Y0 K18 R163 G174 B202 #A3AECA	C25 M40 Y60 K0 R200 G160 B108 #C8A06C	C17 M15 Y63 K0 R221 G208 B114 #DDD072
C67 M40 Y0 K30 R71 G107 B158 #476B9E	C0 M70 Y47 K30 R186 G85 B83 #BA5553	C55 M80 Y100 K30 R110 G58 B29 #6E3A1D	C0 M100 Y0 K100 R30 G0 B1 #1E0001
C20 M0 Y0 K60 R112 G127 B135 #707F87	C17 M30 Y30 K0 R217 G186 B170 #D9BAAA	C25 M40 Y40 K0 R199 G162 B144 #C7A290	C8 M10 Y15 K0 R238 G230 B218 #EEE6DA

Keys to This Color Scheme!

The gladiators that enraptured the people of Rome are said to have undergone grueling regimens at training centers. This color palette is centered on the shades used for metallic objects, such as the armor and weapons, and ones that can be used for the gladiators' skin and the surrounding colosseum. Duller tones of red and blue are used as accent colors to conjure the ancient atmosphere.

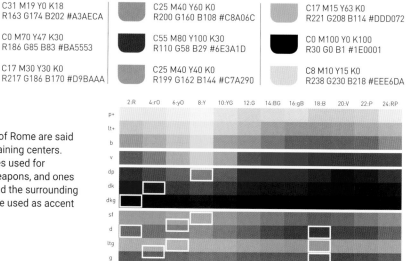

THE WORLD OF ANCIENT GLADIATORS AND THE MAGICAL WORLD OF THE NEAR FUTURE

A Magic University City in the Near Future

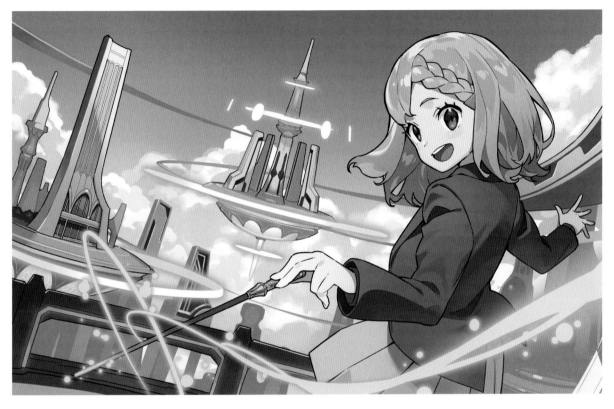

C20 M8 Y0 K0 R211 G225 B243 #D3E1F3	C57 M40 Y0 K0 R122 G142 B199 #7A8EC7
C30 M0 Y25 K10 R177 G210 B191 #B1D2BF	C10 M20 Y0 K0 R231 G212 B232 #E7D4E8
C70 M15 Y0 K60 R5 G91 B124 #055B7C	C50 M60 Y60 K0 R147 G112 B98 #937062

C20 M5 Y0 K27 R171 G187 B201 #ABBBC9	C25 M10 Y0 K55 R115 G126 B140 #737E8C
C0 M0 Y0 K30 R201 G202 B202 #C9CACA	C70 M25 Y30 K0 R74 G154 B170 #4A9AAA
C0 M53 Y25 K20 R208 G130 B136 #D08288	C0 M15 Y7 K0 R252 G229 B228 #FCE5E4

Keys to This Color Scheme!

This is a university city in the near future, where the students major in magic. The main feature of this color palette is that the browns used as base colors in the ancient Rome illustration are intergrated here as an accent color, and in contrast the blues used in the gladiator illustration as accent colors are used here as the base colors. Use blue-grays and blue-greens when you want to create an impression of the near future, and limit the brightness contrasts.

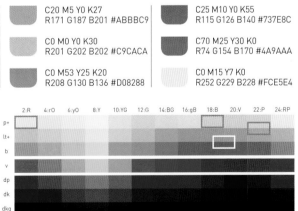

A DESOLATE WORLD AND A VIRTUAL WORLD

A Wasteland Battlefield

C0 M65 Y100 K87 R67 G16 B0 #431000	C30 M25 Y30 K0 R189 G185 B174 #BDB9AE	C0 M55 Y53 K45 R161 G94 B70 #A15E46	C0 M0 Y20 K75 R102 G99 B85 #666355
C70 M50 Y100 K50 R58 G72 B23 #3A4817	C27 M22 Y15 K15 R176 G176 B184 #B0B0B8	C53 M27 Y0 K50 R78 G103 B136 #4E6788	C27 M0 Y0 K65 R93 G113 B123 #5D717B
C70 M65 Y100 K87 R15 G10 B0 #0F0A00	C0 M0 Y0 K74 R104 G103 B103 #686767	C0 M3 Y10 K13 R233 G229 B216 #E9E5D8	C5 M0 Y0 K5 R238 G243 B247 #EEF3F7

Keys to This Color Scheme!

A desolate windswept wasteland is suggested with an "earthy" color palette. Earthen hues centered on brown bring to mind the color of soil or sand and include variations such as khaki and olive. This group includes a lot of similar colors, so the key to using them skillfully is creating significant differences in the brightness levels.

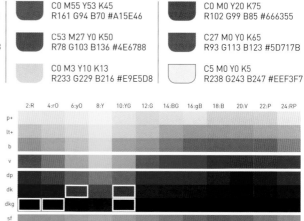

A DESOLATE WORLD AND A VIRTUAL WORLD

A Psychedelic World

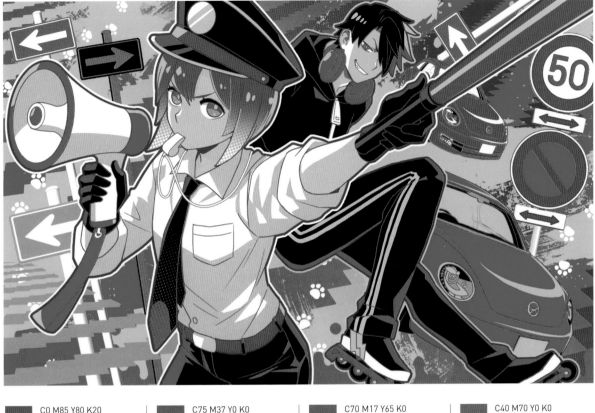

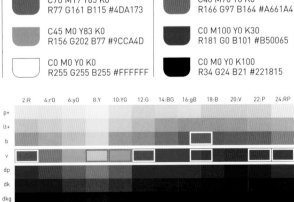

C0 M85 Y80 K20 R202 G60 B40 #CA3C28	C75 M37 Y0 K0 R55 G135 B200 #3787C8	C70 M17 Y65 K0 R77 G161 B115 #4DA173	C40 M70 Y0 K0 R166 G97 B164 #A661A4
C0 M0 Y100 K7 R248 G230 B0 #F8E600	C100 M0 Y0 K0 R0 G160 B233 #00A0E9	C45 M0 Y83 K0 R156 G202 B77 #9CCA4D	C0 M100 Y0 K30 R181 G0 B101 #B50065
C0 M15 Y15 K15 R227 G206 B194 #E3CEC2	C0 M27 Y0 K15 R224 G187 B203 #E0BBCB	C0 M0 Y0 K0 R255 G255 B255 #FFFFFF	C0 M0 Y0 K100 R34 G24 B21 #221815

Keys to This Color Scheme!

The color palette uses psychedelic colors to create an artificial, ersatz fantasy world. Psychedelic colors became popular in the latter half of the 1960s and combines vivid, stimulating and fluorescent colors. Make free use of purples, garish yellow greens and electrifyingly shocking pinks to express a virtual world.

	2:R	4:rO	6:yO	8:Y	10:YG	12:G	14:BG	16:gB	18:B	20:V	22:P	24:RP
p+												
lt+												
b												
v												
dp												
dk												
dkg												
sf												
d												
ltg												
g												

A Dreamy Wonderland

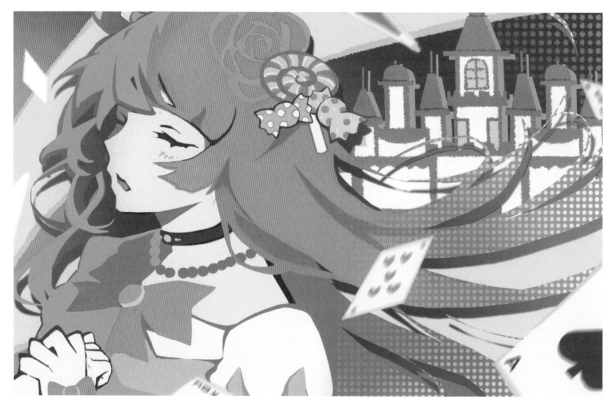

C0 M70 Y5 K0 R235 G110 B160 #EB6EA0	C57 M0 Y20 K0 R106 G197 B208 #6AC5D0	C65 M15 Y0 K0 R75 G172 B226 #4BACE2	C35 M60 Y0 K0 R176 G119 B176 #B077B0
C0 M45 Y0 K0 R243 G169 B201 #F3A9C9	C0 M20 Y77 K0 R253 G210 B72 #FDD248	C0 M13 Y45 K0 R254 G227 B156 #FEE39C	C70 M0 Y0 K20 R0 G162 B208 #00A2D0
C0 M13 Y0 K0 R252 G233 B242 #FCE9F2	C0 M5 Y0 K0 R254 G247 B250 #FEF7FA	C40 M40 Y0 K50 R103 G95 B128 #675F80	C0 M13 Y0 K40 R179 G166 B172 #B3A6AC

Keys to This Color Scheme!

This is a color palette for conjuring a realm of dreamy romance. To create an impression of free-spirited forward-thinking positivity as well as a sense of blissful freedom, this color palette is centered on the four primary colors of color perception (see page 83): red, yellow, green and blue, with bright hues added to them. In a wonderland, everything has a soft glow and a happy ending.

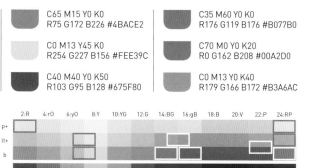

A DREAM WORLD AND A SPACE STATION

A Romantic Space Trip

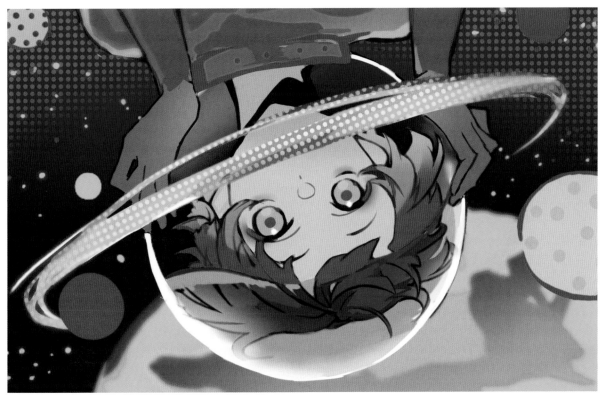

C0 M0 Y0 K0 R255 G255 B255 #FFFFFF	C10 M0 Y0 K30 R184 G194 B200 #B8C2C8
C85 M63 Y0 K25 R34 G74 B142 #224A8E	C30 M0 Y0 K13 R170 G208 B228 #AAD0E4
C15 M0 Y80 K0 R229 G230 B71 #E5E647	C100 M47 Y0 K13 R0 G99 B172 #0063AC

C20 M0 Y0 K60 R112 G127 B135 #707F87	C30 M0 Y0 K90 R40 G52 B59 #28343B
C23 M0 Y0 K30 R160 G185 B198 #A0B9C6	C30 M0 Y0 K65 R89 G111 B123 #596F7B
C0 M87 Y100 K17 R207 G57 B7 #CF3907	C10 M14 Y25 K0 R233 G220 B195 #E9DCC3

Keys to This Color Scheme!

Here the notion of the romantic is encapsulated in the adventure and fantasy of space travel. Dreams and adventure and the idealism of the future are all fanciful factors, so a simple, clear palette that combines unmixed red, blue, yellow and achromatic colors (white, gray, black) is assembled.

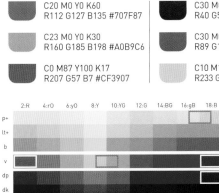

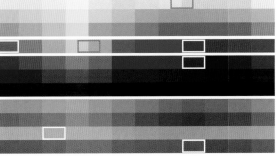

23

UTOPIA AND DYSTOPIA

An Ancient Crystal Palace

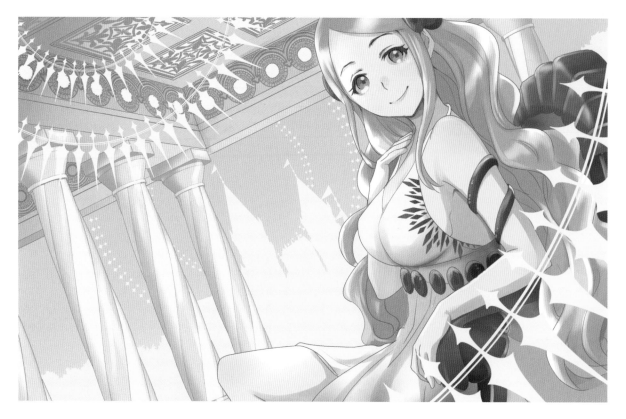

C5 M13 Y0 K0 R242 G229 B241 #F2E5F1	C17 M15 Y0 K0 R217 G216 B236 #D9D8EC	C23 M0 Y7 K0 R205 G233 B239 #CDE9EF	C0 M0 Y0 K20 R220 G221 B221 #DCDDDD
C5 M0 Y0 K0 R245 G251 B254 #F5FBFE	C5 M7 Y0 K0 R244 G240 B247 #F4F0F7	C0 M0 Y0 K30 R201 G202 B202 #C9CACA	C33 M0 Y7 K13 R165 G205 B217 #A5CDD9
C9 M17 Y0 K30 R184 G173 B186 #B8ADBA	C0 M10 Y6 K0 R253 G238 B235 #FDEEEB	C20 M73 Y5 K0 R202 G96 B155 #CA609B	C43 M50 Y0 K33 R122 G102 B146 #7A6692

Keys to This Color Scheme!

A glittering utopia, crystaline and pure in its vision, sparkling with sunlight and spiritual energy. The color palette is strictly limited to pale, clear tones, in order not to transcend a sense of the mundane. Colors such as magenta and purple symbolize spirituality and make strong choices as accent colors.

24

A Dystopia in the Near Future

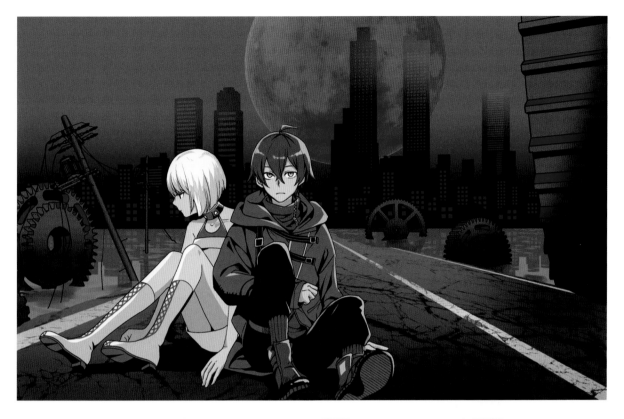

C30 M10 Y0 K3 R183 G208 B235 #B7D0EB	C40 M15 Y0 K27 R131 G159 B189 #839FBD	C40 M15 Y0 K55 R93 G114 B136 #5D7288	C0 M95 Y43 K50 R145 G0 B52 #910034
C7 M0 Y0 K30 R189 G197 B201 #BDC5C9	C20 M20 Y4 K23 R177 G172 B189 #B1ACBD	C37 M0 Y13 K40 R120 G156 B162 #789CA2	C80 M0 Y20 K37 R0 G131 B153 #008399
C15 M0 Y0 K45 R149 G162 B169 #95A2A9	C10 M0 Y0 K73 R97 G102 B105 #616669	C7 M17 Y10 K0 R238 G220 B220 #EEDCDC	C0 M0 Y0 K100 R35 G24 B21 #231815

Keys to This Color Scheme!

In general color usage, dark colors are supposed to be used for the past and bright colors for the future, but this time, that tidy formulation has been reversed. Set in the near future, the dystopia depicted here is devoid of any dreams or hope. Be aware of the strong contrast of the hues (here reds and blue greens) and strongly contrasting brightness. Strong, dark black is also suited to a world without hope.

THE REFINEMENT OF ARISTOCRATS AND THE EVERYDAY LIVES OF COMMON PEOPLE

An Ancient Japanese Picture Scroll

C23 M30 Y0 K13 R185 G168 B199 #B9A8C7	C0 M70 Y35 K10 R221 G103 B115 #DD6773	C40 M0 Y30 K0 R164 G214 B192 #A4D6C0	C15 M0 Y0 K25 R184 G200 B209 #B8C8D1
C40 M55 Y0 K10 R155 G118 B171 #9B76AB	C5 M90 Y90 K13 R206 G52 B30 #CE341E	C50 M0 Y25 K20 R113 G177 B175 #71B1AF	C0 M17 Y75 K13 R232 G198 B72 #E8C648
C45 M65 Y0 K25 R129 G85 B141 #81558D	C0 M30 Y17 K0 R247 G198 B195 #F7C6C3	C0 M12 Y5 K0 R252 G234 B235 #FCEAEB	C0 M7 Y15 K83 R81 G74 B66 #514A42

Keys to This Color Scheme!

The Heian period (794 to 1185) was the great age of the Japanese aristocrat. Of the colors loved by those Heian higher-ups, the purple derived from the gromwell plant was the most prized. Pale colors (usuiro) and dark colors (kokiiro) all meant variations of this main base purple. Pale to dark reds, dyed with the safflower plant, were also favored. Here the color palette is centered on light to dark purples and reds, with muted yellows and greens added as accent colors.

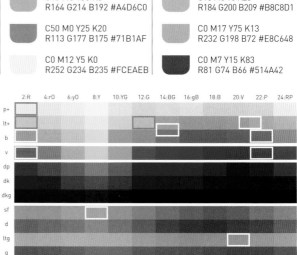

Early Modern Japanese Retro

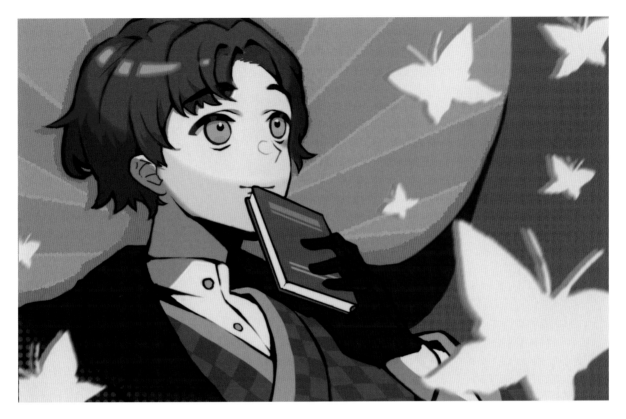

 C60 M77 Y37 K0
R126 G79 B117 #7E4F75

C15 M60 Y85 K0
R216 G126 B50 #D87E32

C17 M27 Y65 K15
R198 G170 B94 #C6AA5E

C55 M23 Y35 K0
R126 G168 B165 #7EA8A5

C47 M5 Y27 K0
R144 G201 B194 #90C9C2

C60 M20 Y45 K55
R59 G98 B87 #3B6257

C30 M55 Y50 K0
R188 G131 B115 #BC8373

C85 M45 Y45 K0
R14 G117 B131 #0E7583

C0 M7 Y10 K5
R246 G235 B224 #F6EBE0

C17 M75 Y70 K0
R209 G94 B71 #D15E47

C0 M0 Y40 K75
R102 G98 B66 #666242

C30 M70 Y55 K80
R66 G20 B20 #421414

Keys to This Color Scheme!

The Meiji (1868–1912) and Taisho (1912–1926) periods were when Japan became modernized at a rapid pace. After the country was opened to outside trade after centuries of isolation, Western influences came pouring in. Synthetic dyes entered Japan from the West in the Meiji period. Brightly colored Western-style clothing didn't become widespread right away, and even in the Taisho period, people dressed in a mix of Japanese and Western styles. In order to bring out a feeling of nostalgia, this color palette brings together warm yellow-based (page 78) low-saturation hues.

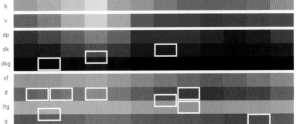

ASK THE
EXPERTS
5

Q & A #5:
Problems with Applying Color

Q When I try to paint a night scene, the image becomes too dark and black. What can I do to make my drawing lively and less monochromatic?

A

Instead of just dropping in the actual colors of the landscape, try mixing in hidden colors.

If you're creating a night scene, if you make even your character similarly dark, the colors will look dull and unvaried.

Instead of putting down dark shades and hues as "night-appropriate" colors, try mixing in hidden colors (page 146) to brighten the scene and creating visual variety. Even the same blacks will look varied, while a sense of depth will be introduced to your drawing.

Q My colors tend to become monotonous, so I'd like to introduce variety. Are there any methods you recommend for this?

A

Try creating drawings of sunflowers. They're good practice for increasing your palette range.

The reasons why you're concerned that your coloring is becoming monotonous or that you don't know what colors to apply in the first place is that you may be trying to replicate the colors of objects and landscapes exactly as you see them.

Manga and anime free you from the contraints of reality. As a way to increase the variety of colors you use, use sunflowers as a subject. They have yellow petals with brown centers, so you can apply the first colors without hesitation. From there, try adding colors not found in actual sunflowers. Your palette range will increase, and you'll complete a new breed of sunflower that's all your own.

Q The colors of my characters tend to be similar.
How can I bring out their individuality?

A Take the plunge and change their hair and eye colors, which tend to favor black or brown.

Think of out the iris or follicle and try changing up your characters' hair and eye colors according to their individuality. If you mix warm hues into the hair color, you can give an impression of your character in an elated state. The eyes of a character so key to their appearance, so if you consider the entire image and use complementary or accent colors for the eyes, you can make the character's face really stand out.

Q When I'm drawing an illustration with a background,
what should I be most careful about?

A Don't just focus on the character and don't forget to always look at the entire image as one illustration.

When you're placing a character against a background, always think of it as one complete visual unit. If you're going to place an ocean behind a woman wearing a dress, think of why she came to the seaside wearing a dress. There's always a reason why the character is where they are and doing what they're doing, so it's important to resolve the specifics of the scenario before you start drawing.

Q I want to become a professional artist. What do I most need to know?

A It's important to consider if your art is commercial and saleable.
Always be aware of your target audience!

If you're aiming to become a pro, be aware of who your art is intended for—in other words, your target audience. For example, if you're aiming at creating illustraitons for young children, use vivid color schemes that are clearly understood by kids and avoid using drab colors. In addition, no matter who the character is, if you decide exactly what they're doing before you start drawing, there won't be any indecision or misdirection reflected in your illustration.

 (We would like to thank Nippon Designer Gakuin and Nihon Kogakuin College for their cooperation with this section.)

PCCS Color List

Chromatic Colors

v1 C15 M100 Y45 K0
R207 G0 B87
#CF0057

v2 C0 M100 Y60 K0
R230 G0 B68
#E60044

v3 C0 M90 Y80 K0
R232 G56 B47
#E8382F

v4 C0 M80 Y100 K0
R234 G85 B4
#EA5504

v5 C0 M63 Y100 K0
R239 G125 B0
#EF7D00

V6 C0 M45 Y100 K0
R245 G162 B0
#F5A200

v7 C0 M28 Y100 K0
R251 G195 B0
#FBC300

v8 C0 M10 Y100 K0
R255 G225 B0
#FFE100

v9 C15 M5 Y100 K0
R229 G222 B0
#E5DE00

v10 C30 M0 Y100 K0
R196 G215 B0
#C4D700

v11 C55 M0 Y88 K0
R126 G191 B71
#7EBF47

v12 C90 M0 Y80 K0
R0 G161 B97
#00A161

v13 C90 M8 Y63 K0
R0 G156 B125
#009C7D

v14 C100 M15 Y50 K0
R0 G144 B142
#00908E

v15 C100 M8 Y35 K17
R0 G136 B153
#008899

v16 C100 M0 Y20 K30
R0 G129 B162
#0081A2

v17 C100 M30 Y0 K17
R0 G115 B182
#0073B6

v18 C100 M60 Y0 K0
R0 G91 B172
#005BAC

v19 C90 M70 Y0 K0
R29 G80 B162
#1D50A2

v20 C80 M80 Y0 K0
R77 G67 B152
#4D4398

v21 C70 M85 Y0 K0
R104 G59 B147
#683B93

v22 C60 M90 Y0 K0
R126 G49 B142
#7E318E

v23 C45 M95 Y15 K0
R157 G36 B124
#9D247C

v24 C30 M100 Y30 K0
R183 G8 B104
#B70868

b2 C0 M70 Y50 K0
R236 G109 B101
#EC6D65

b4 C0 M55 Y60 K0
R241 G143 B96
#F18F60

b6 C0 M35 Y70 K0
R248 G184 B86
#F8B856

b8 C0 M5 Y80 K0
R255 G236 B63
#FFEC3F

b10 C40 M0 Y80 K0
R170 G207 B82
#AACF52

b12 C55 M0 Y60 K0
R122 G194 B131
#7AC283

b14 C75 M0 Y40 K0
R0 G177 B169
#00B1A9

b16 C85 M15 Y20 K0
R0 G155 B192
#009BC0

b18 C80 M35 Y0 K0
R0 G134 B201
#0086C9

b20 C65 M55 Y0 K0
R106 G113 B180
#6A71B4

b22 C45 M70 Y0 K0
R156 G94 B163
#9C5EA3

b24 C0 M70 Y10 K10
R221 G103 B145
#DD6791

S STRONG

s2
C10 M90 Y60 K0
R217 G55 B75
#D9374B

s4
C0 M80 Y80 K0
R234 G85 B50
#EA5532

s6
C0 M45 Y80 K0
R245 G163 B59
#F5A33B

s8
C5 M20 Y100 K5
R238 G199 B0
#EEC700

s10
C40 M0 Y100 K10
R160 G193 B1
#A0C101

s12
C85 M0 Y70 K10
R0 G156 B107
#009C6B

s14
C90 M20 Y50 K0
R0 G144 B140
#00908C

s16
C100 M0 Y25 K30
R0 G129 B156
#00819C

s18
C100 M50 Y10 K10
R0 G98 B162
#0062A2

s20
C75 M65 Y0 K10
R77 G86 B158
#4D569E

s22
C60 M90 Y0 K10
R119 G44 B133
#772C85

s24
C30 M90 Y30 K0
R184 G53 B112
#B83570

dp DEEP

dp2
C30 M100 Y80 K10
R173 G23 B49
#AD1731

dp4
C30 M85 Y100 K5
R181 G68 B31
#B5441F

dp6
C30 M60 Y100 K3
R186 G117 B25
#BA7519

dp8
C0 M20 Y100 K35
R189 G156 B0
#BD9C00

dp10
C40 M0 Y100 K40
R120 G147 B0
#789300

dp12
C95 M10 Y100 K25
R0 G125 B54
#007D36

dp14
C100 M0 Y60 K40
R0 G114 B96
#007260

dp16
C100 M0 Y10 K55
R0 G96 B131
#006083

dp18
C100 M60 Y0 K35
R0 G67 B133
#004385

dp20
C90 M90 Y0 K35
R38 G30 B111
#261E6F

dp22
C60 M100 Y0 K40
R91 G0 B96
#5B0060

dp24
C50 M100 Y50 K0
R148 G30 B87
#941E57

LT+ LIGHT

lt2+
C0 M40 Y25 K0
R245 G177 B170
#F5B1AA

lt4+
C0 M30 Y30 K0
R248 G197 B172
#F8C5AC

lt6+
C0 M20 Y40 K0
R252 G215 B161
#FCD7A1

lt8+
C0 M5 Y50 K0
R255 G240 B150
#FFF096

lt10+
C15 M0 Y45 K0
R227 G235 B164
#E3EBA4

lt12+
C30 M0 Y35 K0
R191 G223 B184
#BFDFB8

lt14+
C50 M0 Y30 K0
R133 G203 B191
#85CBBF

lt16+
C55 M0 Y10 K7
R106 G192 B217
#6AC0D9

lt18+
C50 M20 Y5 K0
R135 G178 B217
#87B2D9

lt20+
C40 M30 Y0 K0
R164 G171 B214
#A4ABD6

lt22+
C20 M40 Y0 K0
R207 G167 B205
#CFA7CD

lt24+
C0 M40 Y10 K7
R234 G171 B186
#EAABBA

Chromatic Colors

SF SOFT

sf2 C0 M55 Y30 K10
R225 G136 B137
#E18889

sf4 C5 M50 Y50 K5
R228 G148 B114
#E49472

sf6 C0 M40 Y70 K5
R239 G169 B81
#EFA951

sf8 C8 M15 Y70 K10
R224 G201 B89
#E0C959

sf10 C35 M5 Y70 K5
R177 G201 B101
#B1C965

sf12 C55 M0 Y50 K8
R114 G186 B144
#72BA90

sf14 C65 M0 Y40 K10
R72 G176 B160
#48B0A0

sf16 C70 M20 Y20 K10
R61 G151 B179
#3D97B3

sf18 C70 M40 Y10 K10
R77 G125 B174
#4D7DAE

sf20 C60 M50 Y10 K5
R115 G121 B171
#7379AB

sf22 C35 M55 Y0 K10
R165 G121 B172
#A579AC

sf24 C15 M50 Y20 K10
R203 G140 B156
#CB8C9C

D DULL

d2 C10 M70 Y50 K20
R191 G92 B88
#BF5C58

d4 C10 M65 Y55 K15
R200 G106 B89
#C86A59

d6 C10 M50 Y70 K15
R204 G134 B73
#CC8649

d8 C5 M12 Y75 K30
R193 G174 B63
#C1AE3F

d10 C35 M10 Y70 K25
R150 G166 B84
#96A654

d12 C55 M10 Y55 K30
R97 G146 B108
#61926C

d14 C80 M20 Y50 K20
R0 G131 B122
#00837A

d16 C85 M40 Y30 K20
R0 G108 B137
#006C89

d18 C80 M50 Y20 K30
R38 G89 B129
#265981

d20 C70 M60 Y20 K20
R83 G89 B133
#535985

d22 C50 M80 Y10 K20
R127 G62 B125
#7F3E7D

d24 C10 M70 Y10 K30
R175 G83 B123
#AF537B

DK DARK

dk2 C0 M100 Y70 K70
R105 G0 B2
#690002

dk4 C60 M95 Y95 K20
R112 G40 B40
#702828

dk6 C0 M60 Y90 K60
R129 G66 B0
#814200

dk8 C10 M20 Y100 K60
R126 G107 B0
#7E6B00

dk10 C40 M20 Y100 K60
R90 G96 B0
#5A6000

dk12 C90 M55 Y85 K30
R1 G81 B57
#015139

dk14 C100 M0 Y50 K70
R0 G72 B68
#004844

dk16 C100 M65 Y60 K25
R0 G72 B82
#004852

dk18 C100 M80 Y30 K40
R0 G44 B90
#002C5A

dk20 C85 M85 Y0 K60
R29 G15 B82
#1D0F52

dk22 C85 M100 Y55 K10
R68 G39 B81
#442751

dk24 C80 M100 Y60 K10
R79 G39 B76
#4F274C

P+ PALE

p2+ C0 M15 Y9 K0
R252 G228 B225
#FCE4E1

p4+ C0 M14 Y16 K0
R252 G229 B213
#FCE5D5

p6+ C0 M8 Y22 K0
R255 G240 B208
#FFF0D0

p8+ C0 M4 Y25 K0
R255 G246 B206
#FFF6CE

p10+ C9 M0 Y29 K0
R239 G243 B199
#EFF3C7

p12+ C20 M0 Y20 K0
R213 G234 B216
#D5EAD8

p14+ C20 M0 Y10 K0
R212 G236 B234
#D4ECEA

p16+ C20 M0 Y5 K0
R212 G236 B243
#D4ECF3

p18+ C21 M10 Y4 K0
R209 G220 B235
#D1DCEB

p20+ C20 M13 Y0 K0
R210 G217 B238
#D2D9EE

p22+ C14 M14 Y4 K0
R223 G219 B233
#DFDBE9

p24+ C0 M17 Y0 K0
R251 G226 B237
#FBE2ED

LTG LIGHT GRAYISH

ltg2 C7 M26 Y15 K13
R217 G186 B185
#D9B9B9

ltg4 C18 M27 Y27 K0
R215 G191 B179
#D7BFB3

ltg6 C11 M23 Y27 K5
R222 G198 B178
#DEC6B2

ltg8 C20 M20 Y40 K0
R213 G200 B160
#D5C8A0

ltg10 C17 M6 Y35 K12
R204 G210 B169
#CCD2A9

ltg12 C23 M0 Y23 K23
R175 G196 B178
#AFC4B2

ltg14 C41 M0 Y20 K15
R144 G194 B191
#90C2BF

ltg16 C47 M10 Y16 K7
R137 G187 B201
#89BBC9

ltg18 C37 M17 Y9 K13
R157 G178 B198
#9DB2C6

ltg20 C38 M28 Y13 K0
R170 G176 B198
#AAB0C6

ltg22 C24 M23 Y12 K12
R186 G180 B192
#BAB4C0

ltg24 C22 M34 Y22 K0
R205 G177 B180
#CDB1B4

G GRAYISH

g2 C15 M55 Y30 K45
R145 G91 B97
#915B61

g4 C0 M45 Y30 K55
R142 G95 B90
#8E5F5A

g6 C0 M30 Y40 K55
R144 G113 B88
#907158

g8 C10 M16 Y52 K47
R151 G139 B89
#978B59

g10 C21 M10 Y42 K47
R137 G140 B107
#898C6B

g12 C42 M10 Y42 K47
R103 G129 B106
#67816A

g14 C47 M16 Y37 K47
R94 G121 B110
#5E796E

g16 C48 M21 Y27 K48
R91 G114 B118
#5B7276

g18 C53 M32 Y16 K48
R82 G101 B122
#52657A

g20 C50 M50 Y6 K50
R89 G79 B116
#594F74

g22 C32 M49 Y11 K54
R108 G82 B107
#6C526B

g24 C22 M44 Y17 K49
R129 G98 B113
#816271

Chromatic Colors

Achromatic Colors

DKG DARK GRAYISH

dkg2 C0 M100 Y60 K90
R60 G0 B0
#3C0000

dkg4 C0 M85 Y90 K90
R60 G0 B0
#3C0000

dkg6 C0 M50 Y100 K90
R61 G26 B0
#3D1A00

dkg8 C0 M15 Y100 K90
R63 G49 B0
#3F3100

dkg10 C40 M0 Y100 K90
R34 G48 B0
#223000

dkg12 C90 M0 Y80 K90
R0 G38 B4
#002604

dkg14 C100 M20 Y50 K90
R0 G28 B27
#001C1B

dkg16 C100 M40 Y20 K90
R0 G13 B40
#000D28

dkg18 C100 M65 Y0 K90
R0 G0 B40
#000028

dkg20 C90 M80 Y0 K90
R0 G0 B34
#000022

dkg22 C65 M90 Y0 K90
R10 G0 B29
#0A001D

dkg24 C40 M90 Y20 K85
R48 G0 B27
#30001B

W C0 M0 Y0 K0
R255 G255 B255
#FFFFFF

ltGy C0 M0 Y0 K30
R201 G202 B202
#C9CACA

mGy C0 M0 Y0 K60
R137 G137 B137
#898989

dkGy C0 M0 Y0 K85
R76 G73 B72
#4C4948

Bk C0 M0 Y0 K100
R35 G24 B21
#231815

"Chromatic colors" are ones that
possess hue, while "achromatic
colors" are ones that do not
possess hue.

Glossary of Color Terms

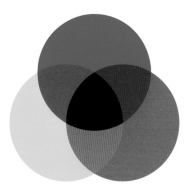

3 PRIMARY COLORS OF PIGMENT

The primary colors used to reproduce colors with paint or printing inks. They point to the 3 colors C (cyan), M (magenta) and Y (yellow), but in printing black, which is called K (key plate) is added for a total of 4 colors.
(Page 82)

ACHROMATIC COLORS

Colors which have no hue—colors "without color". They have no saturation and are indicated by brightness only.
(Page 12)

BRIGHTNESS

The degree of brightness or lightness of a color. In the PCCS system black has a brightness level of 1.5, and white has a brightness level of 9.5. There are several degrees of gray in between black and white, and the higher the number the lighter the color.

- High brightness colors: Light or bright colors. In the PCCS system their brightness levels are between 7.0 to 9.5. To divide all colors into large groups, this group covers white to light gray.

- Mid level brightness colors: Colors that are neither light nor dark. In the PCCS system their brightness levels are between 4.5 to 6.5. The large grouping is medium gray.

- Low level brightness colors: Colors with low saturation. In the PCCS system these are 3s p+ (pale) tones, 2s ltg (light grayish) tones, g (grayish) tones and dkg (dark grayish) tones.
(See page 13) (Pages 16–17) ETC.

CHROMATIC COLORS

Colors with hue. These have the 3 color properties of hue, brightness and saturation
(Page 12)

CMYK

A system to specify the colors reproduced with printing inks. Each data value is shown as percentage of ink used for each ink screen.
(See Chapters 2, 4, 5 ETC.)

COLD OR COOL COLORS

Colors that give a feeling of cold, coolness or chill. On the PCCS chart they are in the range from 13:bG to 19:pB.
(See page 84)

COMPLEMENTARY COLORS

Colors that are on opposite sides of each other on the color wheel. Strictly speaking, complementary colors are included in the range of contrast colors.
(Page 23) ETC.

HUES AND THE COLOR WHEEL

The properties of colors such as red, yellow, green, blue and so on. In the PCCS system they are represented with

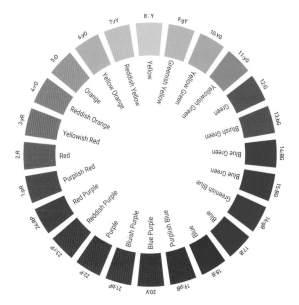

a combination of numbers and symbols, such as "1:pR = purplish red". All hues are represented with this combination of numbers and symbols. The meaning of each hue symbol is as follows:

R = red	BG = blue green	r = reddish
O = orange	B = blue	y = yellowish
Y = yellow	V = blue purple	g = greenish
YG = yellow green	P = purple	b = bluish
G = green	RP = red purple	p = purplish

The color wheel is the hues arranged in a ring. The rainbow color (the spectrum) range from red to blue purple, so purple and red purple are added to these so that the hues go around a circle. It is useful to contemplate the relationships between hues.
(Page 13) (Page 20) (Page 84) ETC.

INTERMEDIATE COLORS · MUDDY COLORS
Colors that are created by mixing both white and black (=gray) into pure hues. The thinking in color science pure hues do not become muddy if white or black are mixed with pure hues, while they do become muddy when they are mixed with gray, so these colors are also called muddy colors.
(See Page 14)

JIS COMMON COLORS
JIS refers to the Japanese Industrial Standards, and they specify the standards used for industrial activities in Japan. Of the color names specified by JIS, there are 269 colors that are held to be commonly used. Each of these 269 colors has a specific name. In this book we have indicated the JIS Common Color names with a JIS symbol.
(Pages 30–77 ETC.)

Note: There is a list of JIS Common Colors in English here:
https://www.color-sample.com/popular/jiscolor/en/

NEUTRAL COLORS
Colors that do not give an impression of cold or warmth. The colors that are not warm colors or cold colors. In the PCCS system they are in the 9:gY to 12:G and 20:V to 24:RP ranges.
(Page 84)

OPPOSITE COLOR
Another way to call a "contrast hue" of the basic colors.
(page 23) ETC.

PCCS
A system that was developed with the main objective of harmonizing colors. Since colors are grouped based on a standard set of rules, it is suited to using for color schemes. PCCS stands for Practical Color Coordinate System.
(Pages 16–17) (Pages 180–184) ETC.

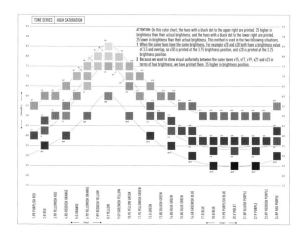

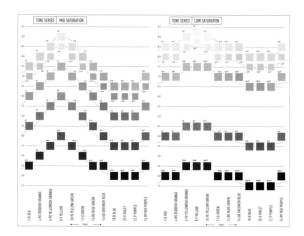

PCCS TONE MAP

A map that shows all the tones in the PCCS system, grouped by achromatic and chromatic colors. It's a useful tool for considering the direction or color scheme of your image.

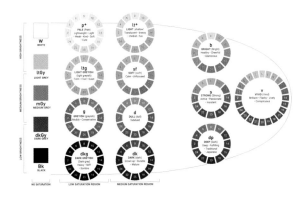

PRIMARY COLORS OF COLOR PERCEPTION

The 4 colors of red, yellow, blue and green that form the basis of the colors we perceive. They are the colors that are the easiest for humans to imagine.
(Page 83)

PRIMARY COLORS OF COLORED LIGHT

The primary colors used to reproduce colors on PC monitors, smartphones and television screens. They refer to the 3 colors of R (red), G (green) and B (blue).

PURE COLOR OR HUE

Colors or hues that are unmixed with other hues. You can think of them as pure hues that are not mixed with white, black or gray. In the PCCS system the v (vivid) tones are pure colors.
(Page 14)

RGB

A color model to specify and reproduce colors on a monitor. The numbers for each value combined determine the color that is displayed on screen.
(SEE CHAPTERS 2, 4, 5 ETC.)

SATURATION

The intensity of color. It shows how flashy or quiet the color feels. In the PCCS system saturation is set to 9 levels from 0s and 9s. S is an abbreviation for saturation.

- High saturation colors: Colors with high saturation. In the PCCS system these are 9s v (vivid) tones, 8s b (bright) tones, s (strong) tones and dp (deep) tones.

- Mid saturation colors: Colors that are neither low nor high saturation. In the PCCSsystem these are 6s lt+ (light) tones, 5s sf (soft) tones, d (dull) tones and dk (dark) tones.

- Low saturation colors: Colors with low saturation. In the PCCS system these are 3s p+ (pale) tones, 2s ltg (light grayish) tones, g (grayish) tones and dkg (dark grayish) tones.
(See page 13)(Pages 16–17) ETC.

SHADE COLORS

These are colors that are created by mixing black into pure colors. On the PCCS color chart these are dp (Deep) tones, dk (Dark) tones and dkg (Dark grayish) tones.
(See page 14)

TINT COLORS

Colors that are created by mixing white into pure hues. In the PCCS system the b (bright) tones, the lt+ (light) tones and the p+ (pale) tones fall into this category.
(See page 14)

TONE

The condition of a color. It's a concept that combines brightness and saturation in the PCCS system, and it's well suited for depicting impressions with color. In the PCCS system, the chromatic colors are divided into the following 12 tones

v (vivid)	sf (soft)	g (grayish)
b (bright)	d (dull)	dkg (dark grayish)
s (strong)	dk (dull)	(page 13) (pages
dp (deep)	p+ (pale)	16–17) etc.
lt+ (light)	ltg (light grayish)	

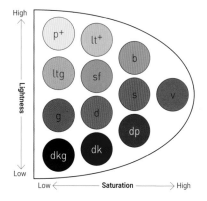

WARM COLORS

Colors that give a sense of warmth, hotness and heat. In the PCCS system they are in the 1:pR to 8:Y range.
(Page 84)

WEB SAFE COLORS

A way of representing colors. With web safe colors you can avoid colors shifting on the the user's side from the ones intended by the creator. Web safe colors are indicated by representing each RGB value in 6 steps (00, 33, 66, 99, CC, FF in hexadecimal notation) and combining them, with a hashtag # at the top. Web safe colors consist of the 256 8 bit colors minus 40 colors, which differ between Macintosh and Windows PC computers.
(See Chapters 2, 4, 5 ETC.)

The kanji character for color, 色, can be read in 3 ways—as "iro", "shiki" and "shoku"!.

Introducing the Illustrators

Profiles and sample works of
the illustrators who contributed work to this book.

AKARIKO
Akariko works as a free-
lance illustrator and cre-
ates book illustrations and
game character designs.
▶pixiv: ID / 4543768
▶web: http://akarinngotya.
jimdo.com

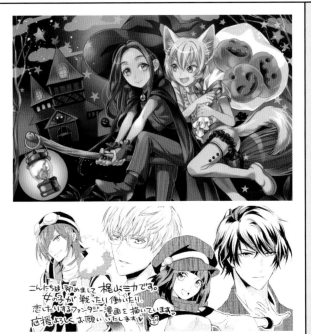

KEIZEN
Keizen is freelance illustrator who has worked on book illus-
trations and gama card illustrations.
▶pixiv: ID / 7642349
▶Twitter: @kei_pwq

MIKA KAJIYAMA
Mika is a manga artist who works mainly in the fantasy
genre as well as comic novelizations. Her works include
"The Cleaner for the Magician King."
▶Twitter: @Kajiyama_Mika
▶blog: https://ameblo.jp/kajiyama-m/

SAYUU

Sayuu is a freelance illustrator and manga artist who has created book illustrations, comic book anthologies and game character design.

▶Twitter: @sayuusuyasuya

JUUGONICHI

Juugonichi works at a production company and also creates illustrations on their own. Juugonichi lives in Fukuoka.

▶pixiv: ID / 851525
▶ Twitter: @15nichi

SOUREN HIIRAGI

Souren Hiiragi is a freelance illustrator specializing in character design and book illustrations.

▶ Twitter: @souren_11
▶ web: https://www.hiiragisouren.com

KANNA FUJIMORI

Kanna Fujimori is a freelance illustrator who creates manga, book cover illustrations and small illustrations.

TOKIHIKO FUTAHIRO

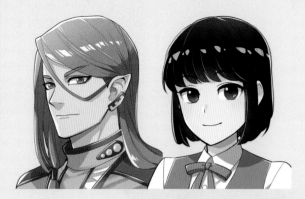

Tokihiko Futahiro is a freelance illustrator who creates manga and illustrations mainly for children's books.

▶pixiv: ID / 1804406
▶ Twitter: @futahiro

TOMOHIRO MARUTANI

Tomohiro Marutani is a freelance illustrator who creates illustrations for children's books as well as character designs.

▶pixiv: ID / 36216 ▶ Twitter: @hizano_kinniku

MARO

Maro is a freelance illustrator who has handled illustrations for novels and games.

▶web: https://qq4u8z5d. wixsite.com/maro3ku
▶ Twitter: @maro_3ku

"Books to Span the East and West"

Tuttle Publishing was founded in 1832 in the small New England town of Rutland, Vermont [USA]. Our core values remain as strong today as they were then—to publish best-in-class books which bring people together one page at a time. In 1948, we established a publishing office in Japan—and Tuttle is now a leader in publishing English-language books about the arts, languages and cultures of Asia. The world has become a much smaller place today and Asia's economic and cultural influence has grown. Yet the need for meaningful dialogue and information about this diverse region has never been greater. Over the past seven decades, Tuttle has published thousands of books on subjects ranging from martial arts and paper crafts to language learning and literature—and our talented authors, illustrators, designers and photographers have won many prestigious awards. We welcome you to explore the wealth of information available on Asia at **www.tuttlepublishing.com**.

Published by Tuttle Publishing, an imprint of Periplus Editions (HK) Ltd.
www.tuttlepublishing.com

KYARA NO MIRYOKU WO SAIDAIGEN NI HIKIDASU!
MANGA KYARA HAISHOKU NO KYOUKASHO
Copyright © Teruko Sakurai 2021
English translation rights arranged with SEITO-SHA CO., LTD.
Through Japan UNI Agency, Inc., Tokyo

English Translation © 2023 by Periplus Editions (HK) Ltd

ISBN 978-4-8053-1722-8
Library of Congress Cataloging-in-Publication Data in process

Staff (Original Japanese edition)
Illustrations Akariko, Mika Kajiyama, Keizen, Sayuu, Jugonichi, Hiiragisouren, Kanna Fujimori, Tokihiko Futahiro, Tomohiro Marutani, Maro
Design and DTP Chihiro Muraguchi, Keita Muraguchi
Photos Shutterstock
Cooperation NIPPON DESIGNERS SCHOOL, Nihon Kogakuin College
Editorial cooperation A & F

Distributed by
North America, Latin America & Europe
Tuttle Publishing
364 Innovation Drive
North Clarendon, VT 05759-9436 U.S.A.
Tel: 1 (802) 773-8930
Fax: 1 (802) 773-6993
info@tuttlepublishing.com
www.tuttlepublishing.com

Japan
Tuttle Publishing
Yaekari Building, 3rd Floor
5-4-12 Osaki
Shinagawa-ku
Tokyo 141 0032
Tel: (81) 3 5437-0171
Fax: (81) 3 5437-0755
sales@tuttle.co.jp
www.tuttle.co.jp

Asia Pacific
Berkeley Books Pte. Ltd.
3 Kallang Sector, #04-01
Singapore 349278
Tel: (65) 67412178
Fax: (65) 67412179
inquiries@periplus.com.sg
www.tuttlepublishing.com

25 24 23 22 10 9 8 7 6 5 4 3 2 1
Printed in China 2209EP